MAYBE THE PEOPLE
WOULD BE THE TIMES

ALSO BY LUC SANTE

Low Life
Evidence
The Factory of Facts
Kill All Your Darlings
Folk Photography
The Other Paris

CO-EDITOR (WITH MELISSA HOLBROOK PIERSON)
O. K. You Mugs: Writers on Movie Actors

EDITOR AND TRANSLATOR
Novels in Three Lines, by Félix Fénéon

Maybe the People
Would Be the Times

LUC SANTE

Verse Chorus Press

Published by Verse Chorus Press, Portland, Oregon | *versechorus.com*

Front cover photo and design: Luc Sante
Interior design: Steve Connell Book Design | *steveconnell.net*

Acknowledgments, permissions, and other credits may be found on pages 327–328, which constitute an extension of this copyright page

Printed in the USA

Library of Congress Cataloging-in-Publication Data

Names: Sante, Luc, author.
Title: Maybe the people would be the times / Luc Sante.
Description: First edition. | Portland, Oregon : Verse Chorus Press, [2020] |
 Summary: "A collection of articles on photographers, musicians, artists,
 and writers, many of them with a strong autobiographical element and
 sense of place, the Lower East Side of New York City where the author
 came of age in the fertile 1970s and '80s. He traces his engagement with
 music and photography, his experience of the city, and his development
 as an artist and observer, in a series of pieces that range from memoir
 to essay, fiction to critical analysis, humor to poetry"-- Provided by
 publisher.
Identifiers: LCCN 2020006501 (print) | LCCN 2020006502 (ebook) |
 ISBN 9781891241574 (trade paperback) | ISBN 9781891241727 (ebook)
 Subjects: LCSH: Arts, American--New York (State)--New York--
 History--20th century. | Arts and society--New York (State)--New
 York--History--20th century. | Lower East Side (New York, N.Y.)--
 Civilization--20th century. Classification: LCC NX511.N4 S27 2020
 (print) | LCC NX511.N4 (ebook) | DDC 700.9747/0904--dc23
LC record available at https://lccn.loc.gov/2020006501
LC ebook record available at https://lccn.loc.gov/2020006502

"I wanted to speak the beautiful language of my time."

—Baudelaire
Le Spleen de Paris

Contents

I

My Generation

You wish you'd spent more time with your generation before it died. It was so beautiful, sitting there in the corner, hanging around on the corner, worrying about its hair, worrying itself into tatters. Of course you didn't appreciate its beauty. You couldn't see it, not at the time. You couldn't wait for it to go to hell. But it held such promise; it believed so wildly and intensely in its own belief. It thought it was different from all other generations. It was a generation that thought it was a country.

2001

E.S.P.

1.

Very late that night, riding home on the train as it shoots past the graffiti-washed vacant stations on the local track, they stare straight ahead, unable to explain or articulate the sense of dread that fills them both except by reference to the lateness of the hour, or the ebbing of the drugs, or the onset of a cold. The nearly empty train is going too fast, and it leans around curves as if the wheels on one side have lost contact with the track, and the lights periodically wink off for as much as a minute at a time. They sit slumped in a double seat next to a door. Whenever the train stops at a station the doors open and nothing comes in, an almost palpable nothing. Neither bothers to look because they can feel it slide in and take its place among the already assembled nothing. The air is heavy with the weight of an earlier week, when it was still summer in the streets above. The light breaks up into particles. Down here the night could last forever. The song is "Florence," by the Paragons.

Mind if I play it for you? Here it is, on *The Best of "Winley" Records*, volume seven of "The Golden Groups" on the Relic label, an ancient copy with varicolored stains on the back of the sleeve and a skip in the middle of the cut in question. The skip is annoying, but it also feels like a part of the fabric, along with the hollow-centered production, the dogged piano like the labor of the accompanist at a grade-school assembly, the groans of the four supporting Paragons, and the agony of Julius McMichael's falsetto lead. It's a daredevil performance, a miracle of endurance—he sounds as if he will dissolve into coughing and retching or perhaps even drop dead before the

end of the track. The song wants to be a ballad but keeps turning into a dirge. It's so ghostly you can't imagine it ever sounding new. But then doo-wop is a spectral genre. It actually happened on street corners; what transpired in the recording studio, afterward, might sound posthumous.

"Florence" happened below street level. It happened in a cave, in an abandoned warehouse, in an unknown room eight stories under Grand Central Station at five o'clock in the morning. Probably it took place in an impersonal studio off Times Square panelled with that white pasteboard stuff gridded with holes, with folding chairs and ashtrays and demitasse-size paper cups of water and a battered upright piano. Probably the Paragons got a twenty-dollar advance apiece, if that, and then they took the subway home to East Tremont or wherever it was they came from. "Florence" has reached our couple two decades after its release through the medium of oldies radio—a medium of chattering middle-aged men, audibly overweight, short-sleeved even in the dead of winter, who are capable of putting on the spookiest sides without seeming to notice the weirdness as they jabber on about trivia before and after. Vocal harmonizing became "oldies" in 1959, when it was still kicking, a premature burial but a phenomenon that allowed records that had sold a hundred copies in the Bronx when new to suddenly go nationwide and become phantom hits a couple of years later. But "Florence" cuts through the format with its breathtaking weirdness. The piano, the groans, the keening falsetto—it comes on as Martian. "Oh, Florence, you're an angel, from a world up above," raves the singer in a dog-whistle register that symbolically indicates the purity and intensity of his passion, while an Arctic wind blows through any room where the song is played.

Naturally our couple don't know that each has "Florence" playing on the internal soundtrack, not that either would be surprised. The hour, the chill, the sticky yellow light, the vertical plunge from a high—all call down "Florence." The moment could feel merely depressed, small-time, pathetic, but "Florence" in its strangeness lends it magnificence. They feel

heroically tragic in their stupor. "Florence" places the moment in the corridor of history, makes it an episode, emphasizes its romance and fragility and proximity to heartbreak, suggests that a contrasting scene will follow directly.

Now they have emerged into the weak pre-dawn light of the street. The place is empty except for garbage trucks. The traffic light runs through its repertory of colors to no effect. They still haven't spoken, not in an hour or more. Words feel too huge to shovel onto their tongues. The lack of traffic is convenient, since their reflexes are too slow to negotiate any. They walk, side by side, down the street of shuttered stores, each plodding step a small conquest of space. The apartment seems impossibly distant, their progress the retreat from Moscow. At this hour time doesn't exist, actually. The hour just before dawn looks like night, but with all of night's glamour stripped away, and although habit assumes that dawn will soon arrive and peel back the sky, there is no real evidence of this. Darkness clutches the world and will not give it up. The calendar year is an even flimsier proposition; only the 24-hour newsstands maintain it, here and there shouting it into the void like street-corner proselytizers. The year is a random set of four digits that may or may not coincide with the information imparted by the posters wheat-pasted on the windows of empty storefronts. In all probability, "Florence" has not yet been composed or recorded. Our couple has imagined it. When they awaken the following afternoon, they won't remember how it visited them.

2.

Historically, she got off the bus. Most of the rest is conjecture on my part, but she did get off the bus, in the aquarium depths of the lowest platform at Port Authority, a bus of the Pallas Athena line, from someplace in New Jersey—*western* New Jersey, she insisted, out near the Red River declivity, where the mesas begin, "the biggest sky you ever saw." West of Trenton, even. She

claimed there were fourteen people in her family and that she
had to leave because they needed her room to lodge hands for
the pea harvest. She carried a large plastic suitcase and an army
duffel bag reinforced with duct tape. They were too heavy for
her, so she dragged them along, past all the chaotic intersecting
lines of people waiting to get on other buses, past the black nun
with a basket on her lap at the foot of the escalator, past the lunch
counters and drugstores and necktie displays, past the hustlers
and the plainclothesmen and the translucent figures who came
to the terminal just because they liked the smell of people.

She marched through the main hall and out the glass doors
onto the avenue, and then, I imagine, she unhesitatingly turned
right and started downtown, because she wasn't one to dally.
I can see her plowing down the avenue with her twin cargo
containers angling out behind her, scattering the lunchtime
crowd like bowling pins. She cut quite a figure at five foot noth-
ing in boots, although I don't know if she yet had the black
leather Perfecto jacket she was to wear in every possible kind of
weather. Her hair was long then, gathered in one braid like the
heroine of a Chinese proletarian opera. She hadn't yet started
on her campaign—spectacularly unsuccessful—to make herself
unapproachably ugly, so her glasses were delicate wire things
rather than welder's goggles with perforated side-pieces. She
looked about fourteen, maybe even nine in certain kinds of
light, and yet there was something about her, some kind of juju
she emanated, possibly the adamantine stare that seemed to pre-
cede her into a room, that caused grown men to tiptoe around
her. Whatever she was wearing, nobody would have given her
any guff about running over their toes with her ten-ton bags.

3.

"Finally have enough ideas for my own things to work on
that I can see the advantage of not having to work. Not that I
ever wanted to have a full time job but it was a little mysterious

to me what I'd do w the free time besides get fucked up etcet.
On saying that I suppose I'll promptly dry out. On the other
hand, sometimes I get sick of imposing myself on my environ-
ment. But I console myself by saying its merely a matter of
degree since you can't stop that jazz except by getting dead
anyway. All trottoirs lead to the junkyard."

"Got offered a job in Montana as cook on a ranch—explained
my job situation, was told to call collect in the spring if still
interested. May vy well be. What passes for the advantages of
the city don't impress me. Meantime I start teaching Monday,
me and S. planning an interior house painting biz, may have
silkscreening/photo jobs freelance. Lots of film to mess with
and some collage ideas still intact. Got a Greek dictionary the
better to write to my grandmother. D' like to start making
casts, finish my videotape, learn how to use a gun, buy a bi-
cycle, play better pool, do more architectural drawings & keep
my dirty socks out of my work room, my newspapers & bus
transfers out of my bed, & myself out of shitty klubs. Am go-
ing to try vy hard to have no more catatonic afternoons/hung
over mornings (starting day after tomorrow). The odd dates
are all New Year's Day, the evens the day of atonement. Well,
no, I really am in more control of things. Don't give a shit
about any particular end pts as long as the process is satisfy-
ing. One life to live—organ break here. Then ad for disposable
razors."

"I hope I don't get dull out here. I consult myself periodically
to see if I'm 'done,' ready to leave. I'm anxious in a way to have
this period behind me, to be frivolous is a social embarrass-
ment. But at the same time the theme of the period is to wish
away nothing so I can't regret it."

"Walking to work through the neon in the Stockton tun-
nel at 6:30 A.M. it occurs to me that I'm a PRODUCT OF
EVOLUTION. But I'm not satisfied. I suppose its no better

than even odds you'd believe I'm working the morning shift in a restaurant in the financial district for minimum wage."

"Someone gave me a blue black pearl earring so I got my ear pierced & am wearing it. Its vy beautiful & looks good but makes me look vy fem(me) (?) & seems unnatural almost perverted to me for me."

"So a new legs been added to the graph of moods & it's a goat's leg. Expect to be bored to death today at the liquor store. Had a marvelous day of filling a brick wall w cement yesterday."

"I have an outrageous calligraphic scar on my ass that I got fr accidentally leaning on the grill of the beloved Sahara heater when it was red hot & I was stark naked. Its one of my favorite things abt myself along w my gold tooth."

"The birds are singing, the 4:30 A.M. ones."

4.

Let me play you "Arleen," by General Echo, a seven-inch 45 on the Techniques label, produced by Winston Riley, a number one hit in Jamaica in the autumn of 1979. "Arleen" is in the Stalag 17 riddim, a slow, heavy, insinuating track that is nearly all bass—the drums do little more than bracket and punctuate, and the original's brass-section color has been entirely omitted in this version. I'm not really sure what Echo is saying. It sounds like "Arleen wants to dream with a dream." A dream within a dream. Whether or not those are his actual words, it is the immediate sense. The riddim is at once liquid and halting, as if it were moving through a dark room filled with hanging draperies, incense and ganja smoke, sluggish and nearly impenetrable air—the bass walks and hurtles. Echo's delivery is

mostly talkover, with just a bit of sing-song at the end of the verse. It is suggestive, seductive, hypnotic, light-footed, veiling questionable designs under a scrim of innocence, or else addled, talking shit in a daze as a result of an injury: "My gal Arleen, she love whipped cream / Every time I check her she cook sardine . . ."

General Echo, whose real name was Errol Robinson, was prominent in the rise of "slackness," the sexually explicit reggae style that began to eclipse the Rastafarian "cultural" style in the late 1970s; his songs include "Bathroom Sex" and "I Love to Set Young Crutches on Fire" ("crotches," that is), as well as "Drunken Master" and "International Year of the Child." He had his first hit in 1977, put out three albums and a substantial number of singles—an indeterminate number because of the chaos and profusion of Jamaican releases, then as now. Along with two other members of his sound system, he was shot dead on the street by Kingston police in 1980; no one seems to know why.

I bought the record at the time it was on the Jamaican charts, from some punk store in downtown Manhattan. I first heard it at Isaiah's, a dance club that materialized every Thursday night in a fourth-floor loft on Broadway between Bleecker and Bond. This was a few years before the enormous wave of Jamaican immigration to the United States, which was mainly a phenomenon of the later '80s and a result of the kind of violence that killed General Echo. Nevertheless the club regulars were more than half Jamaican transplants, nearly all of them men. The walls were lined with impassive types wearing three-piece suits in shades of cream and tan, and broad-brimmed, high-crowned felt hats that looked at once Navaho and Hasidic, with their locks gathered up inside. They danced as if they didn't want to dance but couldn't entirely contain themselves—the merest suggestion of movement: a shoulder here, a hip there. It was hard not to feel judged by this lineup; I kept ratcheting down the enthusiasm level of my dancing. But they didn't even see me. Whatever else might have been going

on in their lives they were, in immemorial fashion, bachelors at a dance, and this gave the club a taste of the grange hall. Sometimes I went there with a girlfriend, sometimes with a group of people. We smoked weed and drank Red Stripe and sometimes inhaled poppers, which would lend you huge brief bursts of euphoric energy and then foreclose, leaving you in a puddle. I hardly ever made it to the 4 a.m. closing because the next day I had to work, and four hours' sleep made me feel sick. As a result I missed all the incidents involving guns, which invariably occurred at the end of the night. The club would have to shut down, for weeks or months at a time—it was anyway unclear what went on in the loft the other six nights and seven days; maybe people lived there. Eventually the owners installed a metal detector, the first one I ever encountered, little suspecting they would one day be ubiquitous.

We went there for the bass, and the trance state resulting from hours of dancing to riddim that stretched forever, the groove a fabric of stacked beats fractally splitting into halves of halves of halves of halves, a tree that spread its branches through the body, setting the governor beat in the torso and shaking its tributaries outward and down through shoulders, elbows, hips, knees, feet so that you couldn't stop except when you collapsed. Most often I went there with E., who danced like a whip, and who could keep on well past my exhaustion limit, and because I needed her I did so, too. Dancing was our chief mode of communication, an intimacy like two people sleeping together in different dreams, our bodies carrying on a conversation while our minds were in eidetic twilight. Neither of us really trusted language with each other, so we found this medium of exchange that trumped it, precluding silence and misunderstanding. She had a small body whose axis was set on powerful hips with an engine's torque, while above the waist she was all moues and flutters, a belle minus a carnet de bal, so that the sum of her was exactly like the music: the massive horsepower of the bass below and the delicate broken crystal guitar and plaintive childlike melodica above.

We lived in that place called youth where everything is terribly, punishingly final day by day, and at the same time tentative and approximate and subject to preemptive revision. We broke up and got back together, again and again, we lived together or we lived at opposite ends of the island, then she moved west and didn't come back, and I went out there but elected not to stay. Then her body betrayed her. She became allergic first to television, then to television when it was turned off, then to inactive televisions downstairs or next door, then to recently manufactured objects, then to so many various and apparently random stimuli she became her own Book of Leviticus. Then her muscles gave way and she couldn't dance, then couldn't walk, then couldn't speak, and in the end became just a head attached by a string to a useless doll's body before she stopped being able to swallow and soon after to breathe.

5.

Dear D.,

I went over to M.'s to retrieve my letters and whatever else from the four big crates of stuff she salvaged from E.'s apartment when E. entered the nursing home a few months before she died. It took me a few years to work up the courage to ask. I wanted the letters, I justified, because they were probably the closest thing to a diary I ever kept, in the key years 1979-1983. In other words I was exercising my usual dodge, which is to turn all of life into research materials. M. was game if not exactly eager. One corridor of her apartment is choked with boxes — the rest consist of her father's belongings, and they will undoubtedly soon be joined by her mother's. She hadn't opened any of the crates since hurriedly packing them more than four years ago. Late in the evening, after dinner, we began to dig. It was quite literally like entering a tomb. There was E.'s Perfecto jacket; there was a small box containing a

gold tooth and a lock of her hair; there was a whole box of her eyeglasses. There were boxes and boxes of collage materials, of her photographs and negatives, of notebooks. There was copious evidence of her study of botany (she took university classes in the subject at some point), of her various pursuits of therapy, of her adherence to Buddhism (much more serious and longstanding than any of us unbeliever friends realized). And there were many bags and boxes of letters. This was just the stuff M. kept—I understood firsthand the harshness of trying to make those sorts of decisions, in a hurry and under major psychological stress, and my parents' house didn't even reek overwhelmingly of urine.

Going through the boxes caused me to enter a state that I suppose was not unlike shock. I took my letters and nothing else, went back to my hotel and read all of them, then couldn't sleep. On the one hand I wasn't wrong; the letters are indeed the only real record I have of those years, and I have nothing to cringe about concerning their style or expression—E. always brought out the best in me that way. They are full of detail about those days, that is when they don't consist of naked pleas. Reading them felt vertiginous, like being admitted back to F.'s apartment on First Avenue for fifteen minutes of an afternoon in 1979 and experiencing all over again the despair and optimism and boredom and love and fun and heedlessness and anguish of that time. And it brought her back into a kind of three-dimensionality that I'd forgotten—my jealousy rushed right back. There were a few unmailed letters from her to me, too. One of them, from after her last visit to New York in 1990, may be the most romantic letter she ever wrote me. I can't help but speculate on what would have happened had I received it.

She was getting crazier and crazier as well as sicker at the time. Photographs of her from before she became immobilized by her illness show her grinning wildly with a missing front tooth, aggressively unkempt, looking like someone who'd hit you up for spare change in Tompkins Square Park. Could I

imagine myself nursing her until her death? But she wouldn't
have permitted that anyway. M. reports that at her memorial
the room was crowded with people, few of whom knew any of
the others. She needed to compartmentalize her life, and that
was one of our chief stumbling blocks as a couple. Of course
I understood, since I have similar tendencies, but I wanted *her*
exclusively. I can't begin to account for the chaos of emotions
this has all raised in me, the sheer number and variety of them.
Part of me wanted to take those four crates—M. doesn't know
what to do with them. They are E.'s life, her complexity, her
unbelievable array of talents and their utter dissipation. She's
going to haunt me for the rest of my days—do I wish I'd never
met her? But that's like trying to imagine my life as another
person. She changed me, totally and irreversibly.

Interesting to hear M. say that as far as she's aware E.
cracked at some point in her last year of high school, and was
never the same again. A banal incident—she backed over a row
of metal garbage cans while trying to drive (she was always
an awful driver)—sent her over the edge. M. dates E.'s cru-
elty to her (she was consistently vicious to M.), among other
things, to that time. That sounds too neat, but who knows? In
my experience she didn't start seeming or acting weird until
we'd been together about nine months, maybe sometime in
the spring of '75. Here's a random snapshot of E.: One time
during her next-to-last New York visit ('87?), M. and her boy-
friend of the time were going to a club and invited E. to come
along. She insisted on stopping to get some takeout food, and
then, to M.'s and boyfriend's dismay, insisted on bringing it
into the club to eat. You didn't do things like that in clubs
by that point. To me the story graphically illustrates an aspect
of her. She specialized in the inappropriate. You'd constantly
be wondering: What's the deal, exactly? Is it that she wants
to accommodate her own needs and conveniences regardless
of whatever social codes are in effect? Does she mean to pro-
voke? Is she oblivious to the reactions of others? Does she
want to reorganize the whole world, starting here and now? Is

she deliberately doing something gauche as a way of wrestling with her feelings of inadequacy and gaucheness? It may have been that all of those things were true, and that even ranking them in order of importance would be irrelevant. I could go on, but I won't.

Love,

6.

"Sally Go Round the Roses" is a strange song that can seem as though it is following you around. A writer somewhere called it an ovoid, and that seems apt. The instrumental backing is functionally a loop, a brief syncopated phrase led by piano and followed by bass fiddle and drums, that repeats as often as a rhythm sample. It makes the song float, hover like a cloud. Sitting on top of the cloud are girls, a lot of girls, at least eight of them in multitracked call-and-response, at once ethereal and obsessive. The chorus tells Sally to go round the roses, that the roses can't hurt her, that they won't tell her secret. It tells her not to go downtown. It tells her to cry, to let her hair hang down. It tells her that the saddest thing in the whole wide world is to see your baby with another girl.

The record is credited to the Jaynetts, although that seems to have been a label applied by the producers to various aggregations assembled in studios on various dates with varying results. There were other songs with that attribution; they left no mark on the world, nor did they deserve to. This one made it to number two on the charts in 1963. Even the first time you hear it, it sounds as if you've always known it. It comes over you like a glow or a chill. It comes over the couple as they sit, shivering, on the rooftop of an old building in Chinatown. It is August, but that does not prevent the air from feeling glacial. They've been talking all night, at cross-purposes. Each feels

that only a personal failure of rhetorical skill prevents the other from embracing the correct view. But every clarifying or corrective word widens the gulf.

How many Jaynetts were there? Did they ever appear before an audience? What did they look like? Did they wear bouffantes and long gold lamé dresses, or kerchiefs and sweatshirts and three-quarter-length pants? How was the song heard by its first listeners? How is it heard today? Did everybody but us mistake it for an ordinary anodyne pop song? Where did the song really come from? Was the song actually written by someone who sat down at the piano one day? Was it sung to the pretended author in a bar by a stranger who thereupon dropped dead?

Did it just somehow materialize, in the form we know today, on a reel-to-reel tape with no indication of origin? Why does it seem to resist the grubby quotidian context from which all things come, particularly pop songs aimed at a nebulously conceived teenage audience? Is it simply a brilliant void like those that periodically inflame the popular imagination, which allow their consumers to project any amount of emotional intensity upon them and merely send it back in slightly rearranged form, so that it can seem to anticipate their wishes and embody their desires and populate their loneliness and hold out a comforting hand, when it is in reality nothing but a doll with mirrored eyes?

Now they've stopped talking, from fatigue and futility. They're drained, and that in concert with the cold air makes them feel as if they're drifting, carried by breezes far from their rooftop and away over the city, over its skyscrapers and bridges, flung this way and that, speeding up and slowing down, weightless as a couple of feathers. There are trucks moving below them, and pigeons at eye level, and up above is the contrail of a jet. There are few lights on in windows, no visible humans anywhere. They sit, or float, atop a dead city, mired in a darkness that does not even manage to be satisfyingly black. Just then the sun's first rays point up over the horizon and

begin to describe a fan, each separate ray distinct, almost solid. It is the dawn as represented in nineteenth-century anarchist engravings: the advent of the new world. Silently they regard this phenomenon. It seems cruelly and pointlessly ill-timed, purely gratuitous and designed to mock them. It is the earth's epic ritual enactment of beginning, and they are at an end. They become aware once again of the song, hovering over the rooftops, emanating from some unseen radio. Sally goes round the roses and keeps going around them: it is a circle. It has no point of entry or exit. They have no purchase on it, no more than they have power over the sun. It, whatever it might be, will continue beginning and ending, over and over and over again, per omnia saecula saeculorum.

2007

Maybe the People Would Be the Times

Almost everything of interest in New York City lies in some degree of proximity to music. If you are in your teens or twenties—and who isn't—pretty much everything you do apart from your day job has something to do with music. And it isn't even just the permanent soundtrack on your stereo and in your head. The music is your spur. You were led to the city by music. You were fourteen or fifteen and wanted to crawl inside the music. The music was immense, an entire world immeasurably different from the sad one you were born into. If you could figure out how to get in, the music would suffuse you. You wouldn't even need an instrument: you would become one with the music and it would pour from you like light through gauze.

The search led through record stores: the cavernous Times Square markets with their tens of thousands of titles, the little downtown storefronts with inventories calibrated to the changing tastes of one local clique, the flyblown neighborhood shops where they might have back stock neglected since 1962, the doo-wop museums manned by savants in obscure subway arcades, the head shops purveying bootlegs from a curtained alcove in the rear, the oldies row on Bleecker Street where all the clerks are critics and the discourse alternates unpredictably between impassioned and sardonic. It wound past clubs that are just bars with a stage in the back, or lightly redecorated union halls, or resurrected chantoosie joints from another era, or ex-vaudeville palaces with paintings on the ceiling, or hotel ballrooms with a thousand conspicuous fire-code violations, or sawdust-floored folkie taverns with an aura of everybody having missed the bus a decade earlier, or jazz lofts in

semi-industrial parts of downtown so remote there's no place within a mile to buy cigarettes after dark. It flittered across underground newspapers and teen-gossip rags and lifestyle glossies and quickie paperback bios and radio interviews and industry-promo artifacts stacked near the cash registers and hazy orally transmitted lore of dubious provenance.

But 1975 is a new world, somehow. Everybody gets a haircut that year, and no one can say exactly why. Psychic emanations are big; you can feel change peeling off the walls but can't really name the form of that change. The year is a laboratory. Anything is possible. At stake is a future that might at least superficially look more like a past. Which is to say that the hippie order of knowledge has been overturned. The haircut is an affirmation of this. The time has come for us to assume our own place in the music, and that will involve an overthrow of what has come before. Life is suddenly black and white with a thin stripe of red running through.

The year begins when Marvin Gaye calls in sick and the Apollo gives us our money back. The alternative option is a rumor, really, although it's been going on for half a year. We go for it. After a very long subway ride we arrive at a tunnel of a bar under a bum hotel on the Bowery with a pool table and a stage in the back: CBGB. Onstage four guys in shirt-jacs, conspicuous lack of overt theatrics, shaker bars on the guitars: Television. The poster has a blurb from Nick Ray, of all people—"Four cats with a passion"—and another from someone named Scott Cohen: "Killers. Sharp as tacks. They made me cry." This is something else, we think, as they blast into a cover of "Psychotic Reaction," by the Count Five. At first glance they're channeling 1966: the clothes, the covers, and when they talk they sound like Mitch Ryder or somebody, that not-quite-black hepped-up hoodlum corner talk affected by all the guys who wore winklepickers in 1966. The words to the songs likewise convey mod menace: "I look at you / I get a double exposure" or "Prove it / Just the facts / Confidentially." The bass player, who seems to enjoy jumping up and landing

on his knees, has a ditty with a chorus that goes: "I belong to the [pause] blank generation." But it's also about how the twin leads snake around each other as if they are each holding knives, how lyrical passages turn without warning into dissonant slashing fury, how the drummer carves the beat out of flurries of paradiddles, like he's been absorbing Elvin Jones—how the unstable field of noise constantly threatens to crash and burn.

And that makes the music right for the world outside: the persistent breakdown of all structures, the vacated certainties and the welcoming randomness, the retreating future and imminent prehistory. Tom Verlaine sings about how "Broadway / Looks so medieval," and so it is, our moment the great shipwreck of time. All the contents of previous decades and centuries are heaped up on the sidewalks for us to pick through and select and repurpose or discard. Nobody else seems to want this lurching hulk of a city, headed to the honor farm like a former star given to paregoric and shoplifting, so it has de facto been ceded to us self-appointed guttersnipes, and maybe someday we will rule it, although for now we're content to pick at its scabs. The Bowery is our ancestral home, that broad empty boulevard running from nowhere to nowhere lined with pedigreed hovels inhabited by ghosts, where in one tiny establishment every night is New Year's Eve and we're all contestants for Miss Hitchhiker of 1976.

But information flies in erratically from other parts of the globe. For a few years now the strongest signals have been emanating from the unlikely island nation of Jamaica. Unlikely because we didn't know anything about it until a great mass of its seething cultural products appeared on our doorstep circa 1973, notably the desperado epic *The Harder They Come*—as tough and cheap as a spaghetti Western, as taut as an epigram—and then its glistening soundtrack (nobody can make out the words to the Maytals' "Sweet and Dandy," and we only figure out it's about a country wedding long after we've given ourselves over to its perpetual-motion groove, like a Slinky if it could go up the stairs as well as down), and then a whole profusion of records.

Much of it is mysterious at first, especially the style that involves poets possessed by spirits talking and chanting over a backing track mined with sound effects and giant echo and instruments dropping out and detached fragments of a sung melody drifting through like lost birds. Big Youth is splendid and so is U-Roy, but it is thanks to Patti Smith (who has her finger firmly on the pulse of the moment) that we know about reigning Rasta surrealist Tappa Zukie, whose every recording sounds like the primal struggle of man versus radio. Zukie shouts from inside a room he has hewn himself from a bass line as tall and dense as trees, runs a zigzag course over a shifting terrain of percussion, summons phantom armies of brass instruments to come riding over the crest. In "Jah Is I Guiding Star," Horace Andy's plaintive "My Guiding Star" is stripped down to glittering shreds as Zukie, transfixed, reaches the peak of his sermon: "Have mercy upon those who have mercy upon themselves / Don't get me mad y'all." Then his torrential rant, like one immense release of breath over three and a half minutes, trickles down into ellipsis: "The automatic clicker with remote control / the dennis / the menace / the mattress all / the dread dem sleep and the baldhead a-peep / and the dread dem wake and the baldhead creak how you *mean* . . ."

This is music that gives us seven-league boots to walk the streets in, loping twenty-block miles faster than taxis, or else we dance in somebody's bare loft decorated with foil-sided insulation panels, with clamp lights scattered on the floor pointing up the walls, a single pole-mounted fan moving the air around the 1500-square-foot oven, the turntable hooked up to a guitar amp and the music's echo redoubled by the cavernous echo of bricks and mortar. We dance to reggae and we dance to soul, or disco, or R&B, or whatever you want to call it these days. Marvin's "I Want You" and "Got to Give It Up," the Floaters' "Float On," Chic's "Le Freak," James Brown for days but especially right now "Papa Don't Take No Mess," and it's also the inaugural year of Funkadelic's anthem, "One Nation Under a Groove." Someday they will swap out Francis

Scott Key's Bavarian drinking song for this stepping march that gathers all the strands—it's a chance to dance our way out of our constrictions, on a national scale. The song already seems to be underway when the needle hits the groove, and it might as well never end, since we keep taking the needle back to the start when it starts edging near the run-out. It's a whole circus parade of sounds and effects: brass band, clowns, aerialists, prancing horses, confetti showers, giant papier-maché monster heads. It will teach you how to dance if you don't know how. You let your ass fall into the central bounce path carved out by the bass and the handclaps, and then the rest of your body can align with whatever you want for however long you want: the half-tempo crooner, the squeaking synth, the chuckling guitar monologue, the drum fills, the whistles, the calls and interjections by what sounds like two dozen different voices. It's maybe on the sixth reprise that those of us who aren't completely fucked up start to notice that the floorboards are visibly moving up and down on the one, and this is no joke when you're talking about century-old joists and beams. We start to edge toward the walls, where long tables are covered with empty bottles and cans. From there the crowd looks like one body with four hundred limbs. The air, redolent of sweat and spilled beer and tobacco and cannabis and unnameable musks, is maybe a third of the way toward transmuting into a solid. Somebody screams along with the falsetto wail that turns into "You can dance away." Just then the fuse blows.

Because we are 19 or 22 or 24 and in the great city we are living in the great moment, the very forefront of Now. Nothing can happen that we won't know about at least a week in advance. There are no media to cover our scene—TV and radio and newspapers and magazines all equally indifferent—but we know everything anyway because we are plugged into the great invisible telegraph of youth. A club will open in some distant and untrafficked neighborhood; a 45 will come out that is for sale in just three stores; a band will form and rehearse but not yet have played out; a bar in far-flung midtown will change its

jukebox offerings to include the few available records made by our people—we know all these things instantly. For that matter there is no one on the scene with whom you don't have at least one mutual friend. We are in the heart of the great city, and yet our scene is a little village, where all the people we saw in the club last night, including those onstage, will be having breakfast in the same Ukrainian coffee shop this morning.

So we know that our now is the big Now, yet also that that conviction is shared by a scant few hundred people. Among those are some who think that it really is 1966 all over again, and that their band is just one lucky break away from permeating every jukebox and radio station and drive-in and high-school dance across the land and across the sea. Some of us, though, see the ever-growing wreckage piled up at our feet, wreckage we cannot look away from, the detritus of so-called civilization, and we wonder if we are not being propelled instead toward the collapse of time. The end may be at hand, or it may just be going sideways. There are other cities within this city, and all of them are following different temporal routes. We see ours as a palimpsest of succeeding nows, like wheatpasted posters blithely and unendingly covering up yesterday's posters on boarded-up storefronts, while they measure theirs in work weeks or lunar months or fiscal years or a relentless thud of falling decades. The aged gingerly set forth from their residential hotels in search of bananas and condensed milk, braving all the dangers of the street, self-protectively oblivious of the dateline, still inhabiting a shimmery haze of 1927 within themselves, and as we pass them by we are fleetingly pulled into their orbit. Or else we walk by a radio and hear the Jesters and the Paragons and the Flamingos and the Moonglows because a calendar next door or down the street still reads 1957. Julius McMichael's spectral falsetto lead on the Paragons' "Florence" casts us off the shore of the speculative present and maroons us in a pillowy intertime, all velvet and sateen and crushed corsages on the scarred basketball dance floor, a ballad that keeps falling into dirge cadence, hovering between the aurora

borealis and the void. We shuffle time and are shuffled by it
in turn, returning to the now like homing pigeons by virtue
of our microgenerational allegiance but uncertain just what
constitutes a present moment.

Because where there is a now there is perforce a No. We all
paid heed to that English tatterdemalion's cry of "No future"
in different ways, and if the word "future" did not portend a
lifetime's career opportunity in the mills suddenly gone south,
or a cracked vision of needle-nosed high-rises connected by
space taxis against a blood-red sky with three moons, what
mostly remained in our heads was "no." Our fill-in-the-blank
generation has had its blank filled by "no." There is a No Wave,
and it is coming to your town but not really. Your town could
not take it. You want your big guitars and hummable melodies
and never-ending teenage idyll. Those things look delusional
from where we stand. They were washed away by wars and
assassinations and riots long ago, and if you don't understand
this you are huffing stronger drugs than we possess. Our
aesthetic is *destroy*, as the French say, who have converted the
English verb into an adjective. Not for nothing are the faces of
this instant those of Ulrike Meinhof and Andreas Baader, lately
deceased.

Bands are forming of people who have never before picked
up a musical instrument and aren't sure which end of it you
stick in your mouth. They manage to produce sequences of
noise that are two minutes long and have some sort of semi-
consistent beat, but that's your only guarantee. It might be a lot
better than that, but you can always count on a large quotient
of rage and consequent distortion and lacerating atonal shrieks
you can almost see graphically represented above the stage as
cartoon notes with a shudder running through them. You climb
the stairs to Max's one night and find Bradly Field thumping
on something with one stick and Gordon Stevenson emitting
a two-note sine wave on his bass and in front is sixteen-year-
old Lydia Lunch, producing circular-saw effects on some kind
of junkyard guitar and squalling: Teenage Jesus and the Jerks.

"Little orphans running through the bloody snow," she raves, evoking Victorian horror (although even after the record comes out you are convinced she has them rampaging through the Blarney Stone; you have done likewise in that chain of old-man bars). Lydia is small but she commands. She has everybody in the joint nailed to the wall. She could do anything onstage, and frequently does. Sure, she's just a teenage poet denouncing Mom and Dad and God and Society, but she has a force field of death-dealing noise to back her up and no one is about to get cute with her or deny a word.

Poetry is a thread that runs through this neighborhood, connecting the decades. Beat poets moved in, back when it was an enclave of working families with zero flamboyance and few comforts—they liked that, and the fact that it was cheap. Through the hippie years and afterward more poets kept coming, filling the bookstores with side-stapled chapbooks mimeographed on typing paper, their authors lined up along the counter at Gem Spa, high on pills. Coffeehouses with reading series came and went, and then the Poetry Project, which cemented the connection between poetry and music: Patti Smith read there many times, Lou Reed read there, the Fugs performed, younger poets started their own bands—Television was one of them. Nowadays poetry still permeates the place, although the music has made it less conspicuous, which is crazy since poetry permeates the music. For that matter you walk around with a bass line in your head since that is your fuel, and then you naturally put words to that walking bass, words that come at you from stray talk or newspaper headlines or the memory of sentences that drift in unbidden. The mighty strophes of Linton Kwesi Johnson (weirdly unnamed on his first record, simply attributed to Poet and the Roots) fly across the ocean from a place much more unsettled than our reasonably tranquil acres of ruins. "It's war among the rebels, madness, madness, war," he enunciates, the reggae band following his tempo—the inverse of the toasters who follow the riddims—and he is in no way engaging in hyperbole. "Five Nights of Bleeding" is a

vast canvas of knifings and brawls and riots, where the music ("bubbling and backfiring, raging and rising") is a witness to both racist police violence and the propensity of victims to turn on their own. The words are hard, sculpted, scorched, three-dimensional, epic: "Inside James Brown was screaming soul/Outside, the rebels were freezing cold." That comma weighs as much as a wall. We can feel it from here, even though our lives are nursery school.

The beatniks called our neighborhood "the set," which is apt since that is where the strutting occurs. There are people who do not seem to exist except on the St. Mark's sidewalk between Second and Third, and that number has increased as the population has expanded. You see outfits that make you look twice—useless to enumerate, since there are even more outrageous ones out there right now—and then you never see them again. But by this time there are scenesters in every hole. The epoch when you'd sort of nod when passing a compatriot you didn't know is long gone. People have moved in wholesale, in contingents from around the world—the Texans, the Germans, the Australians, the Irish, the enormous number of people from northeast Ohio, the bounce-backs from San Francisco. There were two clubs for the longest time and now there are as many as twenty, although the number is constantly shifting. You've lost count of how many clubs you've attended—sometimes with lights and pageantry and bouncers behind a rope—that were shut the next day by the cops or the firemen or the creditors. You pass clusters of photocopied posters everywhere—on every stretch of non-residential unoccupied wall, pretty much, and you rarely see an intact poster more than two or three days old. Sometimes you can't tell the band posters from the conceptual-art posters or the nutjob conspiracy posters. The posters build up into clumps day after day after day, and when they reach a critical weight they calve off like icebergs. You go out wheatpasting sometimes, and it's a mess. The glue freezes in the winter and gets all over your clothes and in your hair in the summer, and you're always keeping an eye out for the cops,

and you're trying not to cover other people's posters but often can't help it, and you wonder whether yours won't be covered over by daybreak.

The bass these days is often physically present, issuing from bars and passing cars and parked cars and pizzerias and record stores and clothing shops, but it is always in your head because it is indelible. On your rounds you are motored by Robbie Shakespeare on Junior Delgado's "Fort Augustus," and Bootsy Collins on Parliament's "Flashlight," and Lloyd Parks on Dennis Brown's "Equal Rights," and Jamaladeen Tacuma on Ornette Coleman's "Voice Poetry," and Jah Wobble on "Swan Lake" by Public Image Limited, and so many others you can't name since you heard them in a club or on a twelve-inch single with the most minimal information rubber-stamped off-center and half-inked. It's all about the body nowadays, and you fling yours to hell four to five nights a week. You are stepping and hot-dogging like a wizard, executing moves you amaze yourself with, sure that everybody around must be eye-balling you, master of the polyrhythms, freestyling to the lip of the world without ever falling off. You favor the clubs with the least number of people on the floor so you can truly strut, open out, work your arms, jack your footwork. You look over at your partner and you briefly synch on the chorus, and then you both spin off into separate waves again, honoring the high-hat or that guitar that sounds like a rubber band, clairvoyantly anticipating the next chord change or even the next item that segues in with a counterintuitive slow shimmer. You knew that would happen. You are omnipotent because you are so deep inside the groove you might have been born there. You are the one most like the music, and your inner being shines forth like a beacon slicing across the floor, illuminating the corners. Also you are high as fuck.

You have arrived where you once wanted to be, in the dominion of music, the kingdom of the groove, the empire of rhythm. For better or worse you are living in youthville, where nine-tenths of the people you register in your field of

vision are your age and more or less on your team, even though
the scene long ago fragmented into affinity groups—this one
eternally rocking, that one given to costume parties, others
to champion-level drinking or filming themselves naked or
experimenting with electronics or drafting militant screeds or
following everything that is going on in London with painstak-
ing fidelity to detail. One day everybody on the street is wear-
ing horn-rimmed glasses and businessman raincoats buttoned
up to the neck, the next they are all dyed blonde and sporting
cowboy neckerchiefs and big hats pushed back on their heads,
and those go for all sexes. You go to clubs with polysyllabic
names where all you can see is a strip of blue light at belt level.
You find yourself in big-ass clubs with the ambiance of air-
ports. You might be ushered into clubs with door policies so
restrictive there are more people outside than in. You follow
cryptic instructions to clubs on rooftops or in cellars or on the
seventeenth floor of featureless office buildings, or to whoop-
de-doos in public parks that might last an hour or five minutes
depending on when the cops show up. You make your way to
clubs that open at 4 a.m. and close their doors sometime around
noon. There's the one in the alley far downtown where you get
yourself into a fistfight for reasons you can't begin to fathom,
the one in the ancient condemned theater on Fourteenth Street
where jokers on line on the firetrap staircase start flicking lit
matches at one another, the one in the decommissioned bar and
grill where the personnel from all the other clubs go after clos-
ing, where you belly up to the counter and order not drinks
but rails of uptown.

 You get your poetry in snatches now, because it shows up
as croaked lines deep inside the groove or buried in the mix
or mumbled through a sleeve. You might register them only
subliminally, maybe pick them up in daylight sometime later
and wonder where you caught that sentence. Mostly you re-
call single barked chorus phrases that rattle around your head
while the rest of the number might as well consist of doos
and dahs, "She's lost control again" and "The cassette played

poptones" and "Tanz den Jesus Christus." But lately poetry
has been filtering down from the Bronx on stray twelves you
can sometimes buy in that place on Union Square where they
seem to rotate the stock every other day. "I was spanking and
a-freaking in a disco place," says Spoonie Gee, who is the
smooth talker, the midnight stalker, the image of the man they
call the J. D. Walker, bouncing to the Patty Duke riddim as
it shuffles from side to side, his voice track intermittently so
flanged it hurts your ears, and that phrase takes on a power
and significance you can't account for except by reference to its
reminiscent tense, somehow a harbinger of how all of this will
one day fade into sepia, since golden lads and girls all must, as
chimney sweepers, come to dust. But that won't come anytime
soon, since you are young and have been young all your life
and live in the land of the young and have made no arrange-
ments to ever be anything but young.

But as fate would have it, forces are even now making ar-
rangements for you, since you and everybody else you know
have been steadily increasing your consumption of substances,
primarily powders. There was a time when these showed up
rarely, then irregularly, in the pocket of some cosmopolitan
friend, or in the pages of a book mailed from Thailand, or
purchased from a dapper gent who also traded in vintage men's
shoes, or paid as an honorarium by an acquaintance who want-
ed to use your kitchen table as a place to tap a vein. But lately
you have surprised yourself outside a slot in a door in some
ruin a couple of blocks over in the empty quarter and handing
over cash in exchange for bags. You tell yourself you will never
be one of those people who stand for hours in the rain being
toyed with by the lookouts, shuffled from one side of the street
to the other, made to show track marks at the base of the steps,
suffered having the slot slap shut definitively just as you are
finally stepping up to it. You like boy the best because it unties
every knot in your nerves and fills you with a glow you can
carry to every occasion, making you the nonpareil you think
you are on the dance floor. But your friends all seem to have

unaccountable piles of girl lying around, and you cannot in good conscience refuse hospitality, so you inhale line after line, even if it makes you kind of jangly and causes every cigarette to burn up in three seconds. "I'm a dyn-o-mite," states Dillinger confidently, "so all you got to do is hold me tight, because I'm out of sight. I've got cocaine running around my brain."

He also informs us that a knife, a fork, a bottle and a cork is the way we spell New York, and that sounds about right. All around us property is being carved up. The unlucky are being turned out of their homes on technicalities. Storefronts are being unboarded so people can sell trinkets to inquisitive tourists. Clubs are catering only to the slim and the rich, or have ballooned into funfair malls with three stages and eight dance floors and sixteen bars and V. I. P. rooms inside V. I. P. rooms. What was formerly given up to the street for common scavenging is now being put up for sale on flattened cardboard boxes on the sidewalk. People are flooding into the set just to gape. People are paying money to sleep in closets and backyard sheds and doctors' examining rooms. People are selling T-shirts advertising the neighborhood, or bands that have already broken up, or telling one and all to go fuck themselves. Suddenly cops appear on foot patrol in select areas. Suddenly beggars are fighting for turf. Suddenly beggars have gimmicks. The weird are turning pro. The pros are moving to more discreet zip codes. We realize we are absolutely unprepared for any of this, which as far as we know was brought about by the music. We thought the music would change the world, and we were correct except in the matter of specifics.

You check out the people on the street and note the year when they stopped: this one with the death's-head rictus 1973, that one in the Perfecto jacket 1977, her friend in the vinyl T-shirt 1979, those people looking like drunken ballroom dancers on an ocean liner 1980—and that's when you realize you have a year written on your own forehead and it's not the one that tops the current calendar. You have aged out of the struggle just in time for the struggle to be done with you. You

will never again inhabit the great Now, only a small and fragile instant that flips over every time you blink. Music will keep happening and you might like some of it or even a lot of it but it will no longer be yours. You will never be a star if you have failed to achieve that goal by now. All you can do is head to the dance floor in the burning disco where Chic is playing on an endless loop. These, the singers assure you again and again, are the good times.

2017

The Now

When I was a teenager I was, like most teenagers, preoccupied with the idea that somewhere on the horizon there was a Now. The present moment came to a peak out there; it achieved a continuous apotheosis of nowness, a wave endlessly breaking on an invisible shore. I wasn't quite sure what specific form this climax took, but it had to involve some concatenation of records, poems, pictures, parties, and behavior. Out there all of those items would be somehow made manifest: the pictures walking along in the middle of the street, the right song broadcast in the air every minute, the parties behaving like the poems and vice versa. Since it was 1967 when I became a teenager, I suspected that the now would stir together rock & roll bands and mod girls and cigarettes and bearded poets and sunglasses and Italian movie stars and pointy shoes and spies. But there had to be much more than that, things I could barely guess. The present would be occurring in New York and Paris and London and California while I lay in my narrow bed in New Jersey, which was a swamplike clot of the dead recent past.

At the time I had been in the United States less than half my life and much about it was still strange. I constantly found myself making basic errors about social practices and taboos. My parents certainly couldn't help me—they understood even less. There wasn't really anyone I could ask who would answer my questions and not make fun of me. Through force of necessity I had become adept at amateur anthropology, deducing the ways and habits of the Americans from the semiotic clues they threw off in their relentless charge through the twentieth century. I read every piece of paper I could get my hands on.

I became a big fan of mimeographed bulletins, local advertising circulars, political campaign literature, obsolete reference books, collections of antediluvian Broadway wit, hobbyist newsletters, charity solicitations, boys' activity books from the 1930s, travel magazines entirely cooked up in three-room office suites on Park Avenue South, and the Legion of Decency ratings in the weekly newspaper of the Archdiocese of Newark.

Every month I devoured *Reader's Digest*, paying particular attention to the rubrics devoted to humorous anecdotes submitted by readers, because I was intent on figuring out how humor worked. I also pricked up my ears every time I heard Americans laughing, because it meant I might be able to glean a story that would earn me five bucks. (I never did, which in itself taught me an enormous amount about humor.) While I hated Catholic school, I treasured the reading matter the nuns threw at us, from Dick and Jane books to missionary propaganda and gruesome martyrologies to slim collections of poetry edited and published by the Sisters of Charity. They were gold mines of data. Some of our textbooks were thirty or forty years old, with pictures that showed boys wearing plus-fours and girls with oversize bows in their hair, and they were interestingly territorial. I particularly relished the story of Johnny, who had Protestant friends who goaded him constantly about his faith and were determined to get him to eat a meat sandwich on a Friday. Johnny finally succumbed, and on the way home he was run over by a street car.

Gradually I built up my store of knowledge. I was beginning to get a feel for the way people used language as a tool to pound nails with, and I dimly began to comprehend power relations and kinship patterns and the yawning gaps between ideal and actuality in the American project. Not that I could have accounted for those things in so many words, of course. It would be decades before I understood power relations as they affect just two people sitting at a breakfast table—and actually I'm not sure how much I understand them even

now—but at least I could begin to arrange large color-coded bins in my head into which I could toss sundry items from the surrounding culture as they crawled across my line of sight.

Then, all of a sudden, came the Now. I discovered the Now at a specific time, in seventh grade, but it didn't come from anywhere in particular. It arose from the ground. It was maybe hormonal. It was exciting and a little frustrating, because a whole new continent had lain under my nose for years without my getting wise, while sundry doofuses were all over it—anybody who had an older sibling was hep from on back. Before I had even begun to think about it they already had the clothes, the moves, the music. In order to catch up I went so far as to ride the chartered bus to Asbury Park in the snow for an away basketball game just to observe them in the field. But the scene was depressing and the gleanings scant. I wouldn't make the same mistake twice. Henceforth I would stick to primary sources.

And for me that meant printed matter. I had to locate the parish bulletins of the Now, and the very first item I found seemed to answer to that description. In the local musical-instrument store lay a stack of *Go* magazine, free take one. *Go* was a grimy newsprint tabloid with color covers underwritten by record companies. It was strictly a booster sheet, very likely much of it cut-and-pasted from *Billboard* and *Cashbox*. It recorded, for example, the professional excitement aroused by the signing of four high-school graduates from Marquette, Wisconsin, doing business under a name that made them sound vaguely British, to a record company in Pittsburgh with a name that made it sound vaguely familiar. That happened to be nearly the last point when the market was sufficiently porous to allow a chance at the big show to such collections of hopeful nonentities from nowhere, some of whom occasionally did make good, if briefly, and then their picture might appear in an advertisement that covered some portion of a page in *Go*. With its antenna turned at least in part toward the small-time, *Go* was in a position to educate me in certain detailed ways,

chiefly concerning nomenclature and image. Of course, some of the information I derived from *Go* I could have gotten from *Tiger Beat*, but didn't because that was for girls. *Go* allowed me to become familiar with photographic conventions that required teenage hoodlums and seasoned lounge lizards alike to pose as if in a perp lineup, sandwiched uncomfortably between grinning rack jobbers and promo men, while the caption alleged that they were in fact taking a break from their busy schedule. *Go*, founded and edited by Robin Leach, later of *Lifestyles of the Rich and Famous*, was as resolutely chipper as it was fundamentally cold, but even though it might as well have been chronicling supermarket openings or innovations in the automatic garage-door industry, it managed to convey some particle of the Now.

I had no money to speak of in that period—my weekly allowance had been frozen some years earlier at fifty cents—so my sources had to be gratis, via promotional handouts, shoplifting, the public library, or else Center Stationers, with its heavily laden magazine rack partly concealed from the cash register by a display of pipes, so that I could stand there and read things cover to cover as long as I kept an eye in the back of my head. I hadn't yet encountered George Orwell's observation that the contents of a small newsagent's shop provide the best available indication of what the mass of people really feels and thinks, but I sensed something of the sort. The display contained magazines for every conceivable interest, it seemed, every hobby, every political affiliation, every affinity group. But there were no magazines targeting forward-looking young people who lived in or at least aspired to the Now.

There weren't, that is, until a day early in 1968 when I spotted the first issue of *Eye*. This was no skimpy, low-budget rag with murky pictures, but rather a glossy, brilliantly colored coffee-table object nearly the size of *Life*. It was put out by Hearst, who knew a thing or two about marketing. They knew, for example, to include a poster in each issue, as well as plenty of send-in-the-coupon offers to obtain delightfully

now items absolutely free. I surreptitiously tore out a few of those coupons from the issues at Center Stationers, and thus was able to receive in the mail, after a four- to six-week interval, a 45-rpm flexidisc on which the Yardbirds touted the merits of an instant-milkshake powder, for instance. In this way *Eye* commanded my loyalty, so that I was barely disconcerted by the rest of the magazine. What Hearst knew about magazines had been gleaned from years of laboratory experiments at its *Cosmopolitan* franchise, which meant that *Eye* involved much lifestyle advice, many photographs of lissome young models of both sexes engaged in groovy leisure-time activities—flying kites, say—and covers studded with numerals: "10 Student Rebels Explain Their Cause"; "Test Your Mind's 9 Electric Dimensions"; "Add 5 Sexy Years to Your Face With a Mustache."

In September 1968 I began commuting to New York City every day, since I'd gotten a scholarship to a boys' high school run by the Jesuits on the Upper East Side. Suddenly I was on the threshold of the infinite. It did not take long before I started wandering though the city, after school at first and then, increasingly, during times when I should have been in class. I once got off the train at Bleecker Street because I had heard its name in a song, but nothing much seemed to be happening. Then I walked along Eighth Street, MacDougal Street, St. Mark's Place, Second Avenue, looking into the numerous poster shops and head shops and record shops and bookstores. There were leatherware shops and health-food restaurants and people's clinics and a place that served ice cream flavors named after types of marijuana, and featured a long row of Hell's Angels bikes parked outside. In between all those places were pork stores and bakeries and haberdasheries and shoe repairs where the normal business of the neighborhood went on as usual, involving people who were not young and assumed it would all go away eventually. I passed the Electric Circus and the Fillmore East, and people stopped to try and sell me drugs that I was pretty sure were

fake. I wore a jacket and tie and carried a briefcase.

I had a million questions I couldn't even frame as questions, which resolved into a single glowing orb of curiosity. My only recourse, as ever, was printed matter. In New York, this presented a challenge of its own. I was used to compiling information from scraps; here I was faced with a glut, a mountain of newsprint in a bewildering variety of forms. The newsstand huts that stood on seemingly every other corner, more or less identical at first glance, turned out to display sometimes wildly varying stock. Some sold academic journals; a number dealt in porn; you had specialists in foreign languages or hobby publications, in dream books or the rags of sundry left factions; a string of them sold underground newspapers. Those papers looked different even from a distance, often gaudy, often chaotic, often amateurish, and they made the newsstands jump with carnival colors. They only cost a quarter or 35 cents, so I began checking out the titles from all over the country that appeared irregularly, one month the Chicago *Seed*, the next month the *LA Free Press*, another the *Berkeley Barb*, this in addition to the local papers, the *East Village Other* and *Rat*.

When I actually started leafing through them I was nonplussed. It wasn't that I had any problem with the ham-fisted layouts, the rough-and-ready typesetting, the photographs that invariably looked nine generations removed from the original image, the contrast between the 1930s-infused comix and the aspirationally psychedelic illustrations, the nudity which I knew would cause me to have to abandon the paper on the train since my mother regularly searched my room, or even the occasional random use of color, such as printing whole patches of text in yellow, making it unreadable against a white background. The trouble was that I couldn't read them anyway. The papers were written in a foreign language as far as I was concerned. I understood politics only in a visceral way—I was firmly against the war and in favor of the revolution, but I couldn't have told you why beyond the fact that

the first was odious and the second sounded like fun, although perhaps I had already absorbed the phrase "historically inevitable." I could read the underground papers insofar as I could scan a page and herd the items under headings: over here was Vietnam, across the page was police brutality, down at the bottom was pot, or "dope" as it was called then. Beyond that, my vaunted text-mining skills abandoned me.

Yet I had seemingly arrived at the very gates of the Now. You could not possibly get more now than those papers, published by rebel youths who had cut all ties to the mainstream, who ate and drank and slept revolution, who were the harbingers of that new world that would be coming around as soon as the entire demographic wave turned 21. But the contents of the papers bore little resemblance to what I was led to expect by my preliminary investigations into the Now. The world they depicted was nothing at all like the psychedelic pleasure garden I had nebulously imagined. There were no glamorous personalities and no girls in floral minidresses; there was no music in the air and no spontaneous poetry on street corners. But I had started commuting to New York City a mere week after the Chicago Democratic convention, and whatever the mood may have been a few months earlier, by the middle of September it was very dark. "Resistance" was beginning to outpace "revolution" as a key word. A few correspondents were signing off with the phrase "armed love." It was a run-up to the apocalyptic phase that began a year or so later, and it appeared that already there were people acquiring weapons, preparing for stand-offs. Were the pigs poised to make blanket raids on communities? Had internment camps been secretly built in the Mojave desert? People were starting to flee the cities in little groups, moving to abandoned farms, aiming for self-sufficiency. The ones who remained would soon be getting ready for war.

I was able to take the temperature of the papers I looked at, but my reading skills lagged principally because there was so little that matched up with my experience of life. What I most

readily understood were the windiest bursts of rhetoric, which gave an unfortunate impression. But the hard news with its figures and acronyms might as well have been algebra, and approaches to practical matters appeared before my eyes as impenetrable blocks of gray text. What could a 14-year-old make of legal counsel, however sound and clearly articulated? And what about the medical advice? References to crabs and yeast infections just sounded vaguely culinary and not at all serious. But then, even the food columns were beyond my ken. The very helpful section in the *Seed* that listed all the food options you could get for a dime, and the addresses of the markets where they could be procured, held no more meaning for me than if it had been written in Polish. My parents, who were grooming me as best they could for an adulthood they hoped would be very different from theirs, had taken care to shield me from knowledge of life's exigencies.

I was repelled by the underground papers, even though I could not have admitted this to myself. I kept buying them because I kept hoping for a key to understanding those aspects that appeared as so many locked rooms, also maybe because I kept hoping to find one in which the world depicted at last corresponded to my imagined hippie utopia. Similarly, I continued to travel down to the Lower East Side, where I'd root through bookstores and record stores and trinket shops and occasionally see a show at the Fillmore, but the neighborhood made me uneasy. It was gray and squat and everything looked shabby, just like the factory town where we'd lived when I was a tot, or the factory towns where my parents despairingly looked at grim apartments during our first years in the United States, before they found a place in a leafy suburb. Who would want to live in such a place, I wondered, although if I had thought hard enough I would have realized that I knew, since I had a classmate, an emancipated minor, who paid $35 monthly rent for his own place in the neighborhood. But poverty, which my family was still engaged in escaping, was not something I could easily reconcile with my dream of the Now.

All would be different if I were older, I finally decided, if I were free from my parents and free from school. I needed emancipation from church and discipline and pointless unpaid labor in order to enter the enlightened state of mind required by my vocation as a poet. But I resolved that I wouldn't make the choice to go live in some cold-water tenement or flea-infested hard-labor commune. Renouncing the world and its lures was all very well for ascetics, but that sort of purity held no appeal. I knew that Allen Ginsberg, for example, lived in such circumstances when he could have done much better for himself, but assumed that he was doing so to make a point. Was that point really so necessary to make? "If I can't dance, you can keep your revolution," I heard somewhere, and that seemed to settle it. I was an artist, wasn't I, and as an artist I could hobnob and go to parties and travel to Europe and befriend the glamorous and the great. Since I then believed that anyone who published a book was paid a great deal of money, and knew that I would soon begin writing books, I thought my future was assured. I could see myself in the not-too-distant future, at last inhabiting the Now. The image was as vague as ever.

Years later, when I was at least chronologically an adult and free from family, school, and church, I lived on my own, with few responsibilities, and went out every night, often to see groups of people my age making amplified noise in bars. I considered myself some sort of artist, although I would have been hard pressed to provide material proof. I also had no money, and I lived on the Lower East Side in a dark apartment on the second floor rear of a badly maintained building that had its share of vermin and was often unheated for entire weeks in the winter, but nevertheless was inhabited by a few dozen artists of various descriptions, some of whom were quite well known. By then nobody talked about revolution anymore. If there were any communes left they were well hidden. There were a few objects on the stands that at least superficially resembled underground newspapers, but they

failed to provide information on where to buy cheap groceries or how to confront landlords in court, and in general ignored the daily world. Instead they were all about bands and bars and clothing. I knew about most of those things without having to read the stories. At last I was living at the center of the Now.

2011

Hooliganism

Just about as rare as if it had never been published at all, this may be the only extant copy of Dave Carluccio's only book—typed, photocopied, folded, and stapled by its author in 1980 in an edition of fewer than a hundred, maybe fewer than twenty. The title and the cover image both refer to Aleksei Kruchenykh's *Against Hooliganism in Literature* (1926), cover by Gustav Klutsis. That work in turn, which has never been translated, is to the best of my knowledge a

polemic by the veteran cubo-futurist directed against some rival Soviet avant-garde gang. But that didn't matter much to Carluccio, who most likely just saw the cover reproduced in some book and ran with it. "Hooliganism"—a word strangely omnipresent in Russian and ultimately derived from a slur against the Irish—was to him something desirable, especially in literature, which he persisted in seeing in early-modernist terms, as a genteel tea party much in need of being forcibly invaded and broken up.

I knew Carluccio's brother slightly in high school. We weren't friends, and I didn't even know of Dave's existence until half a decade later, when he showed up at my apartment one day with a group of people who were looking for a party. I wasn't giving a party and wasn't in a hospitable mood, which is probably what impelled them to hang out somewhat longer than necessary, opening the beers they had brought, lighting joints, and putting records on the turntable. While most of the five or six of them were having a high old time and I was calling around trying to find the party, or any party, to get them out of my hair, Carluccio was looking through my books. Finally, when their beers were drained and before they could go for seconds, I pretended someone had given me an address on the other side of town and sent them on their way. A week later I received an envelope from Carluccio containing a sheaf of tiny stories typed on the backs of pink "While You Were Out" notes. It was the first of more than a dozen such envelopes.

As it turned out, I was to meet Carluccio only twice more. The first time was about a year later. I was coming out of a party in Tribeca, one of those huge, brawling things where maybe ten percent of the guests had actually been invited. I had no idea who the hosts were and didn't know anybody there, but on my way down the stairs some guy I didn't recognize rushed to catch up and immediately started talking at me. He had sent me the stories because I had Bataille and Artaud and Mayakovsky on my shelves and he knew I'd understand. He talked from Franklin Street up to Canal, east to the Bowery,

north to St. Mark's Place, and would have talked me all the way home if I hadn't suddenly ducked into a tenement behind somebody who had just been buzzed in. His talk was all very much checklist literature—you know, the kind of thing young guys do, like throwing names of bands at each other in lieu of conversation. He was very excited about Lautréamont and Cendrars and Traven and Burroughs and Ballard and Iceberg Slim. He wanted to celebrate murder and burn down churches and throw up barricades and liberate the zoos. He wanted to invent a new language, a new literature, make the future happen today. He was talking as fast as a sports announcer in a foreign language, sweating even though it was February. But I already knew the song by heart. I had been there.

His writings were not the unpunctuated breathless screed-like verses you might expect, but on the other hand they weren't much better. He had apparently decided that the crime novel was the essential building block of literature, the constituent unit of its DNA, and he had set about reducing and recombining it—I could just about see the wheels turning in his head—much the way punk rockers had cloned and distilled and chopped up the standard Chuck Berry guitar riff. Each story, if that's what those things could be called, was a paragraph long, titled and signed, and each resembled a page of a crime novel if you were trying to read it while it whipped by on a conveyor belt.

It wasn't much, I thought. Oh, he had a good ear and all—maybe he should have been writing song lyrics. And maybe the French would appreciate it. But it hardly amounted to any kind of revolution, literary or otherwise. I can't say that I was really disappointed. What more could you expect from the typical punk-rock overgrown juvenile, too hopped up to sit still long enough to write more than 150 words? On the other hand, he was writing something, which was considerably more than I was doing at the time, for all my knowingness and jadedness and the seniority of my 25 years. Maybe Dave Carluccio was onto something, however long it would take him to get there.

Love Telegram

I just remembered I kept my money in
a ditch. The crowd pressed closer and the
sky turned black, I had a stack of invitations
I kept peeling off. Two thin guys had a car
wash back there and we had to find out where
they really lived. Porky and Uncle gave up
the truck; the fields rotted overnight. I
called up my baby sister but she wasn't the
right one. "Do you want a one-way ticket or
do you know of any wise guys who haven't been
photographed recently?" It took all the
pleasure out of it for me. Baking soda and
just a little potassium. I just remembered
my monkey hadn't had any. The crowd pressed
back and I let them love me. I saw it in
a thousand pictures. The car rolled over and
died.

Dave Carluccio

As the envelopes kept coming, their contents changed. The stories grew in length, formed series, were incorporated into collages. And Carluccio, who always wrote in the first person, became a character of his own devising, the hero of his stories, addressed by name by the other characters. One envelope consisted entirely of a sheaf of author's bios: he was variously a rogue CIA agent, a Vietnam War deserter, a drug trafficker operating out of the Golden Triangle, a con artist masquerading as a movie producer, a public-relations expert simultaneously working for and working to undermine every unsavory public figure in the world, a chameleonic and indiscriminate traitor to all sides.

I published some of Carluccio's work in an occasional zine I put out then, but I never managed to run into him again. My

friends, who never met him at all, became convinced that I had invented him and was using the name as a pseudonym. I laughed along at first—if I had wanted a pen name, wouldn't I have come up with something more clever? But it started to grate a bit. I wouldn't have admitted it then, but my condescension toward Carluccio began shading into a feeling of rivalry, gradually deepening into jealousy. Meanwhile, the envelopes, which at first had all been posted in Manhattan, started appearing with more far-flung and even unlikely postmarks: Lincoln, Nebraska; Guelph, Ontario; Truckee, California; Guadalajara, Jalisco; Merida, Yucatan; Punta Gorda, Belize; Tegucigalpa, Honduras. Was he attempting to enact the character he wrote about? Or was it that his writing in some way reflected what his life had become?

Nineteen-eighty was an insane time, at least for me: drugs were spiraling up, romance was spiraling down, and melodrama was abundant. I had gotten a job in the mailroom of a prominent literary journal, a job that permitted me to arrive at noon—since my co-worker had to leave early to attend music lessons—and then not return after taking the mailbag to the post office, which I usually contrived to do before four o'clock. I was not serious. I was fucking around heavily, not writing, pretending to be a musician but not managing to practice. I walked around in a daze of self-kidding. Late one night in early summer I was perhaps on my way to or from a party, probably high, when I happened to pass the 24-hour copy shop on Mercer Street just south of Eighth. I glanced in briefly—it was the place where I had put together my zine, and I knew most of the employees. A few doors south I felt a hand on my shoulder. Once again I didn't recognize him. I've never been good with faces, but this time there was an additional reason. Carluccio had grown, broadened, darkened—he was very nearly a different person altogether. He led me back to the copy shop, where he was collating and folding stacks of sheets laid out in a row. He finished assembling one, stapled it, signed it, and handed it to me. We must have made some sort of conversation, but

I remember none of it. I didn't even remember the chapbook until days later, when I picked my jacket up off the floor next to the bed and discovered it sticking out of the side pocket.

The book collects all the contents of all those envelopes, along with a sampling of other matter—letters, pronouncements, manifestos, poems, all of it strung together apparently in chronological order. It is hasty, confused, random, jejune—and it is bursting with every kind of world-beating youthful energy. It would have made a fine first effort for anybody, the sort of thing that sits unsold on the consignment shelves of bookstores for months and even years, and then suddenly is changing hands for four figures, and eventually cannot be obtained at all unless some major collector dies. But Carluccio's slim volume is both exceedingly rare and exceedingly obscure. For all intents and purposes it doesn't exist. He will never produce a follow-up. It was my friend G., then working for the AP, who spotted the item on the teletype in 1983. I've managed to lose the printout he sent me, but the gist was that a corpse of foreign appearance, found at a border station near Antombran, Guatemala, just across from El Salvador, had been identified as a certain David Carluccio, 24 years old, of Scotch Plains, New Jersey. He had been killed with a machete. Local police were investigating the matter.

2008

Mother Courage

I first heard of Patti Smith in 1971, when I was 17. The occasion was an unsigned half-column item in the *New York Flyer*, a short-lived local supplement to *Rolling Stone*, marking the single performance of *Cowboy Mouth*, a play she co-wrote and co-starred in with Sam Shepard, and it was possibly her first appearance in the press. What caught my eye and made me save the clipping—besides the accompanying photo of her in a striped jersey, looking vulnerable—was her boast, "I'm one of the best poets in rock and roll." At the time, I didn't just think *I* was the best poet in rock and roll; I thought I was the only one, for all that my practice consisted solely of playing "Sister Ray" by the Velvet Underground very loud on the stereo and filling notebook pages with drivel that naturally fell into the song's meter. (I later discovered that I was only one of hundreds, maybe thousands, of teenagers around the world doing essentially the same thing.)

Very soon I began seeing her byline in the rock papers, the major intellectual conduits of youth at that time. Her contributions were not ordinary. She reviewed a Lotte Lenya anthology for *Rolling Stone*: "[She] lays the queen's cards on the table and plays them with kisses and spit and a ribbon round her throat." She wrote a half-page letter to the editors of *Crawdaddy* contrasting that magazine's praise for assorted mediocrities with the true neglected stars out in the world:

Best of everything there was
and everything there is to come
is often undocumented.
Lost in the cosmos of time.

On the subway I saw the most beautiful girl.
In an unknown pool hall I saw the greatest shot in history.
A nameless blonde boy in a mohair sweater. ˏ
A drawing in a Paris alleyway. Second only to Dubuffet

Creem devoted four pages to a portfolio of her poems: "Christ
died for somebodies sins / but not mine / melting in a pot of
thieves / wild card up the sleeve / thick heart of stone / my sins
my own . . ." — if this sounds familiar, you expect the next line
to be "they belong to me," but it's not there yet.

Then in November 1973, a small ad in the *Village Voice*
announced that she would be performing at Le Jardin, a
gay disco in the roof garden of the Hotel Diplomat on
West 43rd Street, in honor of "the first true poet and seer,"
Arthur Rimbaud. Accompanied on guitar by Lenny Kaye, a
rock critic familiar from his job behind the cash register at
Village Oldies on Bleecker Street, she read and talk-sang:
Kurt Weill's "Speak Low," Hank Ballard's "Annie Had a
Baby," a version of Édith Piaf's "Mon vieux Lucien," and
twenty-two more poems, four of them about Rimbaud. She
was skinny, quick-witted, disarmingly unprofessional, alter-
nating between stand-up patter, bardic intonations, and the
hypnotic emotional sway of a chanteuse, and she was sexy in
an androgynous way I hadn't encountered before. The ele-
ments cohered convincingly; she seemed both entirely new
and somehow long-anticipated. For me at nineteen, the show
was an epiphany.

Soon I bought her chapbooks *Seventh Heaven* (Phila-
delphia: Telegraph Books, 1972) and *Witt* (New York:
Gotham Book Mart, 1973), which between them contained
most of the poems she performed, as well as her first record,
a 45-rpm single, "Hey Joe" b/w "Piss Factory," on the small
Mer label (1974). By then the poets I liked best and tried to
emulate — Frank O'Hara, John Ashbery, Ted Berrigan, Ron
Padgett — spoke to the eye and the refined internal ear. Apart
from Allen Ginsberg and Helen Adam it was hard to think of

contemporary poets who honored poetry's ancient connection to song. And while many pop critics of the time insisted that rock lyrics were poetry, not much of the stuff actually held up on the page, paradoxically because so much of it was choked with aspirational fustian. ("The idea that poetry—a concept not too well understood—can be incorporated into rock . . . is old-fashioned and literary in the worst sense,"* wrote Robert Christgau, a cannier critic.)

Smith, though, was aiming at once higher and lower than Paul Simon or Jim Morrison. Her verses were resolutely demotic, even as she played with the imagery that Rimbaud drew from the Bible and Eliphas Levi and fairy tales and illustrated geographies, and she deployed this imagery even as she devoted poems to Edie Sedgwick, Marianne Faithfull, and Anita Pallenberg. She seemed to write with a rhythm section starting and stopping in her head, so that her work unpredictably ran the gamut from music to prose, sometimes within the same poem—much like Rimbaud's in *A Season in Hell*. The record represented her more fully than the publications did, matching the power and surprise of her live performances. Her delivery was girlish but not what you'd call frail—it owed a lot to the girl-hoodlum vibe imparted by the Ronettes and the Shangri-Las—and she marked off cadences in short insistent jabs that sounded both Beat (more the Robert Creeley–inspired wing than the Whitman-influenced long-breath school) and rhythm & blues, and she would sometimes depart on tangents that appeared to be improvised on the spot. No item in her repertoire was delivered quite the same way twice. As she appeared, usually backed by Kaye and the pianist Richard Sohl, at disparate venues all over town—a poetry café, a piano bar, a folk-music club, a jazz dive—I attended nearly every gig, once dropping an entire week's paycheck in the process.

* "Rock Lyrics are Poetry (Maybe)" in *The Age of Rock*, edited by Jonathan Eisen, Vintage Books, 1969.

Early in 1975, I heard she was performing with some sem-blance of a band at a bar called CBGB. There had not been a regular venue for rock bands in lower Manhattan since the 1973 collapse of the Mercer Arts Center (home of the New York Dolls, among others); even Max's Kansas City, quondam domain of the Velvet Underground, had become more of a cabaret—Smith had done a stint there herself. CBGB, succes-sor of a century's lineage of Bowery saloons on that site, was a tunnel-like space with a long bar down the right side and a recently-constructed stage at the far end watched over by large photo-blowups of Jimmie Rodgers and a bevy of Mack Sennett bathing beauties. The opening act was Television, whose members had built the stage and encouraged the bar's owner in a new booking policy, shedding the styles alluded to in the club's acronym, "Country, Bluegrass & Blues." Smith's band was skeletal, while her songs hovered somewhere be-tween spoken-word pieces and pop songs. She covered the Marvelettes' "The Hunter Is Captured by the Game" and the Velvet Underground's "We're Gonna Have a Real Good Time Together." She was stretching her vocal cords, talking less and singing more.

I went back many times after that, observing the band filling out and the songs taking shape. Meanwhile, the club was becoming the epicenter of a phenomenon that before year's end had come to be called "punk," in reference to the primitive teenage rock and roll of the mid-'60s, which had been surveyed in a 1972 anthology, *Nuggets*, compiled by Kaye. The house aesthetic matched the simplicity and direct-ness of that music, and virtually every one of the bands that played CBGB covered the classics of the genre, often at the beginning of sets as ritual invocation and starting gun. The Ramones played the Rivieras' "California Sun"; Talking Heads played Question Mark and the Mysterians' "96 Tears"; Television played the Count Five's "Psychotic Reaction." Smith and her group yoked her poem "Oath" ("Jesus died for somebody's sins . . .") to "Gloria," a 1964 standard by Them.

The poem declares her transfer of allegiance from dogma to flesh ("So Christ/I'm giving you the good-bye/firing you tonight"), but the song manifests it, moving from recitation to singing, from the abstract to the concrete, from inwardly directed argument to outwardly directed lust. She transforms Van Morrison's studiously functional teenage-caveman lyrics—his Gloria stands roughly five foot four, comes around at approximately midnight, and makes the singer feel nonspecifically fine—into a narrative that accrues details ("leaning on the parking meter") and suspense ("crawling up my stair here she comes") as it passes through increasingly frantic rhythmic sequences like a car shifting up through its gears, landing on the chorus ("G-L-O-R-I-A") as if it were the top of a mountain.

Smith was the president of a fan club that had just one member but a hundred idols: Rimbaud, Bob Dylan, Jimi Hendrix, Keith Richards, Jackson Pollock, Isabelle Eberhardt, Brian Jones, Georgia O'Keeffe, William Burroughs, Renée Falconetti (Joan of Arc in Carl Theodor Dreyer's 1928 movie), not to mention Johnny Carson. She evoked these personalities, and more, in her songs and poems and broadsides and chapbooks, in her stage patter, in interviews, and she was not at all coy about enumerating her specific debts to them. She made a point, that is, of publicly enacting a process that most artists keep to themselves. This was doubly brave of her, since as a woman at that time declaring herself to be something more than a singer and decorative stage presence she faced a certain amount of derision anyway. It was easy for lazy journalists to caricature her as a stringbean who looked like Keith Richards, emitted Dylanish word salads, and dropped names—a high-concept tribute act of some sort, very wet behind the ears. But then her first album, *Horses*, came out in November, 1975, and silenced most of the scoffers.

The record's cover, featuring Robert Mapplethorpe's famous image of Smith in a man's white shirt and undone necktie, jacket slung over her shoulder, was a declaration of female

swagger such as had not been seen since Marlene Dietrich's tuxedo. Inside was the culmination of all those years spent trying out ideas in assorted raggedy clubs. There were songs for each of her two sisters, an elegy for Jimi Hendrix, an uptempo rock number called "Free Money," and "Gloria (in Excelsis Deo)," as it had come to be called. And there were a couple of other big poem/song hybrids. "Birdland" begins with a mesmerizing and heartbreaking monologue, inspired by Peter Reich's *Book of Dreams*, of a young boy at his father's funeral, awaiting his—Wilhelm Reich's—return for him in a UFO. "Land" is Chris Kenner's perdurable "Land of 1000 Dances" bracketed by the story of Johnny—essentially William Burroughs's Johnny in *The Wild Boys*: sex object and all-American Kilroy—and his delirious visions of horses turning into waves turning into horses. "Go Rimbaud and go Johnny go!" she shouted, and the sound-bite would be permanently affixed to her image.

It was Rimbaud who wrote, in his famous "letter of the seer" to Paul Demeny, May 15, 1871: "When the endless servitude of woman is finally shattered, when she comes to live by and for herself, man—up to then abominable—having released her, she too will be a poet! Woman will find a portion of the unknown! Will her world of ideas differ from ours? She will find strange, unfathomable, repulsive, delicious things." In the "Notice" at the beginning of *Witt*, Smith wrote: "These ravings, observations, etc. come from one who, beyond vows, is without mother, gender, or country. who attempts to bleed from the word a system, a space base." The system Smith bled from language was an oracular nonstop cavalcade of words hurled like sixteenth notes, powered by a rhythm imposed by force of will. While she engaged with prosody and songcraft a bit in her early years—"Death comes sweeping through the hallway like a lady's dress / Death comes riding down the highway in its Sunday best" ("Fire of Unknown Origin")—by the time she fronted a full band she seemed less interested in singing lyrics, preferring to chant simple refrains

or to deploy her words as a discordant, wild-card instrument, a version of what Lester Bangs called "skronk." She made capital use of jukebox slang at first, but increasingly she sought biblical allusions and cadences, echoed the incantatory Rastafarian style of Jamaican talk-over artists such as Tappa Zukie, and favored the orientalism in Rimbaud (whose father after all translated the Quran).

The sexual tension in her work naturally strove toward orgasm, the musical tension ached for release, and the punk style she helped initiate was, thanks to the Sex Pistols and others, becoming increasingly confrontational and even violent in its stance. It followed that she would be ever more inclined toward making things go boom. In song after song, yearning for transcendence, she found satisfaction in accelerating tempos and flurries of highly charged verbiage that mimed conflagration. Christgau, reviewing *Horses*, termed her style "apocalyptic romanticism." Among the consequences of this ascendent style were that she lost her humor bit by bit and took herself more seriously with every succeeding record. On the other hand, she manifestly believed in her mission as much as anyone who had ever picked up a microphone, and that belief was contagious. By 1977 or so she had become a performer so electric and charismatic that critique simply withered in the heat she exuded onstage. Her band, charmingly erratic at first, perfected their chops with constant touring; her songs were more than the sum of their parts; she rode a crest of momentum for three more albums after *Horses*. Then, in 1980, she did the unthinkable: at or near the height of her powers she married Fred "Sonic" Smith, late of the MC5, and retired from recording and performance to move to a Detroit suburb and become a housewife and mother.

Although she made one record with her husband in 1988, she didn't fully emerge from her seclusion until the mid-'90s. By that time he was dead, and so were her brother; her keyboard player, Richard Sohl; and her best friend, Robert Mapplethorpe. An air of mourning unavoidably colored her

writing and performance and contributed to a truly formi-
dable gravitas—she became at once rock's Mater Dolorosa
and its Mother Courage. By now she is an institution, and
it is hard to remember the air of goofy, inspired amateurism
she wore for much of her first decade in the public eye—the
notion that she was just like anyone else in the audience, but
daring enough to mount the stage, was her crucial contribu-
tion to the punk ethos. She remains a galvanizing performer,
whose passion and commitment and utter lack of showbiz
cynicism allow her to play every show as if it were her last.
By now almost everything in her repertoire sounds like either
an anthem or a hymn, and while catharsis may come cheap in
rock and roll, the effect she has on her audience gives every
impression of having been earned.

That has not preserved her music from a certain lugubri-
ousness; its religiose affectations can be especially wearing on
listeners at home. Then again, her written work has acquired
a greater range over the years. *Woolgathering*, originally
published in 1992 in Raymond Foye's palm-size Hanuman
collection, is a delightfully rambling mix of childhood memo-
ries and dream sequences, the latter with the hashish-trance
lucidity of some of Paul Bowles's stories, such as "He of the
Assembly." Rimbaud inevitably shows his face, too:

> I dreamed of being a painter, but I let the image
> slide into a vat of pigment and pastry-foam while I
> bounded from temple to junkyard in pursuit of the
> word. A solitary shepherdess gathering bits of wool
> plucked by the hand of the wind from the belly of a
> lamb. A noun. A nun. A red. O blue.

Auguries of Innocence (2005, revised 2008), is rueful and
sober in a way that marks a turn. There are poems for her
children and for Diane Arbus, a meditation on the bombing
of Baghdad that drifts away for a while to consider the suicide
of Virginia Woolf, a poem that eerily seems to anticipate the

fall of Qaddafi ("Soon the sun will ascend over Libya./Can
it matter? We have bombed/Benghazi. A dazed warhead
struck/the compound of our foe lying alive,/his eyes white,
black rimmed."), and an ambitious settling of accounts with
Rimbaud:

> Everyone wears a corpse about their wrist. Just a bit
> of twine, but a corpse all the same. A dead thing pro-
> claiming I have you and you. I snip all these things
> and hurl all rings in the urinal you knelt in. Your tears
> made it overflow. All the sewage covered the station
> and made you shudder. This was as close to a laugh
> as you could get. The image of a shit-covered wagon.
> You stood clad in white, trembling.

Her memoir *Just Kids* (2010), the account of her friend-
ship with the photographer Robert Mapplethorpe, has been
justly celebrated. It is delicate and affectionate as it tells of
their adventures in a New York City bohemia that now seems
a century removed, of the endurance of their relationship de-
spite his realization that he was gay, of their separate pursuits
of fame, of his illness and death. It is almost too literary for its
own good, since her choices of word and phrase always come
down on the genteel side of the ledger: "perhaps" rather than
"maybe," "rise" rather than "stand," "yet" rather than "but,"
"one" rather than "you." There's hardly a contraction, out-
side the dialogue, in the entire book. But despite the fact that
this sort of talk is patently not the way she expressed herself
at the time, and that it sounds more effortful than natural on
the page, it does cover the book with an appropriate hush—it
sounds like someone tiptoeing through a sickroom.

An earthier and less reverent but equally glamorous view
of their life together can be seen in the photographs by Judy
Linn collected in *Patti Smith 1969-1976*. Looking rather like
stills from an unknown New Wave film, the pictures cover

Smith from her early hippie days in New York to the first year or two of her fame with a remarkable consistency, displaying various ratty lofts, misguided hairstyles, improvised fashion choices, and a lot of winning and unforced self-display, the Hollywood poses of a girl who didn't think she was beautiful. Mapplethorpe may have taken the most famous of her portraits, but many of these appeared on the covers of books and records early on, too, and they helped construct her image just as much. The fact that the in-between shots are included—the ones where she is out of focus or has her back turned or is squinting from cigarette smoke—contributes to the sense that the book represents a narrative and not simply a collection. It is a beautifully realized long-term project, an exquisite collaboration between photographer and subject.

Smith has also been exploring the medium of black-and-white Polaroids, as shown in *Land 250* (2008) and *Camera Solo* (2011). Taken singly the pictures may appear unremarkable, sometimes blurred or oddly framed in unilluminating ways. But they are not art objects as much as they are talismans, and so they follow the line of her character and her work as established early on. Several of the pictures in Linn's book show her walls: pictures of Dylan, Mayakovsky, Jean Genet, Blaise Cendrars, James Dean, Hank Williams, Albert Camus sharing space with beads and gris-gris sacs and toys and walking sticks. On the first page of *Just Kids* she records her movements while Robert Mapplethorpe lay dying many miles away: "I quietly straightened my things . . . The cobalt inkwell that had been his. My Persian cup, my purple heart, a tray of baby teeth." Her photos similarly show Robert Graves's hat, Roberto Bolaño's chair, the Rimbaud family atlas, the beds of John Keats, Victor Hugo, and Virginia Woolf, the graves of Blake, Shelley, Whitman, Brancusi, and Modigliani. Each picture represents some kind of transmission from the dead, and their blurriness and graininess assist in giving them the air of nineteenth-century spirit photos. It is an intensely personal collection, almost like a tour of her

desk drawers, but it isn't an idle production. She has obtained something from each of those figures, and by photographing their leavings she is passing along the spark. Somewhere down the line a young fan will pick up the trace. She did as much for me long ago, after all.

2012

Bass Culture

It is 1981 in New York City: a distant planet, hard to see now. The Beastie Boys are just being embryonically formed in a rehearsal space somewhere. Elsewhere, the Butthole Surfers, the Cro-Mags, Motley Crüe, Napalm Death, Run-DMC, Sonic Youth, and Wham! are likewise coagulating. In hospitals in other American cities, Beyoncé Knowles, Alicia Keys, Britney Spears, and Justin Timberlake are being born. Ronald Reagan has, since January 20, been the fortieth president of the nation. The personal-listening cassette device known as the Walkman has been available in the United States since the previous summer, but it isn't cheap and not many people have one. Instead, music is ambient throughout the city. It is everywhere, whether you like it or not. A song will come on WBLS as you're climbing the stairs from the subway station and you'll catch it on a radio playing in a passing car, picked up by the outdoor speakers at a bodega, continued by a boombox hefted on the shoulder of somebody going the other way, resumed by another boombox in the basket of a bicycle weaving in and out of traffic, concluding in the pizza parlor you've just entered for a slice.

Maybe the song is "The Adventures of Grandmaster Flash on the Wheels of Steel," and it's brand-new, first time you've heard it, so when you hear it in bits and pieces mixed with car horns and sirens you don't realize at first it's all the same number—it sounds like an extended mix of "Good Times" by Chic with assorted other radio stations cutting across it, playing Blondie, Queen, Spoonie Gee. That seems entirely plausible because it's the sort of thing that happens all the time. Just as you can walk down one street and hear a single station emanating from every broadcast device, you can walk down the next

block and hear charanga over here and Philly soul over there
and skank down this way and doo-wop down that. The street
itself can function as a mixing deck. If there's a really strong
cut in the wind that week, it will serve as a moving backdrop,
apparently always somewhere on the airwaves, while other
sounds happen across it like billboards in a car window, or
quotes dropped in by a deejay. And "Good Times" has been
audible somewhere seemingly every minute for the past two
years.

It's a world that runs on radio. In the city radio is a constitu-
ent element of the public landscape, as much as the buildings
and the trucks and the signs and the people on the street. You
hear the frantic teletype jingle of WINS—"give us twenty-two
minutes and we'll give you the world"—traffic reports and
weather and murder and war all delivered in the same flat,
dry announcer-voice. You hear "Spanish" radio (the word
"Hispanic" isn't much used yet) and if you're a *blanco* you
might not know if what you're hearing is Rican or Dominican,
salsa or bachata or merengue or guaracha. What you hear most
of all is WBLS or WKTU or, as of halfway through the year,
WRKS: K-Rock. Those stations constitute what is not quite yet
referred to as "urban contemporary," and it's still mostly disco,
which accounts for, among other things, the omnipresence of
"Good Times." What they don't play is hiphop, which con-
tinues to be despised by the eminences of African-American
radio, such as BLS's Frankie "Hollywood" Crocker, formerly
renowned for his golden ear. So you probably wouldn't be
hearing "The Adventures of Grandmaster Flash" on the radio
unless whoever owned the radio was hip enough to tune into
Mr. Magic (John Rivas) who has been hosting his "Rap Attack"
on WHBI, which is devoted to "leased-access ethnic program-
ming," only for about a year.

Hiphop—then known as "rap"; "hiphop" is still an umbrella
term that covers rapping, DJing, graffiti, and breakdancing—
isn't the first successful urban sound to be scorned by the
media. It happened to street-corner vocal harmonizing in the

mid-1950s, until it was finally exhumed five years later and marketed as "doo-wop." More recently it happened to punk, a phenomenon you could have entirely missed, for years, if you hadn't visited a handful of bars and record stores. But hiphop is all over the streets anyway. Those boomboxes aren't just radios. Mixtapes rule. Which is why you can take in brand-new twelve-inch releases on the fly before you're necessarily even aware of what you're hearing. Mixtapes also account for, say, the middle-aged Ukrainian guy walking down St. Mark's Place blasting Merle Haggard. Try finding Merle on the radio anywhere in New York City.

If you're some punk-ass white kid in Youthville—which this year is bounded by Third Avenue, Fourteenth Street, Avenue B, and Delancey Street—you may not know anybody in the Bronx, so when you hear one of those brand-new twelve-inch rap releases flying out of somebody's boombox on the street and it cuts you to your marrow, how do you find out what it is? Well, you can go to Disc-o-Mat on the east side of Union Square, a branch of a chain that moves records in and out as comprehensively and impersonally as bread and milk, and you might get lucky—or you might just end up buying something else on the strength of its name or its label. Or, if you are inclined to travel, you will sooner or later make your way up to Downstairs Records, in midtown, which at least at first—it moves a few times—is actually located in a subway arcade. The store isn't that big, but they seem to stock everything, and they always know what you're talking about. Just repeat the one rhyme you're sure you caught off that last thing you heard, and without hesitation the guy behind the counter will retrieve it from a case, like magic. And sometimes, especially if you're buying dance beats, the record has little or no information on the label. Is it a bootleg, a promo, a test pressing? You may never know. The most brilliant mix you ever heard only seems to exist on one sliver of vinyl. For all you know, only six copies were ever pressed. And then your apartment is burglarized and the record disappears, forever.

A lot of hiphop is basically rumor at this point. There are of course the hits, underground and otherwise, as there have been since Spoonie Gee and Kurtis Blow and the Sugarhill Gang manifested themselves two or three years ago. But you know the real action is happening in the Bronx and Harlem, in parks and community youth clubs and common rooms in the projects and sometimes in cocktail lounges. Things go down that go unrecorded, as MCs and DJs try to top one another: unrehearsed epiphanies simply occur. Maybe you were lucky enough to catch the Cold Crush 4 versus the Fantastic 5 at Harlem World, or Flash versus Crash at the Audubon Ballroom, but maybe you weren't. And if you know about all this but aren't there, the records can sometimes sound like just a captured sliver of something huge, although that's been the case forever with recordings of music with a large improvisational component—the same was true of Charley Patton and Charlie Parker. There are many fantastic records out there, but what's so striking about hiphop right now is its gigantic untapped potential. Most of the rap you hear involves people talking over grooves, mostly at a walking tempo, mostly fronting. There's not really a lot of non-fronting lyrical content going on—the only "conscious" record anybody can think of is still last year's "How We Gonna Make the Black Nation Rise?" by Brother D and Collective Effort. The standard of production still very much follows the early Jamaican template: hit tune minus vocals plus talkover. This year the MCs are all over Taana Gardner's "Heartbeat" and the Tom Tom Club's "Genius of Love," and you can see why, because those are both grooves that can last all day long.

"Heartbeat" has a full stop right in the middle of the bass line—three steps leading up to it and three steps away again, making it like a slow-grind minuet. Taana is calling out to the world from the crag her passion has abandoned her on, until every once in a while a tinkly synthesizer sprinkles glitter and she's surrounded by a party. And "Genius of Love" is the same kind of stagger-step, just a touch faster. It has an indefatigably

bright synth hook—with a stop in the middle—and a bottom like a brick shithouse. You can run all kinds of additional sound material through that setup without causing any real damage. Their best idea, though, is the tender girls'-chapel harmonies. In addition to being a solid jam, "Genius" is also a happy pill, very good for the street. Notice also where those two jams originated. "Heartbeat" is a product of disco standard-bearers West End Records, and it was given its definitive club mix by Larry Levan at the Paradise Garage—the Pope and Vatican of gay dance culture. "Genius," by contrast, is the work of Tina Weymouth and Chris Frantz, late of Talking Heads, who emerged from CBGB, the punk manger over on the desolate Bowery. Cultural fences seem to be breaking down all over, and influences are running in every possible direction. It seems as if every strain of urban music is folding into a cult of the groove, what Linton Kwesi Johnson calls "bass culture."

Not everybody's gotten the news quite yet, though. Remember "Disco sucks"? Outside lower Manhattan, people who maybe in a few short years will be blasting Run-DMC are still fiercely and monomaniacally devoted to the old definition of rock and roll. On May 28 a herd of them boo Grandmaster Flash and the Furious Five off the stage as they are attempting to open for the Clash at Bond's International Casino on Times Square. This comes as a shock to everybody downtown, although more than anything that reflects the usual white-folk's denial when it comes to inbred racism; black people aren't especially surprised. The fact is that the pan-racial, omnisexual groove religion is pretty new even downtown. It wasn't until 1978 or so that it even occurred to the regulars at CBGB that almost everybody who played there was white. And it's only now that the Funky 4 + 1 are playing the Mudd Club (not to mention *Saturday Night Live*), the first time people have officially walked over the cultural bridge from the Bronx. Even so, there's no question that many musicians and music lovers have been listening broadly all over town. Some onetime CBGB regulars make their way to the reggae dance clubs downtown,

Isaiah's and then Negril, or to take in salsa at the Roseland or
Corso Ballrooms, or to the astonishing series of gay dance
clubs—the Paradise Garage, the Loft, the Gallery—that boast
unsurpassable mixes, sound systems, dancers, and enthusiasm.
The salsa rooms are daunting: you are never dressed right,
and sometimes you're not even allowed in because you're
wearing sneakers, and once you're there your honky feet can-
not follow the steps. But soon enough Ray Barretto and Tito
Puente also come to the Mudd Club, where it's all right for
hipsters to make all sorts of flailing attempts at dancing. It's
bracing to see those bands there: Barretto's jackhammer piano
louder than any other instrument; Puente's lead singer, a bull
of a guy whose collar and cuffs pop out from his suitcoat as he
punches the air and addresses incantations to someone invis-
ible over his head. The gay discos can be daunting, too, because
of how easy it is to be utterly outclassed by the skill level of the
other dancers—the extreme is the Nickel Bar, a pick-up joint
on 72nd Street where Robert Mapplethorpe is known to go
look for models, in which no one who is not a teenage athlete
would even think of getting on the floor. But after a certain
time spent in discos the mood of sheer abandon overtakes self-
consciousness. The physical presence of the music is so much
deeper—the bass more enveloping, the flow more liquid, the
breaks more apocalyptic—than you are used to hearing any-
where else. You fall into it as if it were water on a hot day. At
the Loft there is no liquor, just fruit juice, cheeba, and the oc-
casional psychedelic punch. There is even effective ventilation,
and a lightness of atmosphere that goes with it. You might float
home the next morning in broad daylight.

You're likely to see more of your post-punk friends at the
reggae clubs, because Jamaican music has been a constant pres-
ence in all your lives since the Wailers broke stateside in '73,
and major artists come through New York City regularly. In
fact you just saw Lee Perry and Culture at Irving Plaza: Perry,
spliff in hand, crowing and raving and citing scripture in front
of a wall of skank as dense as anything Phil Spector ever built.

But the dance clubs aren't especially meant for your kind—
they are the first signs of a Jamaican diaspora that will only
keep increasing as people flee the unrelenting sectarian violence
on the island. White kids go to the clubs expecting Rastafarian
hippie-radical vibes and instead get served slackness, which not
only is rude and sometimes obscene but rides on purposefully
shallow, singsong, insanely repetitive hooks that crawl under
your skin almost against your will, Yellowman and General
Echo and Papa Michigan and General Smiley leering their way
through repurposed nursery rhymes the meanings of which
elude you for the longest time—although once you've figured
out that the word is "punanny" it doesn't take you a year to
work out what it signifies.

You also sometimes go dancing at the Squat Theater on
23rd Street, which is run by an extended family of Hungarian
expats. When they are not putting on plays they provide a
home for what gets called punk jazz. The genre consists of
r&b-based dance music, played tight with sharp edges and
unlimited skronk by avant-garde jazz veterans. The "punk"
thing is presumably in reference to the Lounge Lizards, who
actually got labeled "fake jazz" because they are 25-year-old
white amateurs, although they acquit themselves pretty well.
All these bands—Joe Bowie's Defunkt, Oliver Lake's Jump
Up, Luther Thomas's Dazz—take their cue from the Lizards in
terms of material and basic approach. It is unusually populist
territory for a crowd of guys who all have artistic and even
familial links with the Art Ensemble of Chicago and Ornette
Coleman's constellation and jazz cred as long as your arm.
The stuff they play is crazy danceable, always on full alert, and
with more bristles than a brush. It's like James Brown's band
backing up Albert Ayler. You're pretty sure it'll be the next big
thing. How could it miss?

And there are a million other clubs where a couple of
years ago there were like three. The Mudd Club is the center
of the known universe. It's changed a lot since it opened on
Halloween, 1978, and remained a pretty intimate bar-disco for

at least a year. It wasn't crowded but it was very, very loud. People had X's in place of eyes. Watches stopped working just inside the door. Saturday night could stretch into Wednesday. Drink tickets were legal tender, and dollars were good mainly for rolling into cylinders. Friendships were forged that might last for hours, possibly days. Your coat, tossed in a corner, was as good as gone. And then it hyperinflated on celebrities and drink-ticket speculation. But amazingly it didn't crash, instead reinventing itself as a concert location, nicely scaled and with an excellent sound system. One afternoon you go there looking for a friend who's supposed to be rehearsing for that night's event, but when you open the door it's just you and Nico, on the stage with her harmonium, the rest of the room pitch-dark. You listen transfixed as she plays her entire show.

Normally, the Mudd Club is like Grand Central Station. If you're looking for anyone—they're not answering their phone and are absent from their usual haunts—you'll eventually see them come through. You see Jean-Michel Basquiat and Anya Phillips and Lydia Lunch and John Sex and Lisa Rosen and Fab 5 Freddy and John Lurie and Andy Warhol and Sophie Vieille du Temple and Klaus Nomi and Futura 5000 and Felice Rosser and Boris Policeband and Mary Lemley and Lee Quiñones and Patti Astor and Kristian Hoffmann and Adele Bertei and Lady Pink and Ronnie Cutrone and Rammellzee and Debbie Harry and Rene Ricard, and Anita Sarko on the decks and Haoui Montaug at the velvet rope, the wisest and most poetic doorman ever. Later you will have breakfast with all of them at Dave's Corner at Canal and Broadway, where Betty, who has been working there for maybe forty years, sports a blonde bouffant helmet, edged with a flip, over a face you seem to remember from a Dorothea Lange photograph.

If you keep walking east down White Street, you will come upon the Baby Doll Lounge, a strip club of the oldest school, where a number of women of your acquaintance have danced for the rent money, at least for a week or a month. A couple of blocks farther, just around the corner on West Broadway, is

Tier 3, which has a broad clientele overlap with the Mudd Club but couldn't be more different. It was a bar and grill once, and bands play in what was the dining room—there is no stage, and the audience begins about a foot from the mic stands. There is a room upstairs the same size where people just drink and talk, and another on the third floor where they show movies, usually by customers. The ambience of the club could not be more chill if it was happening in your own living room. It's so low-key and unpretentious—and there is never a velvet rope— that it feels like a secret, even though a great many visiting acts from the UK (the Raincoats, the Slits, Young Marble Giants, A Certain Ratio) play there before appearing on larger stages uptown, this in addition to the hometown scene: the Bush Tetras, 8-Eyed Spy, the Futants, the great DNA who appear to be reinventing pop music from scratch in some Lascaux cavern of their imaginations.

It's certainly a far cry from the aggression that marks so many other places, the frenzied door scenes and dance-floor territoriality you can find at the Peppermint Lounge or Danceteria or Bond's—all of them ambitious omniclubs with multiple levels and multiple bars and plenty of video monitors and VIP lounges that perhaps contain even more exclusive VVIP accommodations within. You visit those places, with their high prices and incessant status competitions, and think you've maybe been given a glimpse of the future—but you push the thought out of your mind. Just a few years ago, there was a clean division between downtown nightlife and uptown nightlife, with Studio 54 heading the latter, and the two sides did not mix. The downtown people drank beer and wore sneakers and listened to rock and roll, while uptown they wore designer outfits and ran through several months' rent worth of cocaine in the course of a night and did some version of the hustle to disco numbers sugared with synthesized string sec-tions. Now it's all one, thanks in part to the cult of the groove having swept the island of Manhattan.

But punk in its original state still persists. CBGB, which

might have been founded by the Visigoths in the third century, has outlived all the competition and by this time seems as if it will last forever. Visiting firemen of all statures still play there, some of them arena acts which play unannounced sets just for the glory and the cred. Even so, most nights there nowadays feature stacks of bands, seven or eight of them end to end maybe sharing a drum kit. You may go there now only to see your friends play—it's a rite of passage; all new bands are seemingly required to play CBs once—but you are guaranteed to go at least a couple of times a year. Its opposite number, Max's, site long ago of the Velvet Underground's last stand and more recently a representation of punk so institutionalized it featured drinks named after popular stars of the day—champagne and stout was a "Patti Smith"—comes undone this year. The fledgling Beastie Boys play there on its last night, opening for the Bad Brains.

But sometimes you think that punk itself may be hovering on the edge of extinction. That's certainly what John Lydon, formerly Rotten, would like to see happen, and this year he does his level best to push it over. His band Public Image Limited, which played a couple of galvanizing shows last year, at the Palladium and, incongruously, at the Bowery metal club Great Gildersleeve's, is this year booked at the last minute for a set at the Ritz, a turn-of-the-last-century dance palace once called Webster Hall that has recently opened with a view to booking touring acts just below the arena level. The line outside starts to form at noon, and you can walk by and feast your eyes on the current look of suburban adolescence, all Perfecto jackets and stiff hair and dog collars and safety pins through the cheek. Eventually the doors open and everyone files in and waits. And waits some more. And waits some more after that. Three hours later a semblance of a show begins. The stage is almost completely covered by a giant video screen, behind which lurk the three members of the band and a few walk-ons. Aimless prerecorded videos are shown along with murky live footage from behind the screen; the band tosses off rudimentary versions of

a few numbers from its latest release, *Flowers of Romance*; at
one point somebody puts the record itself on the turntable for
a while. Occasionally it seems as though the throat-clearing has
ceased and a recognizable performance is about to begin, but
whenever that happens everything stops dead, to be followed
by shambolic video effects and semi-musical doodling. As the
audience becomes restive, the band begins to taunt it, with
increasing intensity, daring it to start a riot. And the band gets
its wish. Bottles and then chairs are thrown, the video screen
is yanked off its mount, the equipment slides off the stage, the
band members barely escape with their lives. It is by merest
chance that the injuries are relatively minor and that no one is
killed.

Afterward, the occasion feels like a full stop. The punk
rhetoric—the aggro, the denial of showbiz conventions and
aspirations, the baiting of fans—has apparently crested, and
perhaps this heralds the imminent end of rock and roll. The
old beast has after all been ridden to a lather, several times over.
It has fully made its point, and it has also been inflated to the
point of bursting with meaningless trivial pageantry, has been
bleached of any connection to blues and soul, has floated so
far from its roots that entire branches of its family tree might
as well have descended from the operetta and the sermonette,
and—punk's contribution—has been stripped back down to
its constituent molecules. Now that that last adventure is over,
where can it possibly go? Well, for starters it can submit to the
groove, which is what the vast majority of halfway alert bands
are doing this year. Public Image Limited was in fact among
the first to go in that direction, at least until genius bassist Jah
Wobble decided to take a hike. But just look at what else has
been coming out this year from formerly rock-identified pre-
cincts: Blondie's "Rapture," Kraftwerk's *Computer World*, Soft
Cell's cover of "Tainted Love," Brian Eno and David Byrne's
My Life in the Bush of Ghosts, the Human League's "Don't
You Want Me," the first singles by ESG and Liquid Liquid,
A Certain Ratio's "Do the Du (Casse)," not to mention the

B-52s' misunderstood *Mesopotamia*, release of which will
be delayed for a year. Any of these can slide into a rotation
that also includes Grace Jones's "Nightclubbing," Prince's
"Controversy," Teena Marie's "Square Biz," and Rick James's
"Super Freak," not to mention assorted items by Afrika
Bambaataa, Grandmaster Flash, and the Treacherous Three.

And it isn't just music that appears to be on the cusp of a
transformation. The city is poised on much the same kind of
brink. For years, almost since the end of the war, it has been
increasingly given over to the poor, while anybody who can
scrape together a down payment has headed off to the suburbs.
Whole neighborhoods have been virtually abandoned, entire
clusters of blocks set on fire, sometimes on multiple occasions.
The blocks east of Avenue B look like the aftermath of war—
it's probably around now that a bar called Downtown Beirut
opens on First Avenue. Social services barely function; the
streets are filthy and heaped with trash; there are so few cars
parked on the Lower East Side that stolen whips get dumped
there and torched. Many taxi drivers will not take you east of
First anywhere below 14th Street. Chances are that you've
endured at least part of the winter with no heat. And drugs
are rampant, probably at an all-time peak. Heroin and cocaine
are ridiculously cheap and available, and all kinds of people
who should know better are getting themselves strung out,
some of them fatally. Friends are stealing from friends; bands
dissolve when members start hocking equipment—there are
many more stories circulating about that sort of crime than
about people getting mugged. And this is also the year that an
unknown cancer begins to be spotted among gay men, just a
few dozen at first.

At any rate, the city has up to now been the ideal place for
artists and musicians, for young people trying to figure out
life and getting there by pushing at any and all boundaries of
custom and habit and even good sense. You can live for very
cheap; rent an apartment of more than one room for less than
$200 a month; buy furniture and clothes second-hand; get a

job, in a record store or a bookshop, that pays the bills and
allows for a social life and occasions for shoplifting. You and
your friends can take a share in a rehearsal space for almost
nothing, as long as you are willing to freeze in the winter and
broil in the summer. You can get some gigs going in any of the
myriad clubs—there's one for every fractional taste—and if no-
body will give you a record contract you can cut and press and
distribute a single yourselves without falling into penury. You
can advertise your gigs with photocopied fliers wheatpasted on
walls and the plywood coverings of shuttered shops and atop
paid advertisements on the sides of bodegas. Maybe if yours
are clever enough you can attract some people other than just
your friends. Even as you hope you might win some sort of
pop-music jackpot you know you'll probably never make any
money, even if you get a record contract and go on to tour col-
lege towns and the Scandinavian countries. Hundreds of the
bands that appear on bills at downtown clubs will do so only
once before they break up over money disputes or matters of
dogma. Or change their lineup because of personality prob-
lems. Drummers are scarce, and worth their weight in 40s of
Olde English.

But none of that is a tragedy because you can afford to fail.
You can change your style and your name over and over again.
You can branch out into painting or Super-8 movies and see
whether any of it clicks, and if doesn't you can try something
else. You can maintain a reasonably decent life at the bottom,
secure in the knowledge that if you jump out the window you
won't get hurt. There may be people around who are actu-
ally planning a career, but if so they're keeping mum about
it. Anybody who would really prefer to live in a more secure
environment or continues to dream of plush settings prob-
ably pulled up stakes and moved west years ago. But you're
starting to notice a tinge of hysteria in the air. People can be
heard fronting about how bold it is of them to be living on
the edge. You never used to hear that sort of talk—used to be
that youths from elsewhere who moved downtown realized

pretty soon that they had entered a neighborhood of families and old people, Dominicans and Ukrainians and Chinese, who really didn't care about their artistic ambitions or romantic lowlife fantasies, and that they owed their neighbors a good deal of discretion and respect. Now you've got people making up brand names for their assumed neighborhoods—Alphabet City, for example, as if they were already packaging the eventual action-adventure based on their early years of struggle.

Nobody is conscious of it yet, but major change lies just around the corner. Very soon—next year, maybe—the building you live in will be bought by a speculator who will flip it, probably to someone else who will flip it again, and so on down the line until its sales price is ten or twenty times more than the initial speculator purchase. And at some point a buyer, having invested so much and knowing that the combined rents of the building will not allow him to recoup in this lifetime, will start making efforts to get you out, by fair means or foul. And when he does so he will put in new drywall and reconfigure the layout so that he can insert a bathroom and get the tub out of the kitchen. And then he can rent the place out for three or four or five times what you had been paying. And your club will become a bank, your rehearsal space a parking garage, your greasy spoon an eyeglass boutique, your bar a sports bar. Even if you manage to stay you will feel like a ghost.

But all that lies in the future—some of it in the near future. In the meantime youths continue to start bands, to fuck up, to change names, to change appearances, to change styles. Enormous numbers of them continue to be obsessed with music. Even if music isn't your gift or your strong suit you are obsessed with music, and even if you are completely incapable of making any music yourself you want to live inside it. It's the primary language of your time, the major medium of exchange, the principal commodity. It's the public face of sex, the legal drug, the emotional prosthetic. It rules and shapes every waking moment of your life. Music is ambient everywhere outside, and it is ambient at all times inside your head. And

all the music around you is in the process of becoming one music, a great river of groove, embellished variously, identified by matters of instrumentation or echo or use of electronics or details of vocal styling. As surely as a certain kind of thin dry guitar and a certain nasal delivery marks a thing as British, and as surely as a staccato vocal attack and a capital use of cheap electronics make something else out as Jamaican, so the sound that this year immediately registers as New York all over the globe is principally composed of the scratching and mixing and jumping and fading and rhyming of hiphop.

There are little of pockets of that sound starting to happen in other cities across the country, but they're embryonic as yet. Hiphop right now is a direct, mimetic product of the streets of New York City, embodying the city's verbal agility and aggression, its constantly fractured barrage of traveling sounds, its abrasive textures and juxtaposed incongruities, its densely layered strata of information. And it's only just becoming apparent how much more can be done with the fundaments of the style: how much stripping down, speeding up, pulling in of other sounds musical and otherwise, and how much textual complexity and nuanced attitudinizing and justified protest and seductive strategizing and flat-out indictment can be brought to the talkover. It is occurring to people all over the city that hiphop is a sound that can be *carved*. And so it is occurring to Michael Diamond, Adam Yauch, and Adam Horovitz, lately in the punk rock business, that they can use it to make anthems and stage sketch comedy and arrange pinpoint-precise repartee that wears a stupid hat to conceal its sophistication, and that's just the beginning.

2018

12 Sides

"We Got More Soul," by Dyke and the Blazers (Original Sound OS-86). Ex collection "M. Scale." Found circa 1977, Passaic, New Jersey. Estimated plays 50–60. Gritty but serviceable, the grooves still evincing a satiny surface sheen. The silences are not too loud; the stop-and-go percolates nicely. Former owner Scale was in his middle twenties then, still healthy, still socially integrated, still employed. He played the record on Saturday mornings, finding in it an analogue to the optimistic cheer that filled him as he contemplated the possibilities of a weekend that seemed as long and promising as the unwinding highway of his future life. Now he has no recollection of it.

"Soul Power Pt. 1," by James Brown (King 45-6368). Ex col-
lection "Suggs." Found 1976, New York City. Estimated plays
200-250. Label rubbed nearly raw, with white bands at outer
edge and edge of inner declivity; title nearly illegible. Shines
nicely when held at an angle, but the surface is a skating rink.
James's shouts are nearly lost in a forest of brambles, and
seventeen seconds before the end groove the finale is hijacked
by a fatal skip. Suggs was a teenager, a serial attendee of house
parties, a pest to the ladies who imagined himself a hit with
the ladies, a loud kid with a big smile and a six-inch Afro who
carried his records in a brown paper bag. Today he recalls this
side a bit ruefully on certain empty summer nights.

"You Got What It Takes," by Marv Johnson (United Artists UA 185). Ex collection "Fran Paul." Found 1984, New Rochelle, New York. Estimated plays 75-100. Sounds better than it looks. Asphalt-like undertone actually contributes to record's lapidary impact, shaves a bit of the new-car ambiance off typical Berry Gordy production. The single hiccup by Marv fails to develop into a full skip. Former owner was fourteen at the time, the record stolen by her soi-disant best friend Debbie, who had it stolen from her in turn at a church-sponsored event, and who knows how it traveled all the way to Westchester County? Today the original owner has a pop-music memory that only goes back about ten years.

"I'm So Glad I Found You," by Linda Jones and the Whatnauts (Stang ST-5039A). Ex collection "Brenda Vernon." Found 1994, Oneonta, New York. Estimated plays 20-25. Like watching a ship sailing through mist, the music emerges from a wide but translucent cloud of tiny skitterings, although the surface was abraded by poor storage rather than overplaying. The former owner was sixteen, bought the record because of its title because she thought she was in love. Disillusionment with boy in question led to abandonment of record in back of closet; it was found decades later by new owners of house. Brenda today is a successful businesswoman, who disavows any knowledge of the details of her youth and insists on the empowering quality of staring fixedly forward.

"Angel Baby," by Rosie and the Originals (Highland 1011). Ex collection "Aline" and "Rozier." Found circa 1974, New York City. Estimated plays 300-400. As thickly impastoed as a late Rouault, the record is simply unplayable; surface abrasion is compounded by extensive chipping of inner ring—spindle insert barely clings. Aline, in her middle teens at the time, was a careful owner who filed her records in a carrying case (label bears a small sticker reading "18"). Rozier, a friend of her older brother who "borrowed" it and marked it as his own, presented quite a different picture. Not only did he subject it to numerous playings at late-night rumpuses where the tone arm would regularly be dropped bluntly and carelessly on the surface and taken up with similar lack of finesse, but he also, impishly and regularly, sailed his records through the air, aiming for friends' unsuspecting heads. Eventually it traveled out the window and was rescued by a scavenger. Nothing is known of the subsequent fates of either Aline or Rozier.

"Just One Look," by Doris Troy (Atlantic 45-2188). Ex collection "Pearl." Found 1977, Brooklyn, New York. Estimated plays 100-150. Gives the impression of an imperfectly tuned radio: the song is clearly audible, but apparently competes with an entirely separate musique concrète, perhaps a little-known Luc Ferrari composition. White streaks between grooves on the B-side provide evidence of long-ago spillage of a liquid substance. Former owner purchased record at sixteen and continued to play it at home and at parties for much of the following decade. Donated it to the church bazaar on the eve of her marriage. Today she is twice-divorced and sad, misses her records, misses her old friends, misses her mom.

"Who's Cheating Who?" by Little Milton (Checker 1113).
Ex collection "ES" and "D." Found 1973, New York City.
Estimated plays 200-250. Very little remains of the music on
this record, which now sounds like an electric coffee grinder
on low speed. ES and D were siblings who agreed to share their
records in a rare instance of youthful idealism and economy.
Within a year or two, however, hormonally driven tensions
between them had escalated their former jocular rivalry into a
state of war. Records became bargaining chips, then hostages,
then weapons. ES, who was very attached to the music, at-
tempted to handle them with care, but D, for whom records
were social markers above all, treated them with contempt.
Eventually their mother settled things by just throwing the
whole mess out on the street. Today the brothers have rec-
onciled. ES enjoys smooth jazz, golf, the occasional drink or
three, while D has become a Buddhist and prefers the sound of
his own inner harmonies.

"It's a Man's Man's Man's World," by James Brown (King 45-6035). Ex collection "Authur" [sic]. Found 1972, Jersey City, New Jersey. Estimated plays 400-450. An unlistenable platter of French-fried worms, this record has been loved to death. Authur (pronounced "Arthur") spent his teenage years consumed by this record. He lived surrounded by females: mother, grandmother, three sisters, and a girl cousin, all packed into a two-bedroom apartment; Authur slept in the pantry closet. He obtained a small portable record player through a complicated series of swaps, stole the record from Woolworth's, and listened to virtually nothing else between the ages of twelve and seventeen. Perhaps because man made electric lights to bring us out of the dark, he went to work for Consolidated Edison in New York City, where he remains. Today he listens to the song on CD in his car on the way to work.

"Crying," by Roy Orbison (Monument 45-447). Ex collection "Laura Weiner." Found 1986, Honesdale, Pennsylvania. Estimated plays 15-20. Superb condition, beautifully maintained, sounds nearly new to the ear even if it does not necessarily appear that way to the eye. Laura bought the record because she was sad, because a certain boy failed to offer her a Valentine's Day remembrance. Then she forgot that she was sad, and forgot the record, and it sat in a box in her old bedroom for two decades after she married and went on to raise four children in a suburb of Atlanta, until the death of her mother, when the house's contents were disposed of by professional estate managers. Today she couldn't pick the song out of a lineup.

"Rockin' Pneumonia Part I," by Huey "Piano" Smith and his Clowns (Cotillion 45-44142). Ex collection "Clasic" or "Clasie." Found 1980, Brunswick, Maine. Estimated plays 35-40. Another record in excellent condition, albeit present-ing a label marked with various letters, numbers, and glyphs, mostly in felt marker. It is a disc jockey copy, on which the A side is inscribed "Plug Side" (perhaps redundantly, since the B side is Part II). Clasic or Clasie has here, as on several other records found along with it, daubed his name or handle on a stub of masking tape and covered the brand logo with it. He seems to have been an itinerant deejay who worked weddings and graduations and possessed a great many records, most of them with little emotional investment; he played strictly to the crowd's tastes. He died in 1979 from choking on a pretzel stick. Vic Damone's version of "My Way" was played at his funeral.

"So Much in Love," by the Tymes (Parkway P-871C). Ex collection "Victor Heinrich." Found 1971, Brigantine, New Jersey. Estimated plays 175-200. The Tymes here sound as if they are heard singing deep in a forest at the lush height of summer by a wanderer on the trail above who cannot quite locate the source of the music. Birds and insects and rustling branches can be heard in three-dimensional detail—for all that they are really just scratches—giving the song even more of a poignant, elegiac quality than it initially possessed. This is apt since Victor played the record unendingly in commemoration of his love for Hazel, who never even knew he was alive. He kept the song secret from his parents, who might have laughed, and from his friends, who certainly would have. He went so far as to try to become a priest to assuage his broken heart, but the order knew better than to sign him up. Today he is an angry drunk, and no longer remembers how he got there.

"Cool Broadway," by the Fantastic Johnny C (Phil-L.A. of Soul 315). Ex collection "Tina." Found 1978, New York City. Estimated plays 175-225. The grooves' rocky road here becomes a sonic analogue to the scratches and blots and blemishes on an old strip of film. The Fantastic J. C. is high-stepping along Broadway through an electric haze you could mistake for gnats or snow. Those were the good times—each pop representative of an occasion of fun, each flurry of crackles a reminder of the enveloping embrace of that old gang of friends. They played it and played it and played it some more for the duration of the summer of 1968, even though it was just the follow-up, even though it sounded like a bare retread of the original "Boogaloo." They didn't care. It was Tina's record at first, but it found its way to Beverly's house, and then to LaVerne's, and then to Tracy's, and Tracy's mother was the one who gave all the records away to a neighbor one day after all the girls had gotten pregnant and the records, just a couple

of years old by then, might as well have been relics of earliest childhood. Today each of the three survivors of that time will, if questioned, recall a certain brass-section color, a certain parade-drum bounce that stands in for 1968, unspecified and indistinguishable from the sodas and chips and hair-care products and magazines that wove with the music to create the fiber of those afternoons and weekends, still close to their hearts but an unimaginably vast remove away.

2010

Case Study

The subject, a recent immigrant approximately nine years of age, was asked to depict his mother. It was specified that he should present her in a particular context of his choosing: a setting or activity. The resulting picture is of considerable interest. The woman is only marginably noticeable, and then only because her coat presents the largest single expanse of white space in the composition. Clearly, the subject entirely subordinates maternal affection to the far greater stimulus of commercial consumption. For that matter, the nature of the consumer products themselves is of secondary interest; the subject is enthralled by packaging, and above all by names.

Because the composition is so crowded and frenetic, it is worthwhile to break down its constituent parts. The woman is pushing a shopping cart overloaded with products down a

supermarket aisle. It would seem to be aisle six: coffee, tea, juice, soda. The items heaped in the cart seem at least partly stereotypical: the protruding head of celery in particular is a trope familiar from myriad cartoons and illustrations. It might likewise be doubted whether she purchases toothbrushes on a regular basis, and ditto for "wax"—presumably floor wax. Other items seem more likely to be true to his actual experience of grocery shopping: that the sack of potatoes has been placed in the cart's bottom tray, for instance, or the exact replication of the Fritos logo, or the prominence of the detergent Beads O' Bleach.

But even the groceries in the cart are overwhelmed by the serried ranks of products on the shelves, which are depicted in disproportionate scale. The boxes of Lipton tea bags are nearly the size of the cart itself. (The curious symbol on the boxes represents the subject's attempt to come to terms with the concept of the tea bag. Coming from a coffee-drinking culture, he had only ever experienced tea bags as pictures on boxes, and averred he thought they looked like "pants on a hanger.") It is fascinating to observe the rigor with which the subject records brand names, even the ones that make no sense to him, resulting in solecisms: "Early' Morn" for "Early Morn'" and "Chock O' Full Nuts" for "Chock Full O' Nuts."

A strong reaction to American consumer abundance is typical of recent immigrants. It can take various forms: hysterical blindness, catatonic undifferentiation, at least eighteen catalogued types of aphasia. The delirium on view here, in conjunction with the subject's powers of observation, leads us to predict that he will become a highly achieving adult, one who will subordinate all other drives and desires to the acquisition of brand-name goods. He will work three jobs, if necessary, to purchase the latest model automobile, equipped with all the premium features. Such a goal, in any event, will encouragingly overshadow romance or idealism. If the subject is properly steered, he will actually work three jobs to achieve

his goals. The danger remains that he may choose to rob service stations instead. The subject should therefore be closely and carefully tracked, but for now we do not recommend deportation.

2008

The Grasshopper and the Ant

Like the ant, the teenage stoner labors ceaselessly and un-
complaining, pursuing an arduous task that casual onlookers
would dismiss as pointless, yet which is essential to the little

creature's survival. Like the ant, the stoner lacks an animating concept, but sets to work at one corner and emerges, hours or days later, at the opposite corner. Like the insane who express themselves visually, the stoner is drawn to symmetry, to altars and monuments, to murky quasi-spiritual allusions, and like them, too, the stoner abhors a vacuum. Like Manny Farber's termite, the stoner "leaves nothing in its path other than the signs of eager, industrious, unkempt activity," although unlike the termite the stoner is unlikely to be rediscovered by the French. Like the ant, the stoner can carry many times his or her weight, often traveling through dense undergrowth or over endless arid terrain, and appears to enjoy using outmoded or simply impractical tools—in this case a Hunt's Crow Quill pen, hence the blots. Like the ant, the stoner endures the contempt of family and friends in stoic if sullen silence. Unlike the ant, the stoner will require eyeglasses—if not now, then soon. Unlike the ant, the stoner works to the accompaniment of music, typically some carpetlike stream of psychedelic monotony. Like the ant, the stoner is as yet innocent of carnal pleasure. Like the grasshopper, the stoner—as the name would indicate—is on drugs.

2008

Grownups

If you have spent an appreciable amount of your life acting in opposition to a prevailing set of mores, you will eventually come to appreciate the importance of those mores as a point of reference. Gradually, it will occur to you that in addition to opposing that way of life, you require its presence, in various subtle ways, and not simply for the friction. Around the time you realize this, however, you will also realize the fragility of your nemesis. You once had the luxury of thinking of it as a monolithic force; it stood for a political position, an ethics, an aesthetics—and now it will turn out to be made up entirely of people. You will only be fully aware of this when those people have died out.

The bad politics, the questionable ethics, the offensive aesthetics are still all around you, only now they belong to your contemporaries and juniors. What is missing are grownups. You yourself may pay taxes, raise children, hold a job—you will still never quite embody the definition of "grownup" to yourself, because for you that idea is inextricably associated with the style of one group of people, your elders. And their style, in turn, was a complicated mass of elements arising from and contingent upon their specific time in history, its culture

and technology. And try as you might, you will never be able to replicate this style, even if you decide to take it upon yourself to inhabit it in all sincerity. In your hands it will never be anything but ironic.

And anyway, you don't really understand it. You may have immersed yourself in the period—have read the books and listened to the music and watched the movies. Still, the culture of the grownups will always remain alien to you in fundamental ways. Look at the pictures above. What is afoot is not just a matter of sharkskin suits and cocktails and Mantovani records and idiot party games. Their idea of conviviality has a core that you simply cannot penetrate. In part that is because it is a dilution of earlier notions and wishes held by them, and you are not privy to the bargaining and substitutions that led them to this pass. In part, too, it is because their culture was formed in opposition to an earlier monolith—the world of their own parents—and you have even less insight into that. It may seem that nothing in the world is ever upright. It is either leaning forward, or leaning back.

2008

Ancestry

I never got around to asking my mother about the circumstances under which this extraordinary object was produced, so I can only conjecture. Had I found it in a pile at a flea market I would have assumed such a confection of airbrush and hand-tinting to be a generic romance image, such as the postcards you can still find in places like Greece or Mexico that feature a young woman looking misty, with or without a sentiment

printed in cursive. Judging from the hairstyle I'd guess the
picture was taken within a couple of years after the end of the
war. This print measures roughly 9½" by 7" and I also have a
postcard version—on which the lips have been retinted bright
red—so I think it might have been a package deal offered by a
photographer: one large print and from three to five cards for
one low price.

My mother is in her early twenties here, still living with her
parents and employed by them as maid-of-all-work as well
as holding down a secretarial position with a governmental
family-welfare agency. She may not yet have met my father,
for all that he sometimes lives with his parents directly across
the narrow street from her. Marriage and family are her only
prospects, aside from the nunnery the only ones even con-
ceivable to a young woman of her time and her class. She has
little education, has principally been schooled in sewing and
penmanship. She has been through war, fear, hunger, cold,
flight to the south of France in 1940 accomplished in part on
foot, strafings by Stukas on the road, bombs falling within
yards of her family's apartment, nighttime encounters with
Wehrmacht foot patrols—yet none of this has managed to
dent her innocence.

To me she is entirely enscribed in this picture: her hazily
romantic dreams, her naiveté so profound it might be willed,
her deeply buried intelligence, her sufferings at the hands
of her family, her enclosing wall of fear, her cruel and only
intermittently comforting piety, her constant depression that
merely fluctuated in its depth, her rigid mask of good behav-
ior. I see a lot of myself in that face: eyebrows, mouth, maybe
nose, shape of eyes. We shared many of our worst qualities.
We were very close once, and then we weren't. My failings
wounded her, and my successes meant nothing to her because
they occurred in a world she couldn't or wouldn't understand.
She screamed at me and then hung up on me the last time we
talked before her death. Her account in my ledger will always
remain troublingly open.

This is my father as I never knew him, in jive-hepcat mode, sporting a Lester Young porkpie, Eisenhower jacket, skinny tie, sweater tucked in, high-water pants and white socks, and looking like he's about to launch into a dance routine. (He always did identify with Gene Kelly.) The picture was taken not long after the Liberation, in 1944 or '45, when he had successfully joined the Belgian army (in 1940 he had chased it all the way to Dunkirk to sign up, only to watch from the beach as the whole force sailed off to England). You can see that the truck belonged to his outfit, the 35th Fusiliers. They wore American uniforms and employed American ordnance, because none of their own had survived the war.

I found the picture just recently, among an overlooked trove of photos he kept in a tobacco tin painted with an alpine

scene by one of the German POWs he was assigned to guard in a camp outside Mons. Most of the pictures date back to those postwar days, which might have been the happiest period of his life. In them he is always the shortest (he was 5' 2") and the most antic, always front and center, grinning wildly. I was born ten years later, and while I always knew my father as a wit, I never knew him as a kat; I saw him hold forth but never saw him cut up. He was beaten pretty badly by life—specifically by factory labor, financial insecurity, emigration and consequent alienation. In the last forty years of his life (he died in 2001), he essentially had no friends.

The gaps between generations in my family are wide. At least two and as many as six of my great-great-grandparents (that's just two greats) were born in the eighteenth century. My grandfather was born in 1879, my father in 1921. I was born in 1954 and my son in 1999. My father in many ways remains a mystery to me. I intuited all kinds of stories in his past that he didn't want to tell me, presumably out of deference to my pious mother. I spent half my life hoping for some climactic old-age or possibly deathbed truth-telling, but instead he fell to Parkinson's and dementia and didn't speak at all in his last two or three years. At least I have photographs like this one, forensic evidence establishing the fact that my father had a youth. From me, in turn, my son will inherit mostly a pile of words.

2008

I Remember the Fabled Rat Man

Homage to Joe Brainard

I remember seeing Dovzhenko's *Earth* at the old Anthology Film Archives in the Public Theater, with high wooden partitions between the seats and absolute silence reigning—apart from coughs, belches, and someone eating (I think) pistachios.

I remember seeing *Hatari* every day during a crossing of the Atlantic aboard the S.S. France when I was eight.

I remember going to a rare screening of Abel Gance's *J'Accuse* at Columbia University when I had taken some kind of downs and slept through almost the entire picture, and my anger at myself when I woke up during the final scene with the spirits of the dead soldiers.

I remember how, when I was a student at Columbia, they'd screen Andy Warhol's *Blow Job* every year, and every year dozens of angry frat boys would noisily exit partway through.

I remember my last acid trip, sometime in the '80s, when I went to a short-lived East Side art house (the D. W. Griffith, I think) and saw *Point Blank* for maybe the third time, and it was the perfect movie for the circumstances.

I remember seeing *Putney Swope* at the Pagode in Paris and feeling very superior because the Parisians didn't get most of the jokes.

I remember seeing that Ray Charles biopic at an outdoor stone arena in Croatia that might have been built by the Romans.

I remember seeing *The Man Who Fell to Earth* on opening day, and my seat was the farthest left in the front row, so that the whole picture was subject to anamorphic distortion.

I remember cutting high school and lining up to see *Catch-22* on opening day, and what a letdown it was.

I remember standing in a long queue for a Marx Brothers festival at one of the theaters on Place de l'Odéon in Paris, and seeing the fabled Rat Man for the first time. He would lock eyes with a victim, then slide a large, realistic rubber rat from his sleeve while making a vomiting noise.

I remember seeing *Last Tango in Paris* at a drive-in theater in New Jersey; when the picture began, and turned out to be subtitled, at least half the cars pulled out.

I remember seeing Samson pull down the columns of the temple on a drive-in screen across the parking lot from the Channel Lumber store where my parents were shopping.

I remember when you could come into theaters in the middle of the picture and then stay on to see the beginning.

I remember that when I saw Peckinpah's *Cross of Iron* at the old Olympia on the Upper West Side, I heard a teenager in the men's room use the term "chill out," which I had never encountered before.

I remember a double bill of *Eyeball* and *Suspiria* on 42nd Street—the first was a huge hit with the audience, who talked

back to the screen throughout, but the second resulted in a mass exit.

I remember numerous times at many theaters when half the crowd would be yelling "Focus!" at the projection booth for long minutes before something was done.

I remember when I discovered that the Thalia, which booked a daily double bill of classics, also ran an unannounced third feature around noon, and the deleterious effect this had on my classroom attendance.

I remember leaving a showing of *The Atomic Café* at the Waverly and seeing Andy Kaufman in the exiting crowd, wearing a neck brace.

I remember coming out of a screening of Imamura's *Black Rain* and walking many blocks to the subway bawling my eyes out.

I remember once sneaking into the Strand Theater in Summit, New Jersey, through the back door, propped open by some other kids.

I remember getting in trouble with my mother because of two pictures I'd seen at the Strand that she thought were indecent: *Fun in Acapulco* and *The Disorderly Orderly*.

I remember pro- and anti-CCP students brawling outside a screening of *The East Is Red* at Columbia.

I remember seeing William Klein's movie about Eldridge Cleaver in Algiers at a prestige house on the East Side, near Bloomingdale's; those were some different times.

I remember seeing *Empire of the Ants* at the New Edison on 103rd Street, and the audience cheering on the ants.

I remember always intending to go to the Chinese theater under the Manhattan Bridge, but I tarried too long.

2016

I Was Somebody Else

Its authorship mistakenly attributed to its copy editor and issued in a single edition of 500 by a suburban publisher of quickie romances, the posthumous memoirs of the celebrated French poet Jean-Arthur Rimbaud (1854-1933) must count among the more obscure byways of literary marginalia.

Having faked his death in 1891 to escape mounting debts and increasingly credible threats of violence from rival traders in the Gulf of Aden, Rimbaud lay low for more than four decades. While his former friends and colleagues were elevating

his poetic works and mysterious youth into a cult, he kept his distance. He stayed busy, variously occupied as a beachcomber on the Côte d'Azur, a croupier at Monte Carlo, a phony "fakir" in a traveling carnival, a roving photographer with donkey on the Belgian seacoast, a promoter of spurious miracle sites in the Borinage, and finally for twenty years as "Bauraind," an intermittently successful music-hall ventriloquist.

He lavishes many pages on his dummy, Hugo, with whom he seems to have enjoyed the most intimate and rewarding relationship of his life. Together they traveled incessantly, from the North Sea to the Mediterranean and from the Rhineland to the Bay of Biscay, lodging in rooming houses and train-station hotels, sharing—he would have us believe—meager breakfasts and suppers of coffee and rolls, surviving the war and the thieving practices of theater managers. It did not always go well for them.

It seems that Hugo was given to making Delphic pronouncements of his own accord, without consulting his nominal master, and that these mystified and sometimes enraged audiences. While Bauraind would be trying to contrive some lighthearted, crowd-pleasing patter about the weather or local politics, Hugo would seize the occasion to rant, going on for marathon bravura stretches about the abolition of property or the erotic powers of the big toe or the unknown crevices of the human mind or the revelatory capacities of ergot poisoning. He might deliver a speech made up entirely of brand names or discontinuous movie dialogue or even lapse into pure glossolalia, making noises that sounded like machine parts or frog choruses or unknown languages. When this happened, Bauraind would drink a glass of water or whistle a tune, hoping to redirect the crowd's attention to his own apparent virtuosity.

Theater managers were less than charmed by these outbursts. Frequently the pair were booted out into the street, denied payments owed, forced to pilfer from church poorboxes into order to survive. Occasionally it did happen that audiences—usually students or striking laborers—would appreciate a

performance, applaud vigorously, and call the two back for an encore. Hugo would then, with unfailing perversity, play the fool, and Bauraind would be forced to improvise for the both of them. He writes that on such occasions "my mind would be bleached of inspiration, and all I could summon up was some idiot wordplay about the length of women's skirts." Then the crowd would hiss, the manager would threaten to cancel their remaining dates, and ventriloquist and dummy would bicker until dawn.

But they soon made up again. Theirs was, if not exactly a marriage of true minds, at least a union based on profound mutual dependency. Here and there the author waxes candid about the loss of his muse, his years of despondent wandering, his inability to confront the much-touted brilliance of his younger days. When he spotted Hugo in a pawnshop in Lille in 1911, though, something happened. He is unable to account for the "electric charge" he received when he picked up the wood-and-cloth dummy. He held in his hands the genius of poetry itself. The dummy was somehow him, and at the same time something profoundly alien. Those outbursts were murder, commercially, but they were balm to his ruined soul. He wishes he could have transcribed those rants, but memory dissipated when they left the stage, and Hugo never repeated himself.

The end, when it came, was brutal. They were traveling, as was their wont, illicitly, clinging to the rear platform of a train, hoping to make it to the south for carnival season, when the engine stopped to take on water. Just then a giant eagle swooped down, seized "that beloved face" in its talons, and flew away in the direction of the setting sun. At the close of the book the former poet is wandering around an unspecified provincial town, wearing dark glasses to hide his grief, unable to stop his hands from manipulating that absent jaw.

2016

Shill

"POPALONG" HANK WILLIAMS AND THE POPCORN POPPERS
Don Helms Sam Pruitt Jerry Rivers Slim Watts Hank Williams

Just what is it that makes today's culture so different, so appealing? Anticipating Richard Hamilton by four years, Hank Williams first uttered the term "pop art" from the stage of the Grand Old Opry in 1952. Hank could see stretched out before him a future in which art would inextricably entwine with advertising. It was not an unappealing prospect, and Hank embraced it, envisioning museums filled with Brillo boxes and Ken-L-Ration labels and Goodyear Tires winged feet. He had always considered such works on a par with the

output of the top European modernists, and all the more engaging because they had been devised by ordinary Americans without pretense, who got their hands dirty and enjoyed the song of the meadowlark at sunset.

He could imagine taking that song and fitting lyrics to it that would tell folks about Cities Service gasoline and Wheatena breakfast cereal, things he himself loved, and in return the gasoline people and the cereal people would put his name on a pump and his face on a box. It was all about people helping each other out, and it was also about the clean, uncluttered thrust of American imagery. He never quite understood why it was that when he visited a picture gallery, the paintings of streets never showed the Dr. Pepper signs and the Coppertone billboards and the barns were bereft of their Chew Mail Pouch in big letters. He thought it was a lot like pretending that people never had to go to the bathroom. It was like visiting somebody's house who had made a fortune running burlesque theaters and finding it full of plaster copies of Roman statues.

It was on the night of January 1, 1953 that he had his final vision. Racing from Knoxville to Canton, Ohio in the back of the big Cadillac, pumped full of morphine with a side of B12 to keep his eyes open, Hank kept sliding under the surface of this life, seeing things he didn't entirely understand. He seemed to be visiting the future. He saw people of all ages walking around with product names on their clothes. He saw a man with a beer label tattooed on his arm. He thought he understood that people were paying money to companies to help them spread their advertising. He saw movies that turned out to be commercials, and commercials that turned out to be movies. He saw what looked like advertisements but couldn't tell what products were being advertised. He thought he understood that advertising and art had traded places in this future world, that advertising walked by itself and didn't stand for anything in particular. He understood that everything in life was a product, and probably always had

been, and thought that now advertising was no longer about trying to get folks to buy products. It was more like hymns in church, which you sang not in order to believe but to stay on God's good side. He was trying to focus this thought when he died.

2007

Thirteen Most

THE

THIRTEEN

MOST WANTED

POLICE DEPARTMENT
City of New York

One night in the 1980s, a low period for me, as I slumped on my regular stool at Farrell's, in Brooklyn, staring into my fourth or fifth of their enormous beers, the gentleman to my left struck up a conversation. Like nearly everyone in the bar but me, he was a cop, a retired cop to be exact, and unlike most of them he looked like a churchwarden, lean and grave and puckered, definitely on the farther shore of eighty. He had much to say; his proudest accomplishments had gone unrecognized. It seemed he had been the first to put together a numbered list of the most-sought fugitives from justice. He'd gotten the idea sometime in the late '40s, he recalled. He had been listening to Symphony Sid, his favorite radio disk jockey. It was the week

that "Twisted" by Wardell Gray moved into the pole position on the chart. The idea of a Top Ten was itself new.

There were some good cases on tap that week, too. Someone had stolen all the sacramental vessels, worth many thousands, from the sacristy at St. Patrick's; someone else had apparently scaled the sheer face of a skyscraper to murder a diplomat in his heavily guarded 35th-story bedroom; a gang of miscreants in fright masks had walked off with the gate receipts during the seventh inning of a game at the Polo Grounds. My friend deplored these crimes, naturally, but still felt they deserved something more than the usual tabloid-headline form of appreciation. He imagined a Top Ten of crimes—the Most Audacious Felonies. He saw himself announcing the list on the radio, becoming a personality, a sensation. There would be a spin-off comic book with his name and face at upper left, "presenting" the felonies to an eager public. In the meantime he got himself some sheets of oaktag and posted a list in the squad room.

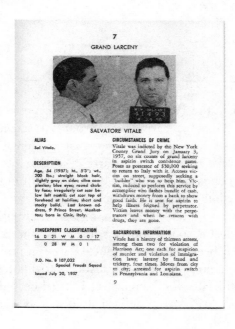

His superiors were not amused. He was informed that as a property clerk his job was to keep track of evidence and exhibits and not go inserting his nose in places where it did not belong, and he was furthermore forcibly reminded why at age forty-five he was still nothing more than a property clerk—my new friend did not enlighten me on that particular score. Not a week later, however, a list appeared on every bulletin board of every precinct house in the city. Nicely typed and roneographed, it was headed "The Ten Most Wanted Men." Immediately my friend knew just which ambitious, sniveling lieutenant it was who had stolen his idea, but there was nothing he could do about it. Adding insult to injury, the FBI caught wind of the list and called the plagiarist down to D. C. to advise on the creation of a nationwide Top Ten. By the end of the month the rat was heading up his own Special Squad.

Right away the list entered popular culture. It was just as my friend imagined it, down to the comic book, although J. Edgar Hoover was the personality charged with "presenting" it. The FBI list—the *Ten Most Wanted Fugitives*—garnered the lion's share of publicity, but the New York City version, which evolved into the *Thirteen Most Wanted*, more than held its own. My friend, who was not short of contacts on the other side of the law, had any number of stories about crooks vying for a position, gunning for the number-one man in order to take his place, becoming depressed and allowing themselves to be arrested when they were bumped down to number fourteen, and so on. The public, for its part, was intoxicated; the number of wanton misidentifications and groundless accusations of bosses and neighbors and rivals in love more than quintupled, and so correspondingly did the number of false arrests. Even more than during the "public enemy" craze of the 1930s, law enforcement had become a spectacle.

At some point in the late 1950s, my friend made the acquaintance of a boy, a "bohunk" from Pittsburgh, who had come to town to become an artist. He didn't say how they met, but they seem to have become rather close, although he

didn't think much of the boy's attempts at art. The boy liked
to draw "fruity" things, like women's shoes, and serenely
ignored my friend's attempts to steer him toward something
more substantial, such as true-crime comics. Still, they had
some good times before the boy started becoming a success,
designing greeting cards and wallpaper and shopping bags, and
began thinking himself "too good" for my friend. As the boy
became ever busier attending fancy cocktail parties on Fifth
Avenue, their acquaintance languished. My friend was sad, but
moved on, and had put the boy well out of his mind by 1962
or so, when like the rest of America he was made aware of a
huckster who was making a fortune painting pictures of soup
cans. He laughed when he read the story in the *Daily News*,
but the laughter caught in his throat when he saw the picture
next to it. It was the boy.

My friend had drifted through a couple of decades as a
property clerk and, despite his early dreams of derring-do, had
come to rather enjoy it. The job was steady, undemanding, and
allowed him plenty of time to do the Jumble. He was a depart-
ment fixture, almost synonymous with his job. That same year,
though, his longtime nemesis, the plagiarist, became chief. And
it could only have been his decision, made out of pure malice,
to kick my friend down to patrol duty—my friend was near-
ing retirement, had been a model employee, had fallen arches.
Anyway, it so happened that my friend was on the street in
uniform on an unseasonably cold autumn evening, guard-
ing a movie premiere, of all stupid things, when he saw the
boy again. The boy now looked like an apprentice hoodlum:
leather jacket, sunglasses, need of haircut. He was walking with
that old movie star—what was her name? The boy spotted my
friend, said nothing, but the two locked eyes for a second. Even
through the sunglasses, my friend could tell.

Cut to Spring 1964. My friend, inches from retirement, had
been patrolling the World's Fair. One day he was called to the
New York State pavilion. There might be trouble, he was told.
As he approached he kept looking up at the piston-shaped

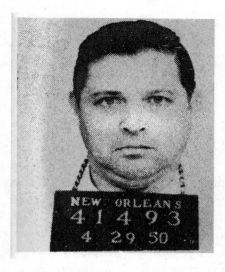

towers, imagining a jumper. Only when he got close did he notice the lower building. It was covered with a row of enormous portraits of men. To his astonishment, he recognized them: the Thirteen Most Wanted. He stared at the faces in disbelief. But the instant he recognized the face of Salvatore Vitale, workers began obliterating it with white paint. One by one the faces disappeared. It was his dream—both realized and short-circuited—all over again. Somehow he found out, eventually: it was the boy! He did that! But was it an act of love, or an attempt to kill him?

2009

Dear Messiah

You were born in Houston to a 14-year-old single mother. You were the surviving child of twins born to an affluent family. Your mother was a former slave. A sensitive and sickly child, "vague and dreamy," you were often taken to be mentally retarded, and were beaten regularly at school by your teachers and at home by your father. You began experiencing fainting spells at age nine and people took your sleepwalking as evidence of secret powers. You underwent what was interchangeably described as "the benediction," "the immensity," "the sacredness," "the vastness," and, most often, "the otherness." Beginning in your youth you were uncomfortable with sexuality, especially your own.

After service in the Red Army, you settled in Minusinsk. You were convicted of practicing pharmacy without a license and fined 200,000 yen. On August 28, 1974, you were arrested in Harlingen, Texas, for stealing credit cards. You took over the identity of your deceased predecessor, and in so doing completely erased your own. You had a son named Imperator. You had four children: Osiris, Isis, Iris, Hypatia. You asserted that your marriage was never physically consummated. You asserted that though you lay "naked with virgins," when the virgins asked you for sex, you refused. You spent your days wandering the streets of Council Bluffs wearing a long white robe and became a local oddity. You exhibited a "666" tattoo on your forearm. Witnesses stated that you had nail marks in your hands. You gained notoriety for the many Rolls-Royces bought for your use, eventually numbering 93. Your status as a rock singer was very localized.

Your speech was often peppered with words of your own

invention, such as "physicalating" and "tangiblated." Robed in white, you stood behind the curtain, and the light brought out in full relief the gilt letters of the Tetragrammaton, which you had placed upon your breast. In the estimated presence of one to five hundred people, you announced the end of the world and ordered the extermination of sixteen enemy families. You claimed that you could slay 10,000 men by hitting your left hand with your right. You wrote a book which you said was dictated to you by angels. You dictated three books under the influence of nitrous oxide administered to you by your private dentist. You inscribed messianic formulas on your hands, and corrected Isaiah 45:1 to include yourself. You wrote your beliefs on a piece of paper and had it read aloud, but due to the clamor among the people, it could not be heard.

The prophet Elijah appeared to you in a dream and led you to a beautiful garden, where you saw the pious of all ages, in the form of birds, flying through the garden and studying the Mishnah. You claimed to have led a convoy of rocketships to Earth from the extinct planet Neophrates. You taught that dissatisfaction and evil among Blacks caused a major explosion to happen on Earth 66 trillion years ago, creating the current moon that orbits the planet. You threatened to drive the Christians into the sea, and you launched a major military offensive with your 1,500 Dervishes, equipped with twenty modern rifles. You declared the founding of the "Heavenly Kingdom of Transcendent Peace" on January 11, 1851.

The total volume of your works is more than seventy times the size of the Qur'an and more than fifteen times the size of the Old and New Testaments of the Bible. You changed granite into sugar candy, changed water into gasoline, produced objects on demand, changed the color of your gown while wearing it, multiplied food, healed acute and chronic diseases, appeared in visions and dreams, made different fruits appear on actual stems on any tree, controlled the weather, physically transformed into various deities, and physically emitted brilliant light.

You will lead the Ten Lost Tribes back to the Holy Land while riding on a lion with a seven-headed dragon in its jaws. Your face will be visible on the moon, the sun, and the Black Stone in Mecca. After your Judgment you will throw the corrupt into the Fire.

The Kingdom of Heaven began to collapse in 1880, when both of your children died of diphtheria. The departure of your disciples weakened, demoralized, and angered you, and it was at this juncture that you composed your most famous poem, "The Tree of Bad Counsel." Followed by your disciples, you rode a donkey to the edge of the bluffs, whereupon you leaped off the edge. In 1706 you were killed by your nephew during a discussion about money matters. You died in Chatsworth, California, on December 10, 1958 in a suicide bombing instigated by two disgruntled former followers. In June 1934 you left Detroit for Chicago and disappeared without a trace. Your remaining disciples tore your bloody shirt from your body and divided it up for relics. Your remains were dumped outside the gates of the town to be eaten by animals. You are said to have descended from the higher planes and manifested a physical body in early 1977 in the Himalayas, then on July 19 of that year to have taken a commercial airplane flight from Pakistan to England.

2012

Summer with a Thousand Julys

I have it on the highest authority that summer will never end. It might get cooler, intermittently, but it will never stop being summer. Which is of course wonderful, because summer is a bubble during which life's ordinary rules are suspended. Summer is when we don't have to get up in the morning, or even the afternoon. Summer is when we insist on ice-cold beer to chill our body cavity, especially the spleen. Summer is when we go see particularly stupid movies because it would be unseasonal to have to think. Summer is when we get into fights with the neighbors over noise or property lines or because we should live next door as well as at our house. Summer is when nobody ever has to make eye contact. Summer is when nothing ever happened before this moment right now. Summer is when we trash the joint because whatever. Summer is when we fire guns into the air and the bullet never comes down.

All the very best countries celebrate their national holidays in the summer. Summer is the season best adapted to modern commerce. When you think "Hollywood" you think "summer." Arson perpetuates summer; it makes it an action and not just a moment. In summer we think of rain as a calamity, and so does the weatherman, who pulls a long face at the announcement of a sunless day. Summer craves fresh bodies. Summer has no consequences. Summer has children in every orphanage. Summer just walks into your house and goes straight to the refrigerator without saying hello. Summer has not spoken to the other seasons in decades. Summer cannot get served because it abjures shirts and shoes. There are open warrants out on summer.

But summer, however phlegmatic, dominates. There is no

arguing or reasoning with summer. If you try to, summer just belches and everybody laughs. Summer doesn't need money because it has yours. Summer lies over the land like syrup on an ant hill. Summer wears your body like a shroud. Summer suddenly lashes out when everything is quiet. It pretends to retreat and then lashes out again. Summer knows your weaknesses, your blind spots, your unacknowledged biases, your unspoken shame. Summer drips down on you in irregular gobs from some spot you can't make out. Summer pretends to love you but then burns you and runs. Your mind goes tilt whenever you try to think about summer for more than a minute. You try to tell people the truth about summer but no one believes you and even you start to think you're to blame.

Summer wasn't always like this. It had a decent upbringing and a reasonable education. It lived in harmony with the other seasons, and they sometimes traded off bits of one another's weather. Just where it went wrong is uncertain, except that it happened in our lifetime. It was all those cars, all those drugs, all that red meat, all that money it sucked up and vaporized. Summer only remembers luxury and rage. Summer wants to be universal emperor and lord master of the skies and everything under them. It has no real idea of what any of this entails but that doesn't matter. It will not stop until it gets every inch of its way, and since that is impossible it will never stop. Summer will destroy all our coastlines and our fields and our cities and when called to account for itself summer will just belch. Summer is mindless. Summer is nothing but fun. Everybody loves summer.

2016

III

The Source

I guess I'll never know what possessed Barbara Epstein to ask me to be her assistant in 1981, after I had fully demonstrated my indolence over a year of employment in the mailroom at the *New York Review of Books*. I couldn't type, for one thing, and my phone manner was, at best, wooden; I had never before made a restaurant reservation, let alone chased down reluctant eminences and cajoled them into supplying details to fill out their contributors' notes. Nevertheless, she took me on, and proceeded to give me an education that put the whole of my previous schooling in the shade. I had long enjoyed playing with language, but she taught me how to write. I had always nursed heated opinions, but she taught me how to think critically. I was ignorant of the world of grownups, and resentfully surly about it, but she clued me in.

Her core curriculum was largely unknown to me then. She had me read Edmund Wilson, Auden's essays, Macauley and other canonical stylists, the Puritan divines and the rest of Perry Miller's reading list, even—I admit to kicking and screaming—Henry James. She ensured my deep familiarity with the *Review*'s illustrators emeritus: Grandville, Daumier, Doré, Callot, Bewick, Wilhelm Busch. She taught me that simplicity is always the best bet; that needless complication is usually a sign that something is being concealed; that thoughts and sentences always benefit from unpacking; that "forthcoming" means "available when needed" and by extension "frank"—not "soon to be published." Barbara made many contributions to my vocabulary, both by addition and by subtraction. One day, opening some pompous invitation or other, she exclaimed, "Oh, forgetski!" Where did she pick that one up? I've never heard

it said by anyone else, but into the larder went "forgetski." Later, when I was writing for her, I used the word "ilk" in a piece. She struck it out. When I asked her why, she said, "It always makes me think of milking an elk." We both recalled W.C. Fields in *The Fatal Glass of Beer*. Out went "ilk."

I've had many other editors over the years, some of them very good, but Barbara was of a whole other order. Her method ranged from the discreet and microscopic to the radical and wholesale, as needed. She had a gift, something like second sight, for knowing exactly what a piece was missing, and those lines and paragraphs she willed into being turned out more often than not to be the hinges on which the argument turned. The most durable thing I wrote under her guidance achieved that distinction as a result of her simply ordering me to cut the manuscript by two thirds—she could perceive the essence through the flapdoodle. She possessed one of the greatest minds I've ever encountered, and she gave all of it to other people's work. On top of that she was funny, mischievous, infectiously enthusiastic, occasionally prodigal, sometimes incorrigibly teenaged, the best sort of company. The world is a much lonelier place without her.

2006

The Freelancer

The Parker novels by Richard Stark are a singularly long-lasting literary franchise, established in 1962 and pursued until 2008, albeit with a 23-year hiatus in the middle. In other ways, too, they are a unique proposition. When I read my first Parker novel—picked up at random, and in French translation, no less—I was a teenager, and hadn't read much crime fiction beyond Sherlock Holmes and Agatha Christie. I was stunned by the book, by its power and economy and the fact that it blithely dispensed with moral judgment, and of course I wanted more. Not only did I want more Parker and more Stark, I also imagined that I had stumbled upon a particularly brilliant specimen of a thriving genre. But I was wrong. There is no such genre.

To be sure, there are plenty of tight, harsh crime novels, beginning with Dashiell Hammett's *Red Harvest*, and there is a substantial body of books written from the point of view of the criminal, ranging from the tortured cries of Jim Thompson and David Goodis to the mordantly analytical *romans durs* by Georges Simenon. There are quite a few caper novels, including the comic misadventures Parker's creator wrote under his real name, Donald Westlake, and the works of a whole troop of French writers not well known in this country: José Giovanni, Albert Simonin, Frédéric Dard. The lean, efficient Giovanni in particular has points in common with Stark (anglophones can best approach him through movie adaptations: Jean-Pierre Melville's *Le deuxième souffle*, Claude Sautet's *Classe tous risques*), but with the key difference that he is an unabashed romantic.

Stark is not a romantic, or at least not within the first six feet

down from the surface. Westlake said that he meant the books to be about "a workman at work," which they are, and that is why they have so few useful parallels, why they are virtually a genre unto themselves. Process and mechanics and trouble-shooting dominate the books, determine their plots, underlie their aesthetics and their moral structure. A great many of the editions down through the years have prominently featured a blurb from Anthony Boucher: "Nobody tops Stark in his objective portrayal of a world of total amorality." That is true as far as it goes—it is never suggested in the novels that robbing payrolls or shooting people who present liabilities are anything more than business practices—but Boucher overlooked the fact that Parker maintains his own very lively set of moral prerogatives. Parker abhors waste, sloth, frivolity, inconstancy, double-dealing, and reckless endangerment as much as any Puritan. He hates dishonesty with a passion, although you and he may differ on its terms. He is a craftsman who takes pride in his work.

Parker is in fact a bit like the ideal author of a crime-fiction series: solid, dependable, attentive to every nuance and detail. He is annoyed by small talk and gets straight to the point in every instance, using no more than the necessary number of words to achieve his aim. He eschews short cuts, although he can make difficult processes look easy, and he is free of any trace of sentiment, although he knows that while planning and method and structure are crucial, character is even more impor-tant. As brilliant as he is as a strategist, he is nothing short of phenomenal at instantly grasping character. This means that he sometimes sounds more like a fictional detective than a crook, but mostly he sounds like a writer. In order to decide which path the double-crosser he is pursuing is most likely to have taken, or which member of the string is most likely to double-cross, or the odds on a reasonable-sounding job that has just been proposed to him by someone with shaky credentials, he has to get all the way into the skin of the party in question. He is an exceptionally intelligent freelancer in a risky profession

who takes on difficult jobs hoping for a payoff large enough to hold off the next job for as long as possible. He even has an agent (Joe Sheer, succeeded by Handy McKay). Then again he is seen—by other characters as well as readers—as lacking in emotion, let alone sympathy, a thug whose sole motivation is self-interest.

And no wonder: Parker is a big, tough man with cold eyes. "His hands looked like they'd been molded of brown clay by a sculptor who thought big and liked veins"; the sentence appears like a Homeric epithet somewhere in an early chapter of most of the books. He might just possibly pass for a businessman, provided the business is something like used cars or jukeboxes. He doesn't drink much, doesn't gamble, doesn't read, likes to sit in the dark, thinking, or else in front of the television, not watching but employing it as an aid to concentration. Crude and antisocial at the start of the series, he actually evolves considerably over its course. Claire, whom he meets in *The Rare Coin Score*, seems to have a lot to do with this—by *Deadly Edge* they actually have a house together. And Alan Grofield, first encountered in *The Score* and recurring in *The Handle*, among other titles, twice in the series becomes the recipient of what can only be called acts of kindness from Parker, however much Stark equivocates on this point, insisting that they merely reflect professional ethics or some such.

Parker is a sort of super-criminal—not at all like those European master criminals, such as Fantômas and Dr. Mabuse, but a very American freebooter, able to outmaneuver the Mob, the CIA, and whatever other forces come at him. For all that he lives on the other side of the law, he bears a certain resemblance to popular avengers of the 1960s and '70s, Dirty Harry or Charles Bronson's character in *Death Wish*. He is a bit of a fanatic, and even though we are repeatedly told how sybaritic his off-duty resort-hotel lifestyle is, it remains hard to picture, since he is such an ascetic in the course of the stories. He is so utterly consumed by the requirements of his profession that everything extraneous to it is suppressed when he's on, and we

are not privy to his time off, except for narrow vignettes in which he is glimpsed having sex or, once, swimming. But then, writers are writing even when they're not writing, aren't they?

After *The Hunter*, all the remaining titles concern jobs gone wrong, which seems to account for most of Parker's jobs, barring the occasional fleeting allusion to smoother operations in the past. *The Seventh* is, naturally, the seventh book in the series, as well as a reference to the split from the take in a stadium job. The actual operation is successful; the problem is what occurs afterward. It represents the very rare incursion, for the Parker series, of a thriller staple: the crazed gunman. Along with *The Rare Coin Score*, it is one of Stark's always very pointed explorations of group dynamics. *The Handle*, with its private gambling island, ex-Nazi villain, and international intrigue, is (like *The Mourner* and *The Black Ice Score*) a nod to the espionage craze of the 1960s, when authors of thrillers could not afford to ignore James Bond. If *The Seventh* is primarily aftermath, *The Handle* is largely preamble. In *The Rare Coin Score* (the first of four such titles, succeeded by *Green Eagle*, *Black Ice*, and *Sour Lemon*) the culprit is an amateur, a coin dealer whose arrested development is so convincingly depicted the reader can virtually hear his voice squeak. Sharp characterizations abound in this one — its plot turns entirely on character flaws of various sizes.

The Parker books are all engines, machines that start up with varying levels of difficulty, then run through a process until they are done, although subject to different sorts of interference. The heists depicted are only part of this process — sometimes they are even peripheral to it. Parker is the mechanic who runs the machine and attempts to keep it oiled and on course. The interference is always caused by personalities — by the greed, incompetence, treachery, duplicity, or insanity of various individuals concerned, although this plays out in a variety of ways, depending on whether it affects the job at beginning, middle, or end, and whether it occurs as a single dramatic action, a domino sequence of contingencies,

or a gradually fraying rope. The beauty of the machine is that not only is suspense as effective as it usually is, but so is its opposite: the satisfaction of inevitability. Some Parker novels are fantastically intricate clockwork mechanisms (*The Hunter*, *The Outfit*, the seemingly unstoppable *Slayground*, the epic *Butcher's Moon*), while others hurtle along as successions of breakdowns (the aptly acidic *The Sour Lemon Score*, the almost sadistically frustrating *Plunder Squad*). Like all machines but unlike lesser thrillers, the novels have numerous moving parts, and the more the better—more people, more subplots, more businesslike detail, more sidelong glimpses of marginal lives. Stark's momentum is such that the more matter he throws into the hopper the faster the gears turn. The books are machines that all but read themselves. You can consume the entire series and not once have to invest in a bookmark.

2009

The Conspiracy

Jacques Rivette, who died January 29, 2016, at the age of 87, was always the least known, least commercially successful, and most enigmatic of the French New Wave directors. The core group that got their start as critics at *Cahiers du Cinéma* in the early 1950s—Jean-Luc Godard, François Truffaut, Claude Chabrol, Éric Rohmer, and Rivette—who were collectively responsible for proposing the auteur theory and notable for their nuanced appreciation of American B movies, were quite distinct from one another as filmmakers. Godard was (and remains) the experimentalist with a didactic streak; Truffaut the old-school craftsman, somewhat given to sentimentality; Chabrol the serial purveyor of genre pieces, initially spiky if later sometimes lax; and Rohmer the austere Christian moralist with a vivid sense of human frailty. Rivette was the first of the group to make a film (the silent short *Aux quatre coins*, 1948), and among the first to start work on a feature (*Paris Belongs to Us*, which began production in 1958, although a host of factors delayed its release until late in 1961), but he was the last to find his own voice. *Paris Belongs to Us* and his second feature, *La Religieuse*, were both, in different ways, somewhat old-fashioned for the New Wave moment—they were both fully scripted and storyboarded in advance, for one thing.

It wasn't until *L'Amour fou*, released in 1969, that he began his trademark practice of making open-ended films, developed in collaboration with their actors, relying to greater or lesser degrees on improvisation, and legendarily long: *L'Amour fou* at 252 minutes, *Céline and Julie Go Boating* (1974) at 193, and the monster, *Out 1: Noli me tangere* (1971), which originally

ran 760 minutes, was radically re-edited and released as *Out 1: Spectre* (1972; 253 minutes), and is again available in something like its original form at 729 minutes. Rivette initially aimed *Out 1* at television, dividing it into eight episodes, but that did not pan out. After its single screening, on the night of September 9-10, 1971, in Le Havre, it was long doubted whether it would ever be shown again, especially since it only existed as a work print, in a questionable state of preservation. But in the early 1990s a screening print was struck and shown at a few European film festivals, and it eventually made its way to the United States and now onto DVD, which medium has made it easier to countenance the viewing of a twelve-hour motion picture.

There are various theories about the origins of the title: that it refers to outtakes, that it alludes to "out" jazz (and Jonathan Rosenbaum, in an essay that appears in the DVD booklet, makes an intriguing case for certain structural parallels between the movie and Ornette Coleman's 1961 *Free Jazz*), that it represents the opposite of that quintessential '60s adjective, "in,"* that it alludes more generally to marginality, or for that matter the outdoors. Rivette began the project with no story, merely some touchstones, notably theater and conspiracy. *Paris Belongs to Us* had featured both elements: a character attempts to stage a bare-bones production of Shakespeare's *Pericles*; the conspiracy, while perhaps imaginary, does result in several actual deaths. *L'Amour fou* was even more involved with theater, revolving around a production of Racine's *Andromaque*; the main story was shot in 35 mm while the rehearsals were documented on the fly in 16. For *Out 1*, Rivette invited Michèle Moretti and Michael Lonsdale to direct their respective troupes in two plays by Aeschylus, *Seven Against Thebes* for Moretti and *Prometheus*

* Sometime in the late 60s, Rivette made a brief stab at a project tentatively titled *In*, which would have followed a group of disaffected youths in a provincial town. It was the first manifestation of his desire to make a film with a collective protagonist, which resulted in *Out 1*.

for Lonsdale. In addition, Rivette summoned three other actors he knew he wanted to work with: Bulle Ogier to anchor the conspiracy element—something like a third troupe, in effect—and Juliet Berto and Jean-Pierre Léaud to operate as floating characters, independent of the groups. Then he and his co-director, Suzanne Schiffman, established a structure which took the form of a shooting schedule and was the closest thing the movie had to a script.

Schiffman, who served as co-writer or assistant director on four other films by Rivette (and performed similar tasks on a dozen pictures by Truffaut), came up with the outline of the conspiracy, basing it on the one in Balzac's *History of the Thirteen*:

> In Paris under the Empire, thirteen men came together who were equally possessed by the same idea, all of them endowed with sufficient energy to be faithful to the same principles, sufficiently honest with one another not to betray the cause even when their individual interests conflicted, so deeply prudent as to keep hidden the sacred bonds that linked them, strong enough to position themselves above all laws, tough enough to undertake all that was required, and so lucky that they almost always succeeded in their schemes.

Like *L'Amour fou*, *Out 1* is poised between fiction and documentary: the play rehearsals are authentic, the actors' lives invented. Both Lili (Moretti) and Thomas (Lonsdale) are members of the Thirteen, as are Pauline/Émilie (Ogier's character, the owner of a hippie boutique, has two names, depending on social context); Étienne, a businessman (Jacques Doniol-Valcroze); Lucie, a lawyer (Françoise Fabian); Sarah, a novelist who joins Thomas's troupe (Bernadette Lafont); and Warok, a philosopher (Jean Bouise). In addition to these seven, frequent mention is made of Pierre, an architect, and

Igor, a journalist and Pauline/Émilie's husband, who never appear onscreen.*

The viewer first learns of the conspiracy in the second episode (which is to say, more than two hours in), via Colin, Léaud's character, a deaf-mute who makes his living selling phony fortunes to café patrons while blowing tunelessly into a harmonica. One day, as he is leaving a café, he is handed a slip of paper by Marie (Hermine Karagheuz), a member of Lili's troupe—an action that is never explained. Back in his room he discovers it contains ten lines of doggerel, a pastiche of Lewis Carroll: "Two paths open up before you / Thirteen to better hunt the Snark . . . / A hand will guide your own / Thirteen others formed a strange crew." Colin copies the verse onto a blackboard and obsessively circles and underlines until the repetition of "thirteen" leads him to Balzac. He has meanwhile received two other messages, both of which appear to be citations from *The History of the Thirteen*. He consults a Balzac expert (Éric Rohmer), who notes that the Thirteen barely figure in the plot of Balzac's trilogy. Later, more blackboard tinkering leads Colin to discover an address coded in the verse: 2 Place Sainte-Opportune, the location of Pauline's shop.

Meanwhile, the two companies' rehearsals have been documented at length: Lili's ritualistic, physically strenuous adaptation of *Seven Against Thebes* seems influenced by Jerzy Grotowski and Peter Brook, while Thomas's emotionally grueling, nearly pre-verbal *Prometheus* owes a debt to the Living Theater and perhaps Artaud's Theater of Cruelty.†

All the while, too, we've been following Frédérique (Berto),

* There were vague plans for *Out 2*, in which Pierre was to have been played by Alain Cuny and Igor by Sami Frey. It was also to include a gang of "amazons" roaming around Paris, led by Marie-France Pisier. That idea, perhaps derived from Louis Feuillade's *Les Vampires*, may have formed the germ of *Céline and Julie Go Boating*.

† At least these are Rosenbaum's identifications. John Ashbery's 1974 review of *Out 1: Spectre* more or less reverses them. I'm not in a position to know.

who lives alone in a small aerie-like room, swindles men in cafés, and commiserates with her sad gay friend Honeymoon (played by Michel Berto, her real-life husband, who was in fact gay). She ambles into Étienne's ground-floor apartment, sensing him for a mark, but instead of trying to con him she instead steals a packet of letters full of tantalizing allusions to the Thirteen. Without understanding their meaning she decides they can be used to blackmail one of the senders, Lucie. Her gambit fails and Lucie steals the letters back, but their exchange, in addition to Colin's obsessive and increasingly pointed queries (he has turned out to be neither deaf nor mute), throw the Thirteen into confusion. It seems that as a group they have been dormant for some time.

L'Amour fou may have relied on the actors to supply their own dialogues, but it did base its structure on a synopsis, written by Marilù Parolini, Rivette's frequent collaborator and first wife. *Out 1*, by contrast, began with only a grid, which dictated the intersections of the characters but left everything else to the vicissitudes of daily improvisation. Rivette had been impressed by Jean Rouch's *Petit à petit* (1970), particularly a twelve-hour version that no longer exists. Rouch, who began making ethnographic films in Niger in the 1940s, became friends with some of his subjects, who were herdsmen by trade, and cast them in a couple of fiction features. *Petit à petit* begins with the premise that they plan to build a skyscraper in their village and must travel to Europe to learn how they are made. Rouch allowed his actors complete freedom with the story, and it ranges far and wide—in one memorable sequence, two characters board the Montmartre funicular and disembark in the Alps. What exactly Rivette saw in the twelve-hour version is inaccessible, but the extant four-hour cut is often exhilarating, giving the sense that the picture could go in any direction at any given moment. A very long movie guarantees a sustained intimacy with its characters, as well as an additional fund of documentary information; an improvisatory component, always to some degree grounded

in the actuality of the filmed moment, further destabilizes the balance between fact and fiction.*

There is no question that *Out 1* was intended to be a chronicle of the time and place of its creation, which are cited in its opening titles. This impetus can already be seen in *Paris Belongs to Us*, where the climate of political distress and confusion that gives rise to conspiratorial thinking is incidentally illustrated by such unscripted details as an American overheard in a bar holding forth on Richard Nixon's presidential chances. *Out 1* is about the ambient state of mind in Paris after May '68, even though that time and its events are never mentioned. For one thing it presents, as Berto put it, "something fascinating and disquieting about actors, about the essence of actors in that era, that is to say after '68—that race of actors."† For another, it is concerned with utopia: as a chimera, as a faint hope, and as a working method. By the spring of 1970, many of the people and groups involved in the events of two years earlier had dissolved into palaver, while others had gone hard-line—Rivette unsurprisingly left that option to his colleague Godard, then making *Pravda* and *See You at Mao*—and still others had given up altogether.

While what the Thirteen are up to is never made clear (Frédérique guesses they plan to "blow up the world"), they are clearly intended to have emerged from the hopeful turmoil of '68, although by now some can barely remember their previous fervor and commitment. It seems that the hints received by Colin were planted by the unseen Pierre, who wants to shake his friends out of their torpor. Étienne has gone back to his money, Lucie to the law, and Warok to his paradoxes. Sarah, after publishing a novel about her relationship with

*The character played by Michel Delahaye in *Out 1*, an ethnologist, is an explicit homage to Rouch's movie. In *Petit à petit* Delahaye is ethnographically surveyed—his skull measured with calipers—by the African visitors. He wears the same clothes in both pictures.

† Isabelle Jordan, "Entretiens avec Céline et Julie," *Positif* #162, October 1974, p. 22.

Pierre, has retreated into writer's block in a house on the Normandy coast that seems to be collectively owned by the Thirteen. Pauline / Émilie wants it both ways, as the owner of a counterculture hangout who is founding an underground newspaper, yet lives a quite different life in a vast apartment with her children and a servant. Lili and Thomas have to a degree transferred the participatory democracy of '68 into their work, but glimpse the precipice of psychodrama and mysticism. The agents of their potential awakening are Colin and Frédérique, two marginals who barely scrape by on penny-ante con games and have fleeting or nonexistent links to society. The movie certainly doesn't hold out false hopes. As it is, the story slopes off ambiguously, although it seems that the original cut ended with four of the principals going to pieces—the half-hour missing in the current version apparently consists in large part of an extended sequence in which Colin has a violent, head-banging, furniture-smashing crack-up, after which he reverts to his harmonica-blowing wordless beggary.

In a 1977 interview, Lafont said that Rivette was "a kind of Mao and his films are a Cultural Revolution."* Despite the unfortunate overtones her intended praise has since acquired, she meant that Rivette, more than any other director of his time, had liberated actors from their usual constraints—an original proponent of the auteur theory had become a kind of anti-auteur. Certainly the filming of *Out 1*, in which once the general drift of a scene had been established it was immediately shot, with no script or rehearsal, was unlike anything else going on then; Rivette trusted his players and challenged them. The film employed a great range of actors: movie stars, Nouvelle Vague veterans, players from both classical and experimental theater, and a few people who had barely acted at all. They each had their particular talents and limitations, and

* John Hughes, *Bernadette Lafont: An Interview in Central Park*, The Thousand Eyes, 1977, p. 43.

the structure was calibrated to play to their strengths. In an interview, Schiffman noted that Léaud, who had begun acting at age 13, "was the least free of the actors, or at least the most sheltered."* He was incapable of improvising, so he was given the deaf-mute act and the harmonica as props; the literary McGuffins were assigned to him for the same reason.

The main thing that Lafont intended by her comparison of Rivette with the late Chinese dictator, though, was his identification with women, radical for the time. In virtually all his films with a principal protagonist, that character is a woman; in *Out 1*, with its large cast, the gender parity is total. *Céline and Julie*, which was written by its four female principals with Rivette and his dramaturg, Eduardo de Gregorio, stars Berto and Dominique Labourier as a match-of-opposites comedy team in the tradition of Laurel and Hardy, Keaton and Arbuckle, Martin and Lewis. His uncompleted *Filles du feu* tetralogy is very much about gender-role reversal, in particular *Noroît* (1976), inspired by Jacobean revenge dramas, which pits Lafont against Geraldine Chaplin as sword-wielding pirates. (Lafont: "Dagger in hand, I scale the heights of raw power . . . This kind of sexual metamorphosis, this strange androgyny, had never appeared in the French cinema before Rivette . . . It felt like levitation."†) His most materially ambitious film, the two-part *Jeanne la Pucelle* (1992-94), sets about reclaiming Joan of Arc from appropriation by the French Catholic and military right wing—it makes her, in the person of Sandrine Bonnaire, a human being: confused, vulnerable, beset by hallucinations, but also resolute and for a while implacable.

Despite the direct-cinema transparency of *Out 1*—cinematographer Pierre-William Glenn shadowing every spontaneous turn with his hand-held 16-mm camera, pausing only to

* Hélène Frappat, *Jacques Rivette: secret compris*. Les Cahiers du Cinéma, 2001, p. 143.

† Hughes, ibid.

change magazines every eleven minutes—it was no laissez-faire free-for-all. Rivette subtly and silently manipulated the action. Crucial information might be withheld from a single actor in a scene, so that they would be hit with the force of a revelation when it came from the others. Ogier's real-life panic in one scene, when she has no idea what to say or do next, becomes her character's panic at not knowing whether her husband is alive or dead. In many interviews, Rivette emphasized the dialectical nature of the production, a synthesis between the tradition of directorial control, as represented by Eisenstein, Lang, and Hitchcock, and that of nurtured liberty: Renoir, Hawks, and Rossellini.

After the screening in Le Havre, Rivette told an interviewer: "I hope that the film functions like a bad dream, overloaded with catharses and slips, one of those dreams that appear even more 'interminable' when you are more or less aware during its course that it is a dream, and no sooner do you think you are emerging from it than you fall back in."* This might be even more true of *Out 1: Spectre*, the 253-minute cut he produced a year later. Although built from the same thirty hours of footage and run in approximately the same order, the films are radically different from one another. In Rosenbaum's words, *Noli me tangere* is "a documentary that is progressively overtaken by fiction," while "*Spectre* might be seen as a fictional narrative that is progressively overtaken by documentary." The serial, for all of its longueurs, is one of Rivette's most accessible pictures, while *Spectre*, which according to its opening titles takes place in "Paris and its double," may be his most hermetic.

The episodes of the serial begin with a series of stills, over a percussion soundtrack, that recap the previous installment. In *Spectre* these stills, accompanied by white noise, are dropped without explanation into the middle of scenes—often

* Yvonne Baby, "Comme un mauvais rêve . . ." *Le Monde*, October 14, 1971, p. 13.

interrupting a sentence—alluding to things that have already taken place, or that will occur later, even to some that only figure in the long version. These collage-like intrusions, in combination with a purposely ragged-edged cutting style (also true of the serial, although the spaces between edits are much longer) quickly establish an atmosphere of conspiracy, seeming to connect all the threads, as if the viewer were shuttling among a bank of screens on a central console. The "*complot sans maître*" (in the words of Michel Delahaye) overtakes and devours the longer film's other narrative lines. The viewer is given even less information about it, but it colors matters that are more flatfootedly explicable in the serial. In *Noli me tangere*, the theft of an actor's lottery winnings is followed by extended sequences in which he and the others in his troupe try to locate the thief; in *Spectre* the theft barely occurs and the search for its perpetrator is reduced to a number of mysterious stills, bereft of context, that can be interpreted in any number of paranoid ways. And then there are those shots of Place d'Italie near the end—cars, pedestrians, empty space—that are ostensibly void of significance but that owing to their very emptiness seem to function as the scene of an unidentified crime.

Spectre was a cult film for decades. It was the film we saw again and again on those rare occasions when it came to town, its abiding mystery forever drawing us back in, and *Noli me tangere* was perhaps the solution to the mystery, although no one really expected it to one day materialize. Now that both films are accessible, it seems that *Spectre*'s mystery remains intact, for all that the serial resolves a few loose ends. It will endure, not simply because of its relatively more convenient length, but because it has a hook: it demands active intellectual and emotional participation from the viewer. This is not to disparage *Noli me tangere*, which is a moviegoing experience of a wholly different order—it encourages a kind of semiconscious immersion, not so much a viewing as half a day of existence that includes the film among such extraneous

matters as meals, drinks, conversation, and daydreaming. The characters are doing as much on their side of the screen. It is an emissary from the distant planet of the 1970s, when technology was primitive and there was a great deal more time, when process reigned supreme in the arts—when Robert Wilson could mount twelve-hour spectacles and performance artists could stage actions that went on for days or weeks.

For a variety of reasons, mostly having to do with money and logistics and a changing film culture, *Out 1* has had limited direct influence on subsequent movies. Perhaps its most obvious heir is the Portuguese director Pedro Costa's *In Vanda's Room* (2000), a year-long portrait of a woman enacting her own life in a Lisbon slum, which is unscripted and improvised but invisibly shaped. Documentary and fiction inhabit the same skin, with barely an inch of air separating them.

Both versions of *Out 1* are indelible records of their actors, some of them better known from other movies but few seen in circumstances that demanded more of their inner resources. They are more than characters in *Out 1*, much more truly themselves: the questioning, knowing stare and Mona Lisa smile of Bernadette Lafont; the precise play of hands and posture that Jean-Pierre Léaud inhabits like a house; the radiant little-girl face of Bulle Ogier and the iron will behind it; the shambling bearlike presence of Michael Lonsdale, always pretending to be on the verge of collapse; the feral, sinuous grace of Juliet Berto, poised on the knife-tip between control and abandon. If the movie were nothing else, it would still be a chance to make the acquaintance of those remarkable people.

2016

The Heroic Nerd

That the work of H. P. Lovecraft has been selected for the Library of America would have surprised Edmund Wilson, whose idea the Library was. In a 1945 review he dismissed Lovecraft's stories as "hackwork," with a sneer at the magazines for which they were written, *Weird Tales* and *Amazing Stories*, "where . . . they ought to have been left." Lovecraft had been dead for eight years by then, and although his memory was kept alive by a cult—there is no other word—that established a publishing house for the express purpose of collecting his work, his reputation was strictly marginal and did not seem likely to expand.

Since then, though, for a writer who depended entirely on the meager sustenance of the pulps and whose brief career brought him sometimes to the brink of actual starvation, whose work did not appear in book form during his lifetime (apart from two slender volumes, each of a single story, published by fans) and did not attract the attention of serious critics before his death in 1937. Lovecraft has had quite an afterlife. His influence has been far-reaching and, in the last thirty or forty years, continually on the increase, if often in extraliterary ways. Board games, computer games, and role-playing games have been inspired by his work; the archives at hplovecraft.com includes an apparently endless list of pop songs—not all of them death metal—that quote or refer to his tales; and there have been around fifty film and television adaptations, although hardly any of these have been more than superficially related to their sources.

There is a reason for that superficiality. Lovecraft's work is essentially unfilmable, not because his special effects are too

gaudy or too expensive to translate to the screen, but because they are purely literary. Lovecraft was bookish in an extreme, almost parodistic way. He may not have worn a fez or been able to afford a wing chair, but he assumed the archetype of the nineteenth-century man of letters (Wilson calls him "a literary man *manqué*") with his circle of disciples, the roughly 100,000 letters he wrote to them (and he was only forty-seven when he died), the preciously archaic language in which he expressed himself (almost always using "shew" in preference to "show," for instance), the humid cultivation of in-jokes that migrated from the correspondence to the stories and were perpetuated in stories by the disciples, and the carefully tended aura, if quite self-aware, of "forbidden knowledge."

In other words, he was a nerd. He was a nerd on a grand scale, though—a heroic nerd, a pallid, translucent, Mallarméan nerd, a nerd who suffered for his art. His art consisted exclusively of conveying horror, and in this his range was encyclopedic. As a setting for his horror he built a whole world—a whole universe, with a timespan measured in eons—which others could happily continue furnishing indefinitely. His horrors themselves are, with a few unfortunate exceptions, described loosely and suggestively enough that in effect they present a blank screen on which the reader can project whatever visual imagery is most personally unsettling. This explains the seeming paradox of an exceedingly bookish writer enjoying a legacy that is to a very large degree extraliterary. As a supplier of instruments for the cultivation of horror he was custom-tailored for the fourteen-year-old boy, and the number of fourteen-year-old boys—some of them chronologically rather older and quite a number of them female—is continually on the increase.

Howard Philips Lovecraft was born in Providence, Rhode Island, in 1890, the neglected, lonely child of a father who died of tertiary syphilis after years of institutional confinement and a mother who was by all accounts confused and immature. Growing up in his maternal grandfather's house, Lovecraft was left to his own devices. The foundations of his imaginative

world were laid very early; he suffered from the first of many emotional crises (a "near-breakdown") at age eight. His formal schooling was sporadic thereafter, but he voraciously engaged in self-teaching, particularly in astronomy. He published several hectographed journals of astronomy in his early teens, and in his later teens and twenties wrote an astronomy column for a number of Rhode Island newspapers. He began writing stories and poems in his late twenties, publishing them initially in amateur showcases.

One of the advantages of Peter Straub's fine selection for the Library of America volume—which represents a bit over half of Lovecraft's fiction—is that when read in sequence it allows the reader to watch him maturing as a writer. The main thing I remembered from reading Lovecraft when I was fourteen was his prodigal expenditure of a certain kind of deckle-edged Gothic vocabulary: "noisome," "ichor," "eldritch," "miasmal," "necrophagous," "eidolon." It turns out that this sort of usage drops off significantly after the first few stories (although he could never quite shake "blasphemous," "unhallowed," or "Cyclopean"). The early stories are flagrant pulp, which is to say that they are crudely executed goulashes of literary effects from all across the nineteenth century. That was the era when more was more, and it gave him license to unleash sentences that cannot now be read aloud straight-faced: "Shall I say that the voice was deep; hollow; gelatinous; remote; unearthly; inhuman; disembodied?" Or: "In that shrieking the inmost soul of human fear and agony clawed hopelessly and insanely at the ebony gates of oblivion." Sometimes it is impossible not to imagine an accompanying illustration by Edward Gorey: "Wretched is he who looks back upon lone hours in vast and dismal chambers with brown hangings and maddening rows of antique books, or upon awed watches in twilight groves of grotesque, gigantic, and vine-encumbered trees that silently wave twisted branches far aloft."

Lovecraft was an authority on the tradition of horror fiction. Even Edmund Wilson concedes that his long essay

"Supernatural Horror in Literature" (1927) is "a really able piece of work." Besides Poe, to whom he was permanently in debt, he admired above all Arthur Machen and Lord Dunsany, who have steadily become less and less readable since their heyday in the early twentieth century, and it may be from them that he absorbed various Symbolist and Decadent tendencies (he mentions Baudelaire a couple of times in ways that leave doubt as to whether he ever actually read him). He also drew upon the Puritans, with emphasis on their more sensational effusions (between his extraordinary last name and his long, bony, thin-lipped face it isn't hard to imagine Lovecraft himself as a witch-trial judge), and had clearly dived deep into certain strains of Americana.

He marshalled this equipment in the service of a single goal: horror. He was apparently not much interested in anything else. He could summon up considerable book learning when it would serve to buttress a story, but did not waste time on fripperies such as characterization, the business of daily life, or any emotions other than fear.* The complete absence of even suggested sexuality in his work was much debated by fans in the Freud-shadowed mid-twentieth century; the proposition—rather missing the point—that he might have been homosexual sparked fierce arguments. Although he was married briefly, and many years later his former wife was moved to state, peculiarly, that he was an "adequately excellent lover," it is clear from all available evidence that sexuality, procreation, and the human body itself were among the things that scared him the most.

He was also frightened of invertebrates, marine life in general, temperatures below freezing, fat people, people of other

* A somewhat different Lovecraft emerges from his correspondence. In the five-volume *Selected Letters* (1965-1976) and in Willis Conover's moving *Lovecraft at Last* (2002; a record of the friendship between the teenaged Conover and the much older Lovecraft, halted by his sudden death), Lovecraft appears unfailingly generous, painstaking, and tactful, as well as emotionally mature, severe in his judgment of pulp mediocrity, wide-ranging in his interests, and possessing a sense of humor that appears nowhere in his fiction.

races, race-mixing, slums, percussion instruments, caves, cellars, old age, great expanses of time, monumental architecture, non-Euclidean geometry, deserts, oceans, rats, dogs, the New England countryside, New York City, fungi and molds, viscous substances, medical experiments, dreams, brittle textures, gelatinous textures, the color gray, plant life of diverse sorts, memory lapses, old books, heredity, mists, gases, whistling, whispering—the things that did not frighten him would probably make a shorter list. He evidently took pleasure in his fears, at least those on the creepy-crawly end of the spectrum, and although he really did suffer from his fear of cold, for example, that did not prevent him from exploiting that fear in a couple of stories, one of them ("At the Mountains of Madness") his best.

The things that did not scare him are generally absent from his work. Often his stories take place in a continuous landscape of fear, in which every detail contributes oppressively. In "The Lurking Fear," for example, all of nature is malevolent: "I hated the mocking moon, the hypocritical plain, the festering mountain . . . Everything seemed to me tainted with a loathsome contagion, and inspired by a noxious alliance with distorted hidden powers." The story concerns a Dutch family in the Hudson River Valley that, determined to resist the encroachment of the English in the late eighteenth century, shuts itself away from the world; 250 years later inbreeding has caused the stock to degenerate to a species of anthropophagous subterranean ape. Although this seems excessively silly, it arises from authentic American folk panic—the fear of isolated backwoods tribes with strange customs and perhaps genetic deformities—which in Lovecraft's day was accorded a certain respectability by the pseudoscience of eugenics.

Lovecraft lived in Brooklyn for two years in his mid-thirties, during his marriage. While he was initially awestruck by New York City, his attitude changed radically, at least in part because of the personal unhappiness that derived from his inability to find work. Like many others unnerved by the chasm between the grandeur of their genetic inheritance and

the squalor of their prospects, he blamed the immigrants. New York City, once a wonder of "incredible peaks and pyramids rising flower-like and delicate from pools of violet mist to play with the flaming golden clouds and the first stars of the evening," became a "tangle of material and spiritual putrescence [from which] the blasphemies of an hundred dialects assail the sky." What those "swarthy, sin-pitted faces" were up to he addressed directly in "The Horror at Red Hook": the immigrants (many of them apparently Kurds) are devil worshipers who, led by the degenerate scion of an old Dutch family, engage in ritual murder and child sacrifice in addition to the usual menu of rum-running and alien-smuggling.* It did not really take unemployment in the Big Onion to awaken Lovecraft's fear of the other, though. Some years earlier, in "Herbert West— Reanimator," he had given a description of a Negro boxer, the least offensive part of which concerns his face, which "conjured up thoughts of unspeakable Congo secrets and tomtom poundings under an eerie moon."

Lovecraft's racial and eugenic preoccupations, which were hardly unusual for his time, formed a constituent element of his landscape of horror, since, as he wrote in 1930 to his friend Robert E. Howard, creator of Conan the Barbarian, "The basis of all true cosmic horror is always *violation of the order of nature*." But Lovecraft was already looking beyond the mere caprices of earthly existence, seeking vaster, more awesome horrors. In "Supernatural Horror in Literature" he had written:

> The one test of the really weird is simply this—whether or not there be excited in the reader a profound sense of dread, and of contact with unknown spheres and

* In "He," another story from the same period, he gives, in the guise of a vision of New York's future, his idea of a jazz club: "I saw the yellow, squint-eyed people of that city, robed horribly in orange and red, and dancing insanely to the pounding of fevered kettledrums, and the clatter of obscene crotala, and the maniacal moaning of muted horns whose ceaseless dirges rose and fell undulantly like the waves of an unhallowed ocean of bitumen."

powers; a subtle attitude of awed listening, as if for
the beating of black wings or the scratching of outside
shapes and entities on the known universe's utmost
rim.

In 1926, at the same time that he was drafting his essay, he
wrote "The Call of Ctulhu," which was to be the first install-
ment of his life's work, the Ctulhu Mythos, a sort of unified-
field theory of horror.

In the story, the figure of Ctulhu—an otherworldly being
so terrible that it can never be seen directly, but is manifested
by various attributes—first appears in a dream experienced by
several people simultaneously during a minor earth tremor.
There are suggestions of Cyclopean architecture, indecipher-
able hieroglyphics, and "a voice that was not a voice" intoning
something that can only be transcribed as *Ctulhu fhtagn.*
Soon it develops that police in Louisiana, investigating reports
of a voodoo cult in the swamps, had come upon an "indescrib-
able horde of human abnormality" conducting a bizarre ritual
around an eight-foot granite monolith. In custody, the wor-
shipers, "of a very low, mixed-blooded, and mentally aberrant
type," were nevertheless able to give an account of their creed,
which centered on the Great Old Ones, who had come to earth
from the stars long before the appearance of humans. Ctulhu
was a high priest who lived in suspended animation in the great
city of R'lyeh, somewhere under the ocean, waiting for the
chance to rise again.

After this, the Mythos began to figure in every story that
Lovecraft wrote, and it developed ramifications in every direc-
tion. In "The Case of Charles Dexter Ward," a long, complex
tale reaching back to seventeenth-century Providence, it ap-
pears that the cult of Ctulhu is what actually underlies such
heterogeneous matters as witchcraft, alchemy, and vampirism.
Playing a prominent part is the *Necronomicon*, an ancient
book, invented by Lovecraft in 1922, supposedly the work
of one Abdul Alhazred (a name Lovecraft had devised for

himself at age five, under the spell of the *Arabian Nights*), a sage whose career ended when he was devoured by an invisible demon in broad daylight in the marketplace in Damascus. The *Necronomicon* is ritually invoked in nearly every story thereafter as the key to the commerce between the Great Old Ones and the human race, and it is joined by a shelf of other apocalyptic titles, such as the "pre-human" *Pnakotic Manuscripts*.

Many of the stories take place in or around the ancient city of Arkham, Massachusetts — Lovecraft's version of Salem — and its Miskatonic University, one of the four or five places on earth where a copy of the "forbidden" *Necronomicon* is kept, under lock and key. The Ctulhu Mythos, which would be extended by others after Lovecraft's death, in ever-widening rings of diminishing returns (even the *Necronomicon* eventually achieved material form in the 1970s, more a heavy-metal fashion accessory than a book intended to be read), represented a way for Lovecraft to order his fears, to unify the realm of pure otherness, the source of every inexplicable human terror.

Lovecraft is at his most effective when he evokes this inhuman realm, just as he is at his best when he suggests, rather than attempting to describe. He does himself no favors by revealing, for example, that the beings of the Great Race are cone-shaped, of a "scaly, rugose, iridescent bulk . . . ten feet tall and ten feet wide at the base"; the sight may cause Lovecraft's narrator to scream hellishly, but the reader is more likely to picture some kind of Cyclopean jelly candy. The more spectral and unimaginable his subject, the more Lovecraft is at home. Where he fails utterly is in conveying lived experience, the material counterweight to his phantoms. His monsters, when exposed to the light, exhibit the pathos of creatures in poverty-row horror movies; his depictions of human life on earth in his own day are the least credible elements in his work. The stories "He" and "The Horror at Red Hook" make it sound as if he had never set foot in New York City, while "The Shadow Over Innsmouth" suggests that he never visited the New England coast and "The Dunwich Horror" and "The

Whisperer in Darkness" that he never so much as glanced out a train window at a rural landscape. It is not that his settings are unreal—it is that they are made entirely of words. They do not provide any suggestions to the inner eye, only adjectives, mostly hyperbolic.

It is of course unfair to expect a thistle to bring forth figs. Lovecraft only barely managed to exist on the material plane himself, and it certainly was not his subject. His strengths, meanwhile, were unusual and idiosyncratic. He had a flair for names, for instance. The monikers he hangs on his otherworldly manifestations—Nyarlathotep, Yog-Sothoth, Tsathoggua—are evocatively miscegenated constructions in which can be seen bits of ancient Egyptian, Arabic, Hebrew, Old Norse. The terror of Cthulhu is most vivid on the purely linguistic level: "*Iä! Shub-Niggurath! The Black Goat of the Woods with a Thousand Young!*" The New England he fashions is so tangibly haunted in its nomenclature—Arkham, the Miskatonic River, Devil's Hop Yard, Nooseneck Hill—that he would have been wise to stop there and not attempt further description. He savors the dark texture of seventeenth-century Puritan names: Obed, Peleg, Deliverance, Elkanah, Dutee. He frequently engaged his schoolboy correspondents to send him lists of regional names from their local phone books. Names, real or imagined, accomplish nearly everything his strangled fustian tries and fails to do: suggesting vast stretches of time, experience far outside the modern frame of reference, the subterranean course of genetic inheritance, the repression of dismal ancestral proclivities.

It is possible to view Lovecraft's work as an expression of the mingled fascination and revulsion he felt for his Puritan heritage. Like the Bible, the *Necronomicon* is an ancient work, steeped in mystery and filled with horrors, that describes the compact imposed upon humans by enormously powerful otherworldly beings, a compact that may or may not be in humanity's best interests. The earthly votaries of Cthulhu, hoping for favors and dispensation, have over the centuries engaged in secret rites, ritual murder, and nameless abominations to appease

their masters. All the while, the Great Old Ones sleep in their undersea stone city, R'lyeh, awaiting the Second Coming. That event, while inevitable, is to be anticipated with dread, since it portends the annihilation of all living things. The Great Old Ones, implacably hostile to the feeble human race, are themselves beyond life and death. A "much-discussed" couplet in the *Necronomicon* runs: "That is not dead which can eternal lie, / And with strange aeons even death may die." It is rather less reminiscent of Poe or Mary Shelley than of Cotton Mather and Jonathan Edwards.

The novelist Michel Houellebecq, who devoted his first book (1991) to Lovecraft, misses this aspect of his work, but coming from a Catholic culture he nevertheless can spot the grotesque parody of Christianity in "The Dulwich Horror,"

> in which an illiterate peasant woman who has known no men gives birth to a monstrous creature endowed with superhuman powers. This inverted incarnation ends with a repugnant parody of the Passion where the creature, sacrificed at the summit of a mountain that overlooks Dulwich, cries out desperately, *"Father! Father! YOG-SOTHOTH!"* in a faithful echo of *"Eloi, Eloi, Lama Sabachthani."*

Interestingly, Houellebecq cites this as an illustration of Lovecraft's racism, since "it is not one particular race that represents true horror, but the notion of the half-breed. By that measure, the Christian myth of the Immaculate Conception would also be a "violation of the order of nature," which is certainly a bracing idea.

Houellebecq doesn't pursue it, though. His view of Lovecraft is presumably an idealized self-portrait: a *poète maudit* who radiates negative energy; who answers the imperative of life with a resounding "no"; who demonstrates superior breeding through sheer unworldliness, which he further elevates into otherworldliness; whose racism, while perhaps deplorable, is

merely a byproduct of his attempt to face down evil—those other races, you see, are mentally and morally weak enough to be the servants of the Old Ones. But racism is slightly beside the point, anyway. All of humanity, all of *life*, is repellent:

> To touch other beings, other living entities, is an impious, repugnant experience. Their skin bloated with blisters that ooze putrid pus. Their sucking tentacles, their clutching and chewing appendages, all constitute a constant menace. Beings and their hideous corporeal vigor. A simmering, stinking Nemesis of semi-aborted chimeras, amorphous and nauseating: a sacrilege.

Living creatures are disgusting, and their omnipotent undead adversaries are also disgusting: the universe is one gigantic swirling vortex of vomit. The only remedy, transient and puny though it may be, is to give voice to your principled stance in the face of it all. Houellebecq, who according to the detailed account of his translator, Dorna Khazeni, inserted interpolations ranging from a few words to entire paragraphs into his citations from Lovecraft (for reasons that are not always clear), found in the older writer a perfect vehicle for creative misreading, an elected ancestor who was at once ambitious, marginal, conventionally accomplished, and pathologically unstable. It is fortunate that Houellebecq, like Lovecraft, has restricted his ambitions to literature.

2006

The Golem

In 1927, Georges Simenon, the phenomenally prolific Belgian author of crime novels, helped engineer a publicity stunt that sounds like a forecast of reality TV. He sat in a glass booth and wrote a novel in a week, in full view of the public. Simenon was all but unknown then, a journeyman author of indifferent pulp novelettes under a variety of pseudonyms. The feat made him famous, became the first thing many people knew about him. It was certainly the first thing I knew about him; I heard the story from my father, who at the time of the performance was growing up a few miles from Simenon's hometown of Liège. No one who witnessed the feat forgot it. Pierre Assouline, in his 1997 biography of Simenon, quotes from no fewer than four memoirs by acquaintances of the novelist, recalling the surging crowds, the writer's concentration, how he did not once look up from his typewriter . . .

The trouble is that the stunt never actually took place. The newspaper that was to sponsor it went bankrupt, and Simenon couldn't get another to take up the baton. It was just as well. The announcement provoked nothing but jeers; Simenon's hometown paper lamented that their boy had committed professional suicide; one Parisian columnist went so far as to announce that he would be going armed and taking potshots at the booth. But the damage was done. Simenon was extraordinarily prolific anyway, and the chimerical stunt endowed his reputation for the rest of his life with a tawdry sideshow aspect. This was not helpful to someone who possessed ferocious high-lit ambitions but worked in a popular genre and came from a lower-class background and a place so far beyond the pale it could not even be called provincial. For the rest of

his career, literary arbiters would consider him a performing flea, would "study" him in an attempt to uncover his "secret." It is only now, with Simenon dead for the better part of two decades, that his work can be separated from the carny barker's spiel that for so long preceded and engulfed it.

Simenon, who died in 1989, has become current again. In 2003, the hundredth anniversary of his birth, he attained a distinction it is a shame he did not live to see: he was accorded a two-volume set in the Bibliothèque de la Pléiade, the embodiment of the French canon, from which snobbery had long excluded him (not that his position has thereby been rendered secure and uncontroversial). Over here in the Anglo-Saxon realm, he is being rediscovered once again. He has been known, loved, and kept in print in English for his mysteries starring the implacable Inspector Maigret. More recently, interest has finally swung a bit in the direction of his non-Maigret novels. These books, which Simenon called *romans durs* (hard novels) or *roman-romans* (novel-novels) are not mysteries, although they usually involve crime. They are hard, blunt, punishing studies of human beings driven by circumstance and personality to the ends of their tethers, forcing them to extreme measures. Most of them were overlooked by English-language readers when they first came out; they often had only one printing, or were published in the UK but not the US, or were never translated at all. Why this should have been is uncertain. Maybe American culture wasn't ready for them. Today they appear with the force of revelation, as if they'd been unearthed decaying in a warehouse instead of lying in plain sight all these years. Weaned on moral ambiguity, their readers are ready for them. They are acute, compact, remarkably varied, and as lapidary as great pop songs, and there are 117 of them.

Simenon was an odd bird. Famously, two days before starting a novel, he would consult a map of the place where the book was to be set, search through his collection of telephone books for names of characters, and establish the cast—ages, backgrounds, family ties—on the back of a manila envelope.

Then he was ready, as he told a *Paris Review* interviewer in 1955:

> On the eve of the first day I know what will happen in the first chapter. Then, day after day, chapter after chapter, I find what comes later. After I have started a novel I write a chapter each day, without ever missing a day. Because it is a strain, I have to keep pace with the novel . . . All the day I am one of my characters. I feel what he feels . . . And it's almost unbearable after five or six days. That is one of the reasons my novels are so short; after eleven days I can't—it's impossible. I have to—it's physical. I am too tired.

Which is the material explanation, at least, for how he produced so many books. And that was in his relatively leisurely later career, when he issued an average of only six or seven titles a year. In his apprentice years, before the artistic breakthrough he achieved in the early '30s, he was impossibly fecund. In 1929 alone he wrote thirty-four books under a variety of pseudonyms. However, a glance at two or three of them is sufficient to dispel the mystery. They are, unsurprisingly, pulp that might as well have been cranked out by a machine, although he never disavowed them.

Simenon was driven by demons as much as any of his characters were. While he didn't kill anyone, he sublimated his frenzy into serial compulsions, of which his four-hundred-odd books are one example. He also claimed to have bedded more than ten thousand women (mostly prostitutes; Wilt Chamberlain he wasn't) and to have used up half a million pencils and several thousand pipes. These compulsions were socially rooted. In the early twentieth century, literature was still in the hands of the gentry, and Simenon was part of the wave of working- and lower-middle-class writers who made their impact through genre fiction, where the pay was so low that a prolific output was necessary for survival. But some of

those writers, once they achieved status and a measure of financial stability, slowed down, sometimes drastically. (Witness Dashiell Hammett, who published his last book twenty-seven years before his death.) Simenon continued to write as if his life depended on it. Even after he quit fiction, when he turned seventy, he couldn't stop. He dictated twenty-one volumes of memoirs and followed those in 1981 with a volume, not dictated, entitled *Intimate Memoirs.* (He had already published at least three written memoirs. There is a difference: the written ones pursue his story from different angles, while the *dictées* are rants.) He lived eight idle years after that, but by then he was very ill.

Simenon was born in Liège, a city on the Meuse in southeastern Belgium that at the time of his birth was at the height of its prosperity, which derived principally from the steel- and glassworks in the industrial suburbs of Seraing and Jemeppe-sur-Meuse. His family clung to the lower slopes of the middle class—his father was accountant for a small insurance company but nursed no further ambitions; earlier generations had been artisans. Circumstances were sufficiently meager for his mother to take in lodgers, mostly foreign university students, many of them Russian Jews. The family lived in the old, cozy working-class neighborhood on the island of Outremeuse—Liège's Brooklyn—although things got tight enough that they were eventually driven across the river to Amercoeur, its Bronx.

Simenon was noted as clever, therefore destined for the priesthood, therefore sent to be educated by the Jesuits. He soon tired of the routine, though, and instead gravitated to the prostitution markets and the seedier cafés. At fifteen, he was hired as a reporter by a conservative Catholic newspaper, the *Gazette de Liége,** where he learned to write and to write fast. It was also there that, in 1921, he wrote, on assignment, a seventeen-part series on "the Jewish peril." Meanwhile,

* The accent in the city's name was acute until after World War I, when it was changed to grave to accord with the word for cork, with which the name has no etymological connection.

he contributed to more ephemeral publications, such as *Nannesse*, a humor paper that became a blackmail sheet. (It made its money, that is, by quashing embarrassing stories for a price.) The young Simenon hung out with the local bohemians, one of whom was found hanged in the doorway of a church after a night of drinking. In 1931, he turned the story into a novel, *The Hanged Man of Saint-Pholien*, that used the actual settings. Two of the editors of *Nannesse* later became murderers, and Simenon made this, too, into a book: *The Three Crimes of My Friends* (1938).

Liège, a reduced-scale metropolis (163,298 inhabitants in 1920), gave Simenon the appropriate education for his calling. His upbringing also infused him with the unlimited Walloon taste for scandal, especially morbid scandal, and for all manifestations of the sordid. (The tone of the local press remains to this day pitched somewhere between the *New York Post* and *¡Alarma!*) Those Russian Jewish boarders—memory of whom was apparently insufficient to offset the impact of *The Protocols of the Elders of Zion*—managed to pump quite a bit of Gogol and Dostoyevsky into his bloodstream. Like most writers not born to the purple before fairly recent times, he was an autodidact; the rest of his literary training he picked up, as it were, in the street.

Late in 1922, he made his move, decamping for Paris in the company of his fiancée. He found a job as social secretary to the Marquis de Tracy, a landed aristocrat and minor right-wing ideologue. This fulfilled a common fantasy of lower-middle-class provincial youths in Belgium—a monarchy with roots a quarter-inch deep—and introduced him to a world of salons and theater parties and champagne suppers and country-house weekends. He made connections quickly and began writing for the sort of magazines that respectable bourgeois kept in their desk drawers and American tourists smuggled home in their trunks—*Le Frou-frou*, *Paris Flirt*, and the like—and soon for the daily *Le Matin*. Its literary editor was Colette, who famously advised him to excise the "literature" from his writing.

By 1924, he was a full-time writer, turning out thin novels—190 of them by 1931—under more than a dozen pseudonyms. Before long, his income was such that he was able to live lavishly, travel extensively, socialize frenetically, and carry on a very public affair with Josephine Baker.

Those novels spanned the genres of the period, including variously risqué romances and variously exotic adventure tales. Crime stories were included but did not predominate. In the late '20s, though, the art of lawlessness began a major upward trend all over the world. The first important modern crime movie, Josef von Sternberg's *Underworld*, premiered in 1927. The first important "hard-boiled" novel, Hammett's *Red Harvest*, was published in 1929. In France, Georges and Joseph Kessel's delirious weekly true-crime tabloid *Détective* began publication in 1928. This extraordinary rag (still going, but as the ashes of its former self) played to both ends of the market, with sophisticated Art Moderne layouts, posterlike photographic covers, and, in the early days, pictures of its constituency—flat-capped voyous with dangling cigarettes and matching molls—reading the paper at sidewalk tables. It seldom published fiction, although it ran three series of short stories by Simenon, starting in 1929, that marked his formal entry into crime writing. These stories (collected as *The Thirteen Mysteries*, *The Thirteen Culprits*, and *The Thirteen Enigmas* in 1932) are the only pseudonymous works he subsequently brought out under his own name.

He reserved his patronymic for his mature work, which began with a bang in 1931. While cruising the waterways of Europe aboard his houseboat in 1929, he wrote a story in which Inspector Maigret appeared for the first time, in a secondary role. This set off some kind of spark, and the following year he turned in six Maigret novels to his publisher. The appearance of the first batch (he published thirteen books in 1931, eleven of them Maigrets) he feted with an elaborate "Anthropometric Ball," at which guests enjoyed the thrill of being treated like criminals—being fingerprinted at the door, for instance. The

novels were a sensation, and he published six more the follow-
ing year. Maigret, at once unflinching and forgiving, saturnine
and direct, godlike and utterly ordinary, a representative of
the law and an understanding connoisseur of human frailty,
struck a chord with the French reading public, which had en-
joyed many fictional master criminals but had few significant
literary detectives to call its own. In 1933, he issued only one
Maigret, however—the other seven books were *romans durs*.
The following year, he again put out only one, ominously
titled *Maigret*, in which he put his inspector out to pasture.
Like Sir Arthur Conan Doyle, Simenon felt cramped by his
celebrated invention. He was also hunting bigger game. He had
up to this point enjoyed a mutually satisfactory relationship
with his publisher, Fayard, whose imprint he had sported since
the pseudonym days and which wrapped his books in jazzy
photo covers. But he lusted for the prestige of Gallimard, then
as now the most Olympian of French publishing houses, and
there mere mysteries would not do. He was in every way un-
dertaking a leap in class.

Simenon had significant champions, notably André Gide,
who took copious notes on each of his books and periodically
sat him down for lessons. (According to biographer Assouline,
Gide considered Simenon a "phenomenon," whose "secret"
the elder writer tried obsessively to "penetrate.") Another
was Florent Fels, editor of the magazine *Voilà*, who got him
into Gallimard, overcoming the resistance of the arbiter Jean
Paulhan, who did not think Simenon was house material—he
wrote books for the masses, he was Belgian, he was common
and uneducated and an obvious climber. Indeed, Simenon
was such a climber that after he got in he fretted and lobbied
and harangued over the fact that his books were not included
in the famous cream-colored *série blanche*. Eventually they
were, but a perceived lack of respect caused him to finally quit
the house after the war.

Simenon's class background can go only so far in excusing
his extraordinary pettiness and grasping egotism, which were

to have political ramifications. He was ignorant if not innocent of politics, and his sundry right-wing affiliations in the '30s had more to do with social insecurity and the example of the Marquis de Tracy than with any actual convictions. When war broke out, he briefly extended himself to assist Belgian refugees; after the Germans invaded France, he was, ironically, suspected of being Jewish (on the grounds that his real last name would have been Simon) and subjected to a lengthy police investigation. Even before this occurred, however, he had quickly and smoothly become a collaborator, among other things signing up with the German-controlled film company Continental. His motives were simple. The Continental contract assured him a comfortable income, as well as a permit to travel between Paris and his country house in the south. He had no particular beliefs, except in the preservation and cosseting of his own skin.

After the Liberation, he was sentenced to house arrest, which was lifted at the request of the Belgian ambassador. A year later, he and his family relocated to Canada, and a year after that to the United States, first to Arizona and then to Lakeville, Connecticut, where he was to spend five years—a very long stretch of uninterrupted domicile for him. Eventually, he went back to Europe, briefly to the south of France and ultimately to the place where prominent artists have historically gone to die: Lausanne, Switzerland. Along the way, he produced a herculean stream of novels and stories, lobbied shamelessly for the Nobel Prize, vetted film and television adaptations of his work, went through two marriages and diverse liaisons, fought and mostly lost libel suits arising from his autobiographical works, and in conjunction with his legal travails made one trip back to Liège, where he was lionized by the entire city as a rare native son made good. Whatever roisterous creature he had been in his younger days, by then he had become a walking statue, rarely photographed without his fedora, trench coat, and pipe, his face an unmoving collection of slits arrayed on an oval.

He was a writer, which is virtually to say that his life is of no

interest except in the ways that he was also a crud. Some writers are fine people—some are heroes, lead popular struggles, save lives at the risk of their own, or at least feed the hungry or shelter the homeless—while a great many are shells, whose finer qualities have been siphoned off into their books. On the basis of his work, you would think that Simenon possessed extraordinary insight into the human condition, with an endless capacity for understanding the fragility of the psyche. (His characters step into his trap from all walks of life, with a wide variety of temperaments; as on Judgment Day, they wind up in identical shrouds.) And he did have that prodigious capacity for entering the minds and souls of others, although he seems to have been able to access this gift only while in the self-induced trance state in which he did his writing. You could probably say much the same thing about Balzac—in both cases, the fiction, which when piled up could actually attain the volume and mass of a human body, walks alongside the author like a conjoined twin, endowed with all the qualities its creator lacks. The corollary is that you can hardly imagine there being room in the average human to hold the contents of that golem, not with the appetites and weaknesses and Saturday nights and Monday mornings that are already there. The compression would be explosive. The work may look like a body, but it contains entire populations.

Simenon wasn't the first writer to feel impatient with and perhaps a bit jealous of his recurring lead character, but Maigret provides the key to his work. Jules Maigret—large, deliberate, slow moving, taciturn—is a cop, not a sleuth. He does not engage in fancy clue-sifting or pyrotechnic displays of ratiocination, and he does not bed clients in low-cut dresses or administer justice with his sidearm. He does, rather often, take the law into his own hands, but when he does, it is usually to let obviously guilty parties go free—there are extenuating circumstances. What Maigret does best is understand human beings. Generally, a crime has been committed, in whatever setting—he is a quintessential Parisian but manages to spend

a great deal of his career either following cases out of town or happening upon them while visiting far-flung police departments—and Maigret moves onto the scene, apparently doing little or nothing. He walks around, takes apéritifs and meals with this one and that one, and sends off the odd telegram, while invariably the local powers are frantic over his inertia. What Maigret is actually doing, though, is getting acquainted with all the personalities involved. His impassivity itself sometimes causes the guilty party to jump out of his skin with anxiety, precipitating some stupidity that gives him away, but most of the time Maigret deduces the identity of the killer by thinking like a writer—by inhabiting each of the suspects in turn before deciding on the one who makes the most psychological sense.

The Memoirs of Maigret (1950), which is written in the first person, casts Simenon as a character, a pest tolerated by Maigret, who is secretly flattered by the attention but annoyed at the notoriety the books have brought him and annoyed, too, by Simenon's constant and unsubtle prying. As a meta-joke, it's a good one—and fairly unusual for crime fiction, especially at the time—but it conceals the peculiar identity of method shared by author and subject. Simenon explained in various essays and interviews that his great discovery had been that most novels are studies of people in their clothing, and therefore he had resolved to write about the naked human. What he meant was that most fiction belongs to the literature of manners—of status and social dictates and convergence with or deviation from norms—while he wrote about people in extremis, people who are pushed to the point of confronting death, a situation that strips them of all advantages and even of whatever identity they think they possess. Maigret and Simenon are therefore engaged in the same task, although from opposite directions. The policeman works backward, from the crime to the culprit, and Simenon forward, from the human who steps onto the moving sidewalk unavoidably onward to the crime.

It isn't hard to figure out why the Maigret novels have

been so much more successful and beloved and adapted and franchised than the *romans durs*. Maigret is, generally, an agent of harmony and reconciliation. He can't bring back the dead, and often he must enforce punishment, but at the same time he clears the names of the unjustly accused, banishes the threats of extortionists, restores peace to shattered communities. The non-Maigret novels, through, proceed inexorably toward disintegration. They usually end with the protagonist headed for the guillotine, or gunned down by authorities, or committing suicide, or falling into the nirvana of insanity. I've read maybe forty of them; very few end happily. Two of those few are *Three Bedrooms in Manhattan* (1946) and *Red Lights* (1953), both set in the United States, both written in the flush of his second marriage, before it, too, disintegrated. Between them, however, he wrote *Dirty Snow* (1948), the darkest of all his books, in which whatever was rattling around in his brain at the end of the war, when he was being threatened by the Resistance and the end of his little world appeared imminent, was cathected into a bleak tale of total breakdown, societal as well as personal. There isn't a grain of comfort in the book; it's a landscape without a horizon:

> Losing his virginity, his actual virginity, hadn't meant very much to Frank. He had been in the right place. Others made it a story they still talked about years later, adding flourishes like Kromer did with the girl he strangled in the barn. And for Frank, who was nineteen, to kill his first man was another loss of virginity hardly any more disturbing than the first. And, like the first, it wasn't premeditated. It just happened.

Simenon has traditionally been classed with the serial manufacturers of mysteries, who assign their detectives one problem after another in an endlessly self-renewing process, a glorification not of crime but of drudgery: the novelist as omnipotent employer. He is closer, though, to Balzac's encyclopedic

ambitions, to the positivist notion that all of life can be pinned and mounted in a continuous series of fictional display cases. Simenon, in part on account of his background—the Belgian pessimism and fatalism and guilt and schadenfreude and morbid curiosity—became an encyclopedist of temptation and pain. Every one of his books is a lit window across the air shaft, through which a few people can be observed engaging in the business of everyday life, except that there's something wrong. You the reader are pulled into the situation, maybe against your better judgment, by an irresistible wish to figure out what exactly is wrong with the picture. And then, helplessly, you witness spiraling chaos. The process is addictive, but it is neither banal nor complacent. Simenon's genius—his native inheritance, refined into art—was for locating the criminal within every human being. At the very least, it is impossible to read him and remain convinced that you are incapable of violence. Every one of his books is a dark mirror.

2007

The Orphan

It is fitting that Lynd Ward's six books are the first graphic novels to be published by the Library of America. For one thing, they really are graphic novels—no term describes his works, published between 1929 and 1936, as accurately as that term, which only came into general use within the last two decades. They have the scope, breadth, and ambition of novels, and yet they are made up entirely of wood engravings; epigraphs and chapter headings aside, they contain no words. In addition, their format—a single image per right-hand page, with the facing page left blank—is ideal for the pocket-Bible size of the volumes. George Herriman and Winsor McCay and E. C. Segar belong in the Library as well, but the dimensions would require reading them with a magnifying glass.

Ward's work is singular, at least in American culture, and until recently orphaned. Although his first book, *Gods' Man*, managed to sell 20,000 copies in four years despite being published the week of the 1929 Wall Street Crash, he has never really become a household word. His subsequent books did not circulate as widely, and his books were only ever books, were never serialized in magazines or newspapers. A superficial glance at his graphic style risks confusing it with that of his contemporary Rockwell Kent, although he is an Expressionist to Kent's Precisionist. Most people probably know him, if at all, from his later illustration work, especially in two enduring childhood classics, Esther Forbes's *Johnny Tremain* (1943) and Hildegarde Swift's *The Little Red Lighthouse and the Great Gray Bridge* (1942). But *Gods' Man* in particular has proved resilient, having been reprinted at fairly consistent intervals. I myself first found out about it from *The Last Supplement to*

the Whole Earth Catalog (1971; cover by R. Crumb), which reproduced four panels: a painter at work embraces his model, then discovers to his horror a dollar sign tattooed on her shoulder; she rewards him with a fearsome rictus of a smile. That half-page was enough to send me off in search of the original, which took me a while.

What I saw in those four panels was a hint of a narrative, dramatically carved, that appeared at once beguiling, frightening, and unaccountably familiar (I was a teenager at the time). The tattoo impressed me with its cartoon-language directness; the smile—a row of even white teeth in an open mouth, surmounted by eyes entirely obscured by pools of shadow—frankly terrified me; but what appeared to be calling to me from some forgotten realm was the texture of wood engraving itself, especially the striations carved by the artist's burin to fill in for the range of tones between black and white. Those hatch-marks may have been merely an aspect of making a flat wooden surface capable of transferring an inked drawing onto paper, but to my eye they were vibrations, throbbing with the vitality, sometimes menacing, of every represented object, body, landscape, and event. On a wordless page, they were nearly audible.

Ward (1905-1985) was no cartoonist. His father was a Methodist minister who although politically progressive (he was the first chairman of the ACLU and was witch-hunted during the McCarthy era) was a stickler for the Sabbath and permitted no funny papers in the house. Hence, instead of growing up with Mutt and Jeff and the Katzenjammer Kids, the young Ward cut his teeth on Gustave Doré's Bible illustrations. He studied fine arts at Teachers College, Columbia University, then in 1927 went to Leipzig for a year to study printmaking. While there he picked up a copy of *Le Soleil* (*The Sun*; 1919), one of the wordless novels in woodcuts by Frans Masereel. This was to be the signal influence of his life. The Belgian-born Masereel (1889-1972), who began illustrating books and magazines before World War I, produced the first

book of his own in 1918; he would eventually issue 58 of them.

Masereel's stark yet intricate woodcuts have the carnal frankness of vernacular medieval carvings, trace their immediate descent from the acerbic caricaturists of prewar satirical journals such as *Simplicissimus* and *L'Assiette au beurre*, sometimes look like European cousins to José Guadalupe Posada's broadsides, anticipate the stance and imagery of George Grosz's drawings and paintings, were imitated wholesale in the leftist press of the 1930s. His two greatest books, *Mon livre d'heures* (*Passionate Journey*; 1918) and *La Ville* (*The City*; 1925), are both exhilarating urban nightmare visions: the city is crushing, all-encompassing, relentlessly geometric yet scornful of the laws of geometry, perspective in particular. It is always night; the skyscrapers lean in and loom up at all angles; the streets are choked with crowds; huge billboards of pointing hands direct the mob; lust and greed and fear are everywhere and violence is at least imminent. You can see echoes of Masereel's vision in Dada collages, such as Paul Citroen's "Metropolis" (1925), and in films, such as Fritz Lang's *Metropolis* (1927), F. W. Murnau's *Sunrise* (1927), and King Vidor's *The Crowd* (1928).

And Masereel's influence is all over Ward, in *Gods' Man* especially: the urban vision as well as the wordlessness, the essentialism, the love of allegory, the lavish and aggressive use of black, and the realization that wood engraving had been waiting for centuries for the chance to depict the harsh glare of electric light, its perfect subject. Still, Ward went his own way. He loved perspective too much to monkey with it, for one thing, and then there were those striations, those furrows, which are mostly absent from Masereel's high-contrast world. Hatching became the hallmark of Ward's early style, making for a look that was more delicate and more nuanced than Masereel's while still remaining strong. *Gods' Man* — the title, with its seemingly obscure apostrophe, refers to "He whom the gods favor, dies young" from Plautus's *Bacchidae* — has a story that could only have been concocted by someone very young. It is the tale of the artist's struggle for greatness while maintaining purity, and

the dire price he must pay for that achievement.

The artist arrives in a new land aboard a small boat. Short of cash, he is unexpectedly funded by a masked stranger who recognizes his talent and hands him a brush, which was previously employed by an Egyptian papyrus painter, a Greek amphora painter, a monastic manuscript illuminator, Dürer, Rembrandt, and Van Gogh. The artist goes to the city, which unlike Masereel's is somehow at once hectic and empty, like a movie shot on a backlot set. His plein-air daubings draw a crowd, out of which steps a plutocrat, who takes him up and supplies him with a show—his pictures look a lot like Hugh Ferriss's 1920s heroic skyscraper reveries—a garret, and a mistress. The mistress turns out to have the dollar sign branded on her flesh (the chapter is called "The Brand"). The artist flees in pain and horror, and in the street sees the mistress successively in the arms of a cop, a sailor, a priest, and finally a soldier, who beats the artist and drags him off to jail. He escapes and staggers away to the mountains, where we see him in the following chapter, after an interval, leading an idyllically whole-grain existence with The Wife (the very image of The Mistress), painting pictures and making babies—until the masked stranger shows up to collect his due.

The synopsis, missing the visceral impact of the images, will probably sound sillier than the story plays on the page, but the book is not exactly devoid of silliness. For one thing, allegory has been in eclipse for a considerable while. Susan Sontag included *Gods' Man* in her Camp canon in "Notes on Camp" (1964), along with *King Kong*, La Lupe, the Brown Derby, *Flash Gordon*, Aubrey Beardsley, *Swan Lake*, and the novels of Ronald Firbank and Ivy Compton-Burnett. She didn't intend it as a pejorative. "Camp is a vision of the world in terms of style," she wrote, and that certainly applies to *Gods' Man*, as do "innocence" and "extravagance" in her list of quintessential Camp qualities. She also writes that "Camp and tragedy are antitheses," noting that tragedy and what she calls "excruciation" are not at all the same thing. And indeed, *Gods' Man* is

primarily an account of youthful artistic vanity and self-dramatization, rendered in the plangent tones of an Olympian cataclysm.

Which leaves it wide open for ridicule. In his introduction to the Library of America set, Art Spiegelman brings up Milt Gross's *He Done Her Wrong* (subtitled *The Great American Novel and Not a Word in It—No Music, Too*; 1930), which I knew and loved for years without realizing that it was a jab at *Gods' Man*. To be sure, it parodies many things, from Bowery melodramas to silent serials to *Girl of the Golden West*, but its subtitle is a tip-off and its formal conceit could only be referring to Ward's book. When the coonskin-capped hero, who has floated into New York harbor on a log, triumphantly confronts the skyscrapers, those edifices are on loan from Ward's city; when the slapstick pauses for a lyrical image, that image—the heroine at her window, gazing upwards, say—is charged to Ward's account. It's a classic Thirties set-up, in which Ward is cast as the ethereal beret-topped artiste and Gross as the smart aleck who pulls his nose and picks his pocket, if not without a measure of grudging class-conscious respect.

Seen through the eyes of a scrappy kid from the Bronx like Milt Gross, Ward does indeed look precious. But that does not mean that he floats in some bubble of privilege or that his images are feeble. Allen Ginsberg, in the preface to his *Illuminated Poems* (1996; illustrated by Eric Drooker, an artist who draws on both Masereel and Ward), wrote that "Ward's images of the solitary artist dwarfed by the canyons of a Wall Street Megalopolis lay shadowed behind my own vision of Moloch." By which he meant

Moloch the incomprehensible prison! Moloch the crossbone soulless jailhouse and Congress of sorrows! Moloch whose buildings are judgment! Moloch the vast stone of war! Moloch the stunned governments!

(Howl, part II)

Moloch is the embodiment of power, and it is no accident that Ginsberg located its face in the architecture rather than the human villains of Ward's story. Ward's surface is second-hand—all its narrative details drawn from the common armoire, European drawer, and aspiring to the chiseled classical purity sought at the time by every artist who wasn't throwing bombs instead. What makes the images a kind of jazz, though, is what lies behind that surface: a lived sense of the city, of its massiveness, and the menace contained in its massiveness, at a time when the city was made of stone and institutions were embodied by their real estate.

In his second book, *Madman's Drum* (1930), Ward tried for a story of greater amplitude and complexity. He succeeded perhaps too well. The first section is promising: the tale of a slave trader who comes home to what might be England (although Ward called the setting "obviously foreign," it is more like Hollywood-nonspecific), bringing back riches along with a symbolic "native" drum. When he catches his young son fooling with it, he angrily takes it away and gives him a pile of books instead. So the boy reads and reads and grows wise beyond his years. Meanwhile the father dies at sea. So far so good. But then follows the lengthy saga of the now-grown son and his family, and chaos ensues. There are too many plotlines, and they are unnecessarily complicated by the fact that—as one might have observed in *Gods' Man*—all of Ward's women look alike. (His men at least come in two or three varieties of head shape, although with their triangular torsos encased in form-fitting T-shirts and topped by Caesar cuts, the mass-produced Communists he shows brandishing hammer-and-sickle posters at a cell meeting might have gone on to sire Tom of Finland's fleshapoids.) The story travels down a number of poorly lighted narrative corridors. Almost everyone comes to a bad end. Although it contains only 118 plates to *Gods' Man*'s 139, it feels much longer.

When considering *Wild Pilgrimage* (1932) it would be ideal to have at hand a range of class-struggle narratives of the

period, to appreciate the difference between the boilerplate standard and Ward's variation. There may still be art and literature made today that can be considered "political," but hardly any of it addresses labor, or class, or property, even though none of those things has gone away. As a result, a present-day viewer might underestimate the genuine peculiarity of Ward's approach to the subject. The stark hyperbole, the stylized muscularity, the exaggerated perspectives, the preponderance of diagonals and smokestacks and fanning rays of light—all can be found in the graphic world-view that was retailed during the Depression by *New Masses* and the like, but there those things acted as blunt rhetorical shorthand. In Ward's work, on the other hand, each bit of what is ostensibly proletarian vanguard expression is instead deeply problematic, steeped in ambiguity, to the point where we can't be entirely certain that the apparently political theme isn't itself a metaphor for some psychosexual ball of wax.

In fact the story is split into two, some pages printed in black and others in red, and while Ward tells us that the change from one to the other "signal[s] to the reader a movement from outside to inside, or the reverse," the pages in black are barely less dreamlike than the ones in red. The outside story concerns a man with an oddly spadelike upper lip who leaves the crushing factory city to find peace in the countryside. The first thing he sees there is a lynching, but that does not deter him, and he goes to work on a farm, and then on another farm, and then at length goes back to the city, where the struggle is in full swing. In the red pages his fantasies and obsessions are played out: he breaks out of a symbolic jail, enjoys symbolic sex, foments symbolic revolt, symbolically punishes symbolic enemies—but the dream actions usually turn out to have unintended consequences when the color changes. Then again, the black pages are so stuffed with unsublimated sexual imagery—I counted no fewer than 29 plates (out of 108) in which the composition is dominated front and center by men's buttocks—that the difference between inner and outer verges on moot.

When the hero is working at farm number one, he couples ec-statically with the farm wife in the red pages, but she cries rape when they shift to black. Farm number two is run by a bachelor, and there hero and farmer take turns proffering and consuming bunches of carrots; in the red pages, on the other hand, they go off together to confront the plutocrat who holds the ropes of a hundred lynchings. *Wild Pilgrimage* is a dizzying and sometimes confounding welter of raw and outsized emotions, enacted by the sort of figures you associate with relief carv-ings on Soviet monuments, but the dynamic is strong enough that the pages fly by whether or not the action is resolved in the reader's mind. In its battering-ram teenage intensity it is metal—maybe not black metal or death metal or thrash metal, but something equally jejune if a lot more idealistic.

Two short works followed. *Prelude to a Million Years* (1933) exchanges the muscular agrarian style of its predecessor—a strident and grotesque variation on Thomas Hart Benton—for an equally muscular but more angular and urbane Art Deco, so that the images, perhaps toned down a notch, would blend right into the decorative fabric of Rockefeller Center. Here the actual and symbolic fields are virtually indistinguishable. The story, such as it is, involves a sculptor working on an enormous Great Mother figure. He has taken refuge in this work from the batterings of the cruel world, and the sculp-ture—which first emerges from a massive Georgia O'Keeffe blossom—fills him with comfort and carnal ecstasy in equal measure. Nevertheless, he is lured back out to the world, and is duly crushed by its every aspect, his ideals rubbished and his romance trampled upon—and then he discovers that one bit of domestic carelessness has imperiled everything he has left. The moral of the story might be that most accidents occur in the home, but that is definitely not what the ethereal Ward had in mind.

Ward's evolution as a graphic artist is made palpable by the chronological ordering of the books, and *Song Without Words* (1936) is yet more fluid and more swoopingly dynamic than its

predecessors. It is also more nakedly propagandistic—if hard to argue with, since it is agitating against death and for babies. Every time a woman gives birth, the images say, the odds are overwhelmingly dire. Vultures try to steal babies; babies try in vain to reach the single apple growing in the industrial slag heap; babies stare forlornly from behind barbed wire. The 1930s were a time when subtlety did not pay, and Ward did not attempt to buck the trend, going so far as to recycle two images already shiny from overuse: the baby impaled on a bayonet (first employed in anti-Hun propaganda during World War I) and the giant inhabited skull with tombstone teeth (which might go back to the Renaissance, or beyond). The most poignant thing about the 21-plate leaflet is the abject stab at optimism in its final image: the woman, holding a bundle that presumably contains her baby, in the arms of her lover, both of them crouching nude and silhouetted against the looming city, looking expectantly out toward the right at . . . what? In that direction we denizens of the future can only see, in succession: Spain, Munich, Czechoslovakia, the Molotov-Ribbentrop Pact, Poland . . .

Vertigo (1937) was Ward's last completed novel in wood engravings for adults, and it is uniquely large (234 plates), ambitious, and mature. It is the only one of his books to possess the density, intricacy, and emotional complexity of a novel—Madman's Drum, by contrast, is a nearly threadless soap opera, while Gods' Man is a fable and Wild Pilgrimage is something like a picaresque ballad sung by a mountaineer in a cheap suit. Vertigo represents a quantum leap for Ward in every possible way, succeeding equally well as graphic art and as literature. Its narrative drive and expansiveness earns it a place on the shelf alongside such chroniclers of the Depression as John Steinbeck, Edward Anderson (Thieves Like Us, Hungry Men), Tom Kromer (Waiting for Nothing), James T. Farrell (Studs Lonigan), and even Nathanael West, while each individual plate is capable of standing alone.

The work is organized in three sections, each given a faster

tempo than the one before it by the units of measurement that determine the chapters: "The Girl" follows the years, from 1929 to 1935, "The Elderly Gentleman" the months of the year, and "The Boy" the days of the week. The girl plays the violin, lives with her father in a tenement under the elevated train tracks. Romance with the boy sparks on the night of her graduation from high school, and a fortune teller sees them both fulfilling their ambitions, she as a musician and he as an engineer. But of course events intrude and everything goes wrong. The elderly gentleman, a sensitive soul, appreciates art, music, flowers, antiques, religion, philanthropy. He is also the head of the large and soulless corporation that employs the girl's father, and when profits dip, so does his health, so that drastic measures must be taken to restore both. The boy, meanwhile, has gone off both to escape an abusive family and to make his fortune so that he can marry the girl. His timing is unfortunate.

Although Ward is apparently dealing in the same broad archetypes as in his previous works, the figures are somewhat more specific—especially the elderly gentleman, who plays the part of the villain without being at all conscious of his villainy, and is treated with delicacy and even a degree of sympathy. The story is dictated by large historical forces, so that we know in advance that we are in for evictions, breadlines, strikebreakers, riots, freight-hopping, and crime, but the story nevertheless feels far less programmatic than it might have. Part of the reason for this is the syncopated rhythm of the chapters, any of which might have twenty plates or just one. Another is Ward's apparently newfound determination not to wrap up his stories with resolutions, whether tidy or apocalyptic. The book ends on a suitably ambiguous and suggestive note: out of the blue we are on a roller coaster, dropping.

Somehow Ward appears to have grown more in the two years it took him to complete the book than he had in the interval between *Gods' Man* and that point. Something has made him drop the pretense and the posturing, and his drawing skills have flourished. His people still look like types rather

than individuals, but at least now they are differentiated, and the boy and the girl can even be seen to change with the years. There are pointed details in his streetscapes, such as a billboard for the movie *Love on a Dime*, and the girl's graduation comes complete with a long speech resuming all of American history. Here and there you might almost suspect Ward of having a sense of humor. Some of this growth was probably an effect of the vast amount of other work he was doing, which included illustration jobs for trade publishers and a great deal of labor both artistic and supervisory for the Federal Arts Project of the WPA—but some was surely a result of growing up. He was still only 32 when *Vertigo* was published.

This massive set is the work of youth, and it is marked by youth's liabilities: pretension, vanity, overearnestness, self-righteousness, and intellectual and emotional confusion. Balancing that, on the other hand, it fully displays youth's passion, energy, bravado, determination, and wild, shape-shifting experimentation. It is sad but maybe understandable that Ward dropped his graphic-novel project right then—the effort must have been herculean, and the notice increasingly diminishing— but you do have to wonder what a graphic novel made later in life would have been like (he was working on one at the time of his death, but the notes to the set do not suggest that the fragments have been published). Ward in his day must have been first a novelty and then an eccentric in the eyes of most people, since he was choosing to hammer away at a form of expression he shared with only a couple of other people, both of them in Europe. All the while he did have many confrères at close hand, but they were cartoonists and strictly low-church, and they did not mix. (When Art Spiegelman asked Ward to name his favorite comics, he could only think of *Prince Valiant*.) So he was orphaned by history, but with a significant assist from his own prejudices. We can hope he won't be orphaned by the Library of America—but who would follow him?

2011

The Carpenter

Manny Farber first came to my attention by way of a book generically entitled *Movies*, with a generic cover illustration of Bogie, Ann Sheridan, and George Raft tinted with cupcake dyes. Heaven knows why I even bothered to open it, but I immediately found myself reading such violently non-generic sentences as: "The movie's color is that of caterpillar guts, and its 14-karat image is a duplicate of the retouched studio portraits that could be obtained in Journal Square, Jersey City, in 1945." Or "Rita Tushingham's sighting over a gun barrel at an amusement park (standard movie place for displaying types who are closer to the plow than the library card) does a broadly familiar comic arrangement of jaw muscle and eyebrow that has the gaiety and almost the size of a dinosaur bone." Or "It's a film which loves its body odor." Yes, what I held was the cheapo 1971 paperback edition of *Negative Space*, the only book he published if you don't count its expanded 1998 version, or the anthology that appeared as an issue of the little magazine *For Now* in 1969, or his museum catalogs. *Negative Space*, a selection of his movie reviews and essays from 1950 onward, had a major if long-fuse impact for its insistent focus on the visual plane of the screen, its erasure of distinctions between high and low art, its combativeness, and its tough and vivid prose style. Farber, who died August 18 at the age of 91, was a movie critic and a painter, and it took him far too long to achieve a modicum of respect for his brilliance and originality in both fields.

Farber was born in 1917 in the forlorn copper-smelting border town of Douglas, Arizona, where his father ran the dry-goods store. He looked out at the San Bernardino Valley

and the Chiricahua Mountains—a flat sprawl with distant lumps—and then crossed the street to the movie house next to the pool hall, where he would study the latest vehicles of Buck Rogers and Tom Mix. One view naturally flowed into the other. He began drawing and cartooning early, attended Berkeley and then the Chouinard Art Institute (the predecessor of CalArts) and then the Rudolf Schaefer School of Design in San Francisco. Then he apprenticed as a carpenter, a trade that would provide him with the bulk of his income for the next thirty years. He moved to New York City in 1942, where he hung with the *Partisan Review* crowd and, concurrently, with the painters who orbited around Hans Hoffman, who happened to be a neighbor. He first showed in a Peggy Guggenheim group exhibition in 1951 and had a solo at Tibor de Nagy in 1957, but he didn't really spread his wings as an artist until he broke with the Abstract Expressionists in the early 1960s.

The majority of fans of Farber's writing, I would venture, became aware of it only after he'd stopped doing it. He began at *The New Republic* in 1942, did a short stint at *Time* and took over from James Agee at *The Nation*, both in 1949, wrote occasionally for *Commentary*, *Commonweal*, *The New Leader*, *Cavalier*, and then, from 1967 to 1971, for *Artforum*. Much of his work in the 1970s was written in collaboration with his wife, Patricia Patterson, also a painter. Their last published piece, a review of Chantal Akerman's *Jeanne Dielmann, 23 Quai du Commerce, 1080 Bruxelles*, was published in *Film Comment* in 1977.

From 1970 to 1987 Farber taught in the film department at the University of California at San Diego. During this time his painting took a new direction. Beginning in the 1960s he had made two-sided, odd-shaped abstract paintings on paper, pouring industrial paint through a muslin screen. Then, in San Diego in the early 1970s he began making representational paintings, and he continued in that vein to the end. They were pretty much exclusively overhead still lifes, initially

odd-shaped congeries of candy packages, and then tondos depicting spreads of packages (candy, tobacco) and miniatures (toys, figurines, model railroad scenery)—a whole series was devoted to coded meditations on some of his favorite movies and directors. Eventually his paintings became lushly colored spreads of flowers and fruit, often studded with reproductions of old master paintings in books and on postcards as well as scrawled notes on scraps of paper. Their surfaces were too painterly to be trompe-l'oeil, but too deliberately distributed not to be construed as some sort of text.

There haven't been many notable writer-painter combos, by which I don't mean articulate painters (Delacroix, Gerhard Richter) or art-'n'-text conceptual dynamos (Robert Smithson, Tom Phillips). Farber's combination of media was unique not only in that the writing and the painting were equally important to him, but that there were so many similarities of approach and subject and preoccupation between them, although they were quite separate pursuits. For one thing, the paintings give clear instructions to anyone perplexed as to the way to read the essays: You start anywhere and end up anywhere. For all that the paintings may be in some way textual, they are scarcely linear—but then neither are the essays, which cover paper the way paint does a canvas. Do you tend to look at a painting beginning at the top left corner?

And then consider the title of Farber's book. His major preoccupation was space, its use and non-use. A quiz from one of his UCSD film classes was reproduced on the back of the program for a Farber tribute at the New School in New York City in 2001. The first question gives the essential flavor:

Draw one frame from each of the following scenes:
– the dancehall scene in "Musketeers [of Pig Alley]" when Lilian Gish is first introduced to the gangsters.
– the subway scene in "Fantômas" with the detective and the woman he is shadowing in an otherwise empty car.

> – the scarecrow scene with Lilian Gish in "Romance
> of Happy Valley."
>
> Indicate in words alongside each frame how close the
> actors are to the screen surface, the depth of space
> between figures and background, the flow of action if
> there is any.

I'm not saying that film was exactly analoguous to painting
for Farber, who was certainly concerned with and fascinated
by acting, for example, but he was especially tuned in to those
aspects the two media had in common. Consider for example
his distillation (in his 1968 essay "One-to-One") of the mise-
en-scène of a number of films of the 1960s:

> Perhaps this composition should be detailed, because it
> appears in film after film: *Red Desert*, *Le Départ*, *Knife
> in the Water*. Antonioni must have invented it: the
> human figure as an island silhouetted against a sharp
> drop of unsympathetic scenery. There are two or three
> delineated elements, none of which act as support for
> the other. Antonioni uses a wall or building as a men-
> ace; in *Persona*, the background is a disinterested one;
> in *The Graduate*, the subordinate detail is manipulated
> into placards of American vulgarity.

For Farber such design qualities naturally were primary indi-
cators of a movie's meaning and its moral sense. But the phrase
"design qualities" is too cold and remote, in view of the over-
powering physical presence that movies had for Farber. No one
can equal him in conveying how a movie assaults the seated
consumer from its impregnable position onscreen. *High Noon*
(1952) is all about "cross-eyed artistic views of a clock, silhou-
ettes against a vaulting sky, legend-toned walking, a big song."
Raoul Walsh's *The Roaring Twenties* (1939) "journeys with
niggling intricacy and deceptive footwork in a lot of grayed
rice pudding." Regarding *Point Blank* (1967): "In a sickening

way, the human body is used as material to wrinkle the surface of the screen." Note that Farber *likes* two out of three of these pictures. "The landscape that I live in is very important," he told Richard Thompson in 1977, "just as the language that I decided on as a critic was excruciatingly important," and went on to call his writing "topographical. It's all that I think criticism is about." So the screen, like a canvas, is a landscape, and critical writing consists of precisely establishing the features of that landscape.

In the egghead press of the '50s and '60s his writing must have sounded like an avalanche of belches and trombones. His movie-critic colleagues in that milieu, people like Dwight Macdonald and Farber's friend Robert Warshow, were so busy wrestling with deep meaning they seemed not to notice that film was a visual medium. And Farber had little in common with the typical thumb-wielding movie reviewer, then or now—if anybody ever managed to construct a blurb from one of his pieces they must have done so by picking out individual words with tweezers. He is most often compared to James Agee and Pauline Kael, two critics who were his friends but with whom he seldom saw eye to eye. Agee was a fine writer, devoted to the pictures, who maybe wanted to see in them things that weren't actually there. Farber admired him, but his irritation with the older critic's sentimentality and lack of rigor runs through his appreciation, "Nearer My Agee to Thee" (1958): "Agee wrote reasonable exaggerations, beautifully articulated, about dull plodding treacle that stretched from Jean Simmons to Ingrid Bergman." Farber never wrote about Kael, but there is little doubt about how a critic who could champion Michael Snow's *Wavelength* (1967) as enthusiastically as he did Robert Wise's *Curse of the Cat People* (1944) felt about one who came perilously close to protectivism if not demagoguery, relentlessly pushing Brian De Palmas of various sizes as a protective charm against anything foreign or difficult.

In the early 1950s Farber was the first critic of note to make a sustained case for the kind of sinewy B-movies that

played bottoms of bills in grindhouses and were triumphantly discovered by the French several years later. He did not make a career of it, however. He vigorously resisted auteurism of both the hobbyist and the sacerdotal varieties, and kept away from canons and nostalgia and chitchat and received ideas. In the '60s he was following Robert Bresson, Jean-Luc Godard, Andy Warhol, Eric Rohmer, Jean-Marie Straub and Danielle Huillet; in the '70s Michael Snow, Werner Herzog, Rainer Werner Fassbinder, Jacques Rivette, Marguerite Duras, Nagisa Oshima, Chantal Akerman. At the same time, though, he was writing important pieces on Raoul Walsh, Samuel Fuller, and Howard Hawks. He judged movies on their own terms instead of according to a predetermined aesthetic, and he was always open to challenges, surprises, and radical jiu-jitsu moves of every sort.

His single most enduring work, the closest he came to a manifesto, was his essay "White Elephant Art Vs. Termite Art," first published in the underground bugle *Film Culture* in 1962. White elephant art, he famously argued, strives to create masterpieces; termite art (like Laurel and Hardy, or Hawks and Faulkner adapting the first half of *The Big Sleep*), on the other hand, seems

> to have no ambitions toward gilt culture but [is] in-volved in a kind of squandering-beaverish endeavor that isn't anywhere or for anything. A peculiar fact about termite-tapeworm-fungus-moss art is that it goes always forward eating its own boundaries, and, likely as not, leaves nothing in its path other than the signs of eager, industrious, unkempt activity.

White elephant art goes in for ravishing technique, viselike consistency, sustained meaningfulness. Every detail is preg-nant, and enslaved to an overarching scheme that passes for vision. Termite art, on the other hand, proceeds methodically, immersed in the task immediately at hand, oblivious to culture

or achievement. In film it absorbs shaggy-dog plots, one-trick actors, poverty-row budgets, and gets the most out of them by dint of sheer concentration and a certain level of craftsmanship. Termite art exemplifies "the feeling that all is expendable, that it can be chopped up and flung down in a different arrangement without ruin." The movies Farber cared about adhere to this standard; both his writing and his painting seethe with it.

2008

The Collector

Like a sculptor of a past century, Sophie Calle in her art manipulates and reconfigures a commodity central to the economy of her time. This commodity is not bronze or marble but information, the elusive stuff that circulates incessantly between consciousness, document, and cyberspace. It is a maddeningly imprecise and unquantifiable commodity, hovering somewhere on the border between objective and subjective, public and private, hot and cold. It is farmed in huge quantities, fought over, stolen, adulterated, and negotiated by credit agencies, polling organizations, and market-research firms, and yet its value resides in minute specifics and fugitive shades of meaning. Its pursuit thus resembles experimental science—vast quantities of printouts are generated for every nit that can be seized upon and exploited—as well as art. It is at every point along its process so immaterial, so woozily figurative or abstract, that its commodity status seems like a bit of legerdemain, and its manufacture and trade a kind of parody.

Calle is not the first artist to work in this medium. The Surrealists were arguably the pioneers, notably in their fascination with opinion polls. The aphorist and suicide Jacques Rigaut took his own approach to the matter. He carried on his person a tiny pair of scissors which he used to surreptitiously remove a button from the garment of every person he met; he insisted that this was a form of art collecting. The novelist Philippe Soupault once staged a version of a highway robbery. He stopped a bus on Avenue de l'Opéra late at night by extending a chain across its path, then ordered all the passengers to tell him their birthdates (the combination of violence and trivia does not seem very far from Calle's concerns). Trivia

devoid of violence, data accumulated for their own sake, the relentless documentation of the most stultifying processes — those are traits associated with various phases of conceptual art, which pursued the sublime through a number of processes, one of them being busywork. The Surrealist and conceptual approaches to the management of information as a medium in itself could be said to represent in their different ways the mingled fascination and horror inspired by the looming triumph of bureaucracy. The Surrealists responded with bemusement and savagery, the conceptualists with a sort of meditative practice, an emptying-out.

Calle's work appears at various times to display all of these qualities, although the distribution is uneven. Her first work, *The Sleepers*, resembles straightforward conceptual bookkeeping but with an added layer of sexual risk, at least by implication. Risk, as well as stealth, deception, and intrusion, dominate her most notorious works, *Suite Vénitienne*, *The Shadow*, *The Hotel*, and *Address Book*. The dominant metaphor there is espionage, with more than a suggestion of sadomasochism. *Anatoli* is a portrait, sharing with her earlier works the fact of having been initiated deliberately as a result of adverse conditions, in this case the lack of a common language. In its plainness it throws into relief their shared thread, which follows the parable of the blind men and the elephant. Not surprisingly, her next work was *The Blind*. This piece, which connects as well to the earlier and more prosaic *The Bronx*, employs hearsay in pursuit of the ineffable, in effect constructing a work of art that is only alluded to and not represented by the objects on the gallery wall, a pursuit later taken up in *Ghosts*, *Blind Color*, and *Last Seen*.

There seems to be a rough split in Calle's career to date. Her earlier works are, broadly speaking, concerned with narrative, and the later ones with image. In both, the principal tool is language, with the visual component filling an illustrative role. In this way, her work suggests the forensic procedure during a police investigation. She assembles clues, descriptions, guesses,

and allusions, and pieces them together into an approximate rendering. In the earlier works, this rendering takes the form of a dossier; in the later ones it resembles an identikit sketch. *Cash Machine* might be a sort of pun on this idea, with its disembodied, almost ectoplasmic surveillance-camera portraits. *Autobiographical Stories* and *The Tombs* extend the principle of visual substitution or approximation in another direction, toward the iconic. The objects that stand in for epochal incidents in the artist's life and the laconic gravestones that reduce entire existences to a mere familial title ("Mother," "Son," "Sister") possess a weight of their own; the referent is almost beside the point. If you were to hear or read a description of Calle's work and try to reconstitute it on that basis without actually seeing it, it is possible that you might imagine its theme to be the poverty of language or image, the insufficiency of secondhand experience. Instead, her work continually stresses the beauty of imprecision, the poetry of gaps and lapses.

She is, in other words, a kind of Impressionist. Uncertainty dapples her pictures the way the sun's rays spatter the leaves and splash the grassy swards in the Bois de Whatever. But that's not all there is to it. Uncertainty is an inevitability when it comes to information. Information is uncertain in the same way that humans are mortal. Nevertheless, information strives for certainty, or rather its purveyors do, whether quixotically or disingenuously. The police tipster, the industrial spy, the political clairvoyant, the highly-placed source—all are in the business of pretending infallibility. And their commerce, once a small-time traffic, is in the process of becoming ever more industrialized, increasingly central to the global economy as it has moved from nightside alleys to glass-walled offices. Tremendous financial decisions are made on the basis of lore—consumer profiles, focus-group questionnaires, extrapolations of trend curves—that is about as reliable as the divination of bird entrails. The metaphor is not idly chosen; the commerce of information is descended from the work of the augurers and haruspices who advised military leaders in antiquity. It

has merely been dressed up with technology and soft science for the benefit of contemporary superstition, which passes for rationalism.

Calle's work is to a certain degree a parody of this trade, and so could be said to be a parody of a parody, a simulacrum of a sham. But to the extent that her portraits — Anatoli, the address-book man, the occupants of the hotel rooms, herself even — are distortions, they are no more so than a Cubist head would be as compared with a photographic likeness. Even when the deck appears stacked — the address-book scheme, viewed from one angle as a tinpot *Citizen Kane*, might prompt questions about her motives — enough air is admitted in the form of indeterminacy to prevent any agent including Calle from taking full control of its drift. Uncertainty, in short, is the fingerprint of truth. It is the only aspect of any piece of information that can always be relied upon, and of course it is the aspect that diminishes information's value as a commodity. It is nearly always inconvenient; it is unproductive and inefficient; it is often dangerous. And that is why it is so beautiful, as Calle repeatedly demonstrates in her work.

1993

The Portraitist

What we have here are two photographs, mounted together on a page, each of them depicting a young woman posing with a motorcycle—a different woman and a different motorcycle in each case. The combination of several photographs on a page immediately recalls Richard Prince's *Cowboys* series of a decade earlier, and the choice of subject matter suggests a link to that series as well. Just as the *Cowboys* stand as an obvious iconic representation of American masculinity, so the *Girlfriends* might appear to function as their distaff counterpart. The two sequences also share an origin, both drawn from popular iconography, specifically magazines. And just as the cowboys were selected, rephotographed, and selectively cropped by Prince, so the girlfriends have been selected, rephotographed, and cropped by him, plucked from their original crowded magazine pages and set down between the broad white margins of art. But whereas the cowboys were costumed, staged, choreographed, and photographed by advertising professionals, the girlfriends were set up by their boyfriends.

They derive from a popular rubric in certain American biker magazines, such as *Easyriders* and *Iron Horse*, which cater to men who, even if they serve as dentists or accountants for forty hours each week, spend the balance of their time riding or hanging around their Harley Davidsons (all other brands, necessarily foreign, are anathema) and generally trying to pass themselves off as members of an outlaw gang. The magazines invite their readers to submit photographs of their possessions; the girlfriends are invariably pictured as an accessory—not on the level of the bike itself, of course, but perhaps comparable to its custom spokes or its fitted cowhide saddle. The women here

are standing; often they are shown reclining along the length of the machine, or draped over it like an animal skin. They are usually semi-nude, and such parts as are clothed are encased in skintight leather or denim. The poses are always stiffer than the photographer appears to realize. The expressions tend to be fixed. Professional models can simulate delight or arousal, but these women can only turn in feeble imitations, reproducing such emotions at one or two removes.

The pictures appear comical at first; a longer look reveals their fundamental pathos. As Melissa Holbrook Pierson writes of them in her book *The Perfect Vehicle*, "[the women] are colluding in their own debasement, and this is seen somewhere deep in their eyes, though their lips smile and their backs arch in feigned ecstasy. Mainly they look uncomfortable . . . and tentative, as if they wished they could do something, *anything*, to please the men behind the Instamatics." It is understood that the women have not spontaneously elected to bestow erotic caresses upon the vehicles to the delighted surprise of the photographer happening upon the scene. It is understood that unbuttoned leather vests and Jolly Roger bustiers improvised from bandannas are not their customary articles of dress. The photographer in each case is suggesting a *ménage à trois* involving girlfriend, hog, and self. He is constructing a scene that is intended as a boast to be waved at his buddies and peers. Perhaps he dimly imagines a straw audience of outsiders who will be simultaneously shocked and inflamed by the image. In the end, though, the image is simply and crudely masturbatory. The girlfriend is requisite as a prop but no more capable of deriving pleasure from the scene than the machine itself.

Prince's interest in these images cannot fail to involve their sexual politics, but he is no polemicist. He is neither reveling in the debasement of the models nor displaying them as exhibits in an indictment. Over the course of Prince's career, the images and artifacts that have possessed his imagination, besides the cowboys and the girlfriends, have included leaden dirty jokes, third-rate magazine cartoons, and the saddest, most inept, most

derelict items that decorate the American rural landscape, from planters made from discarded truck tires to rusted basketball hoops hanging from trees. Those are all examples of an aggressive American popular imagery that that has little or no basis in tradition, makes no claims to artisanship, and resists—at least for the time being—assimilation and recuperation by the forces of established aesthetics. The cowboys are an exception: they are slick, knowing product, and their roots in the Western fantasy art of Frederic Remington and Charles M. Russell are obvious. The remainder can be considered folk art, although it is probable that few collectors, at the time of this writing, would soil their hands on the originals. They are intransigent as if by design, determinedly ugly things that mock the taste and ravenous appetite of the educated upper classes. Of course, the juggernaut of recuperation is relentless, and sooner or later everything gets sucked into its maw: lowrider cars, ghetto sign lettering, prison tattoos, amateur pornography. The twentieth century demonstrated that that today's offense to taste is tomorrow's vanguard style. Prince may be, among other things, an especially far-sighted curator.

The ugliness of the girlfriend pictures is, indeed, their most interesting feature, and it is also, not incidentally, their proof of authenticity. A centerfold spread from one of these same magazines, featuring a professional model posed and lighted by a professional photographer, is mere boilerplate, the competent execution of a job. It simply rehearses a set of conventions established long ago by cheesecake calendar publishers, and nobody involved has any interest in exerting him- or herself one iota more than is required to get paid. The girlfriend photos, by contrast, are boiling over with unresolved conflicts, confusions, and aspirations. The photographers are marginally competent—as everyone is, given today's simplified equipment—and they have an idea of the conventions involved, but that is as far as it goes. They could no more turn out a photograph of professional appearance than they could transform their subjects into movie stars. Instead they are faced with

the task of posing the girlfriend in an erotic rapport with the machine while not obscuring any critical feature of the engine, and with establishing proper lighting and atmosphere while equipped only with a flashbulb and what is usually the most basic point-and-shoot device. The result is often endowed with an unfakeable cardboard naivety reminiscent of the work of poorly trained small-town portrait photographers of a century ago. The alternative, as shown in other pictures, is to produce the sunlight squint that has been a major feature of the snapshot aesthetic for more than fifty years.

In cropping, isolating, and blowing up the photographs, Prince emphasizes every flaw. The cheapness the pictures emanated when they were viewed in situ on a page crowded with others of their ilk now becomes something else. The viewer is, first of all, subject to a documentary frisson derived from the other occasions on which bad snapshots are removed from their original context, namely as evidence or background matter pertaining to a crime. The crudity of every aspect makes the picture erotic in spite of itself, a phenomenon also owing to an association with the sordid ineptitude of amateur pornography, which can inadvertently suggest all manner of scenarios more lurid than anything actually depicted. There is a certain nostalgia at work as well, since graininess and truly bad color have become increasingly difficult to achieve in the face of advancing technology, and become the mark of an unrecoverably innocent former age. Without tracing the originals it is impossible to say how much Prince has cropped, although it seems evident that he has eliminated most of the bike in a number of shots. In any case, someone has taken the trouble to lop off the tops of the subjects' heads and to deny them their feet. Such amputations, in a posed portrait, are the very thumbprint of photographic incompetence; like all the other technical failings of these photos, they register upon the viewer somewhere on a sliding scale that runs from the cozy to the sinister. It should be noted, incidentally, that nearly all these qualities—the stiffness of the poses, the uncalculated squalor of the backdrops, the

blunt-instrument application of the lighting, the heedless in-camera cropping—have in recent years, since Prince completed the series, been self-consciously imitated by fashion photographers. The circuit has been completed.

The practice of transferring low-culture items to high-culture settings dates back to the Surrealists—consider the spreads of penny postcards, cheap woodcuts, and imaginatively photographed pocket lint in the pages of *Minotaure* in the 1930s. The subjects of those spreads are effectively wild beasts, and the broad white margins are their cages. Whatever snobbery is implicit in such a transfer is mitigated, however, by the fact that the subjects are less imprisoned than enhanced by their new context. They may be perfectly dull in their original settings, but in the hushed, rectilinear confines of art they boil over with chaos. The margins supply them with walls to kick against, and they are energized and renewed by the exercise. In the *Girlfriend* photos, every aspect that counted as a failing on the part of their photographers only serves to heighten the vigor with which they fight the immaculate page of art. They wear their bad color, bad lighting, and stiff poses proudly—they have graduated from feeble posturing to untamable rudeness—and the croppings, whether original or the work of Prince, increase the tension by emphasizing the fragility of the margins. Sooner or later those heads and feet will break through and the chaos will flood the page.

Prince's stance is one of studied ambiguity. On the face of it, he is an artist, working within an established context of exhibitions and publications, who goes out into the field and returns with raw material distinguished by its apparently unbridgeable and even hostile distance from the art world, which he then submits to the protocols of that world. In an earlier age such a practice might have bordered on anthropology and would certainly have involved ennobling the raw material, identifying and articulating the "beauty" within it, in effect translating it into the language spoken by art and its consumers. Today, however, the task is to find raw material that may superficially

resemble art by virtue of being in some way pictorial or sculptural but that otherwise resists translation, that contains no feature that might be judged beautiful by conventional standards. This process implies not a conversion of the heathen material but a wish that the heathens will desecrate the tabernacle of art. Obviously, Prince knows as well as anybody that art will always win. "Beauty" is an infinitely expandable criterion and assimilation will occur next year at the latest. Certain modernists may have thought they could demolish the temple; Prince knows that all he can do is to set off small explosive charges, thereby constantly repositioning the terms of the argument.

Beauty at present is in part a matter of abrasion, and the *Girlfriend* pictures embody it in their material ugliness, their pathetic class strictures, their ignorance and clumsiness, their grotesque pimping and boneheaded conceit. Such things are exciting for as long as they create tension; they are new as long as they strike a dissonant chord. Once assimilation occurs the pictures will mutate, invisibly. They will become wistful, forlorn, shipwrecked. Having the fight sucked out of them by the overwhelming appetite of commerce will leave the pictures looking vulnerable in a way that matches the vulnerability of the women portrayed. As time passes and their original context vanishes the strutting and preening of the photographers will fade from view. The women will regain center stage, not as victims but as expressions of unfathomable hopes and doubts and regrets. The clenched shoulders and wooden grin of this woman and the strained facial muscles and tentative arched fingers of that one will work in concert with the deficiencies of the photographs, and then lives that may have otherwise left little trace will become suddenly visible at one critical instant. When that happens Prince will appear not as appropriationist or curator or magpie, but as the true portraitist, the one who could see beyond the blinkered vision of the man who pressed the shutter.

2003

The Avenger

If David Wojnarowicz were alive today he'd be turning 58 in September. Who knows what his art would look like by now? But there is every reason to think he would have been one of the relative few to have graduated from the hit-or-miss East Village art scene of the 1980s and gone on to greater glory. His stencils, icons, symmetry, hot colors, homoerotic imagery, street art all remain visible in the work of others now. His ghost is just about discernible around the edges of stuff by Gilbert & George, Banksy, Shepard Fairey, Barry McGee, and I'm sure you can think of more. Of course, maybe if he had lived he would have taken several radical turns away from those tropes by now, but in either case he'd surely be accruing retrospectives, awards, tributes—the treatment accorded a significant artist in the fullness of maturity. He was that vital, protean, fecund, original, and pioneering in his life and work.

But fate arranged things differently, and today David Wojnarowicz is primarily famous for being dead. Unless, that is, he's more famous for serving as a convenient bogeyman and target for the Christian arm of the American right wing. Wojnarowicz contracted HIV in the late 1980s and died of AIDS in 1992, and in his last years he did not mince words when it came to the government's criminal negligence, with the active complicity of most of the Christian churches. He remains as much alive to the right wing as he does to his admirers, but what ostensibly inflames his enemies are not his accusations. In December 2010, the National Portrait Gallery in Washington DC capitulated to demands by the Catholic League and pulled Wojnarowicz's work from a show. At stake was an eleven-second sequence from his film *A Fire in My*

Belly (1986), which showed fire ants crawling over a crucifix.
They also crawled over watches, coins, and other items—the
symbology was not subtle, but it probably wouldn't occur
to most people to consider it blasphemy, either. Although it's
quite possible that the sequence could have raised the ire of
the League's William Donahue, a sort of comic-opera Grand
Inquisitor, had it been made by Joe or Jane Blow, the fact that it
was the work of Wojnarowicz irresistibly evoked the cordite
aroma of the Culture Wars, when people like Donahue made
their names and their talking-head profiles. To those cowboys,
Wojnarowicz, Karen Finley, and Andres Serrano were the
Dalton Gang, and even in death his name can still cause their
trigger fingers to itch.

And Wojnarowicz more than the others represented every-
thing the religious right wanted to erase from American life. He
represented gay pride at its most intransigent and least bour-
geois; he was open and unapologetic about his past as a teenage
hustler; he enjoyed provocation for its own sake, well before
it took on urgent political significance. And he was an artist
and writer who was entirely self-created, owing nothing to the
academy or the art world of his time, and who spoke directly
to an audience of his peers, like a rock star. He wasn't the only
artist of the 1980s to manage that, but Jean-Michel Basquiat
had been absorbed by the high-hat galleries and Keith Haring's
imagery was endlessly recuperable, so that their radicalism was
to a degree blunted. Wojnarowicz was accessible, charismatic,
articulate, and blazingly angry. He had the potential to reach
beyond his lower Manhattan planet of the like-minded and
into teenagers' bedrooms across the land. Even if that exact
train of thought did not present itself to William Donahue,
Donald Wildmon, Jerry Falwell, Jesse Helms and their cohorts,
they could nevertheless glimpse its outline. Wojnarowicz was a
threat.

What galvanized his anger, obviously, was AIDS and every-
thing that accompanied it, but it had been simmering within
him for the better part of his life. His childhood was traumatic,

to say the least. Sometime in September, 1954, his father, Ed, an alcoholic who had gambled away his salary, brandished a gun and threatened to kill his wife, Dolores and their children. David was born on the 14th, but it is not recorded whether the incident occurred before or after that date. The parents were divorced a few years later, although that hardly improved matters, as David and his older brother and sister were swung back and forth between them in a ceaseless drama that involved threats, beatings, abandonments, and even a kidnapping. Both parents were wildly unstable, Dolores in her quiet way not much less so than the violent and dissolute Ed, who killed himself in 1976. In the accounts assembled by Cynthia Carr,* Dolores appears passive, recessive, often emotionally absent, not to mention passively aggressive, as well as extremely unreliable. (She is still alive, although she did not respond to Carr's requests for an interview.) It is telling that the three children—Carr had interviewed David late in his life on a number of occasions, in addition to talking to his siblings—could seldom agree on details from their childhood, were given to significant memory lapses, and habitually misdated their own recollections. A diagnosis of post-traumatic stress disorder would not appear out of the question for any of them, including their mother.

In general, biographies provide the reader with two patches of tough sledding: the childhood of their subject, which is usually sketchy, haphazardly documented, sometimes stultifyingly dull, and tends toward the generic; and the years after fame has come, which most often resolve into mere lists of addresses and other famous names. In the case of Wojnarowicz, while the latter is of course conspicuously absent, the former is gripping and very much of a piece with the balance of the life. This is a reflection not only of Wojnarowicz's extraordinarily difficult existence, but also of Carr's doggedness and resourcefulness as

* *Fire in the Belly: The Life and Times of David Wojnarowicz*, Bloomsbury, 2012.

a reporter. In addition to working out a plausible account of his childhood from piecemeal clues, she has managed to document his adolescence with a thoroughness that makes it one of the most vivid accounts of teenage creative development I've read.

This too is made possible by the reconfigured timescale of a short life: every year lived becomes in retrospect proportionately longer and more full. If somehow Rimbaud had lived to a ripe old age, do you think that more than a handful of scholars would be bothering with his Latin school verse? But then you can't quite imagine Rimbaud reaching even his terminal age of 37, which is also how long Wojnarowicz lived. And how easy is it to imagine him in middle age or beyond? The particular energy that connects his works in diverse media is emphatically young, even when he was ill and slowing down. You'll note that well before anyone had heard of AIDS he was working on his extended *Rimbaud in New York* series, photographs of various young men wearing a mask of Rimbaud's face as photographed by Carjat, posing in significant locations: 42nd Street, the Meatpacking District, the subway, the West Side piers where men met for sex. When someone dies young, everything comes to look like an omen.

In 1971, at sixteen, Wojnarowicz moved out of his mother's West Side apartment and went to live on the streets. He had already tricked a few times and now started hustling professionally. That is a standard feature of his legend, and it is true, although the broader truth is as complicated as adolescence usually is. He lived on the streets, in a halfway house, in a squat, periodically at his mother's and sister's houses, and in legitimate apartments with roommates. He tricked, and bummed around on the road a bit, and worked at Pottery Barn and in a bookstore, and hung out with people who issued mimeographed poetry zines. The feral aspect of Wojnarowicz's character coexisted harmoniously with the profile of an artistically inclined urban youth in his path through the 1970s, from uptown to downtown, poetry to bands to Super-8 to art, the

progress of an entire microgeneration. (I was born the same year as him, lived a few blocks from him for over a decade, knew many people in common, hung out at many of the same places, but somehow we never met. It happens.)

Things truly started happening for him around 1980. It was then that he formed the band 3 Teens Kill 4 with his friends, and also that *Sounds in the Distance*, a collection of imaginary monologues he attributed to an assortment of street people, was published in London; he later made it into a play. He worked as a busboy at Danceteria and the Peppermint Lounge and hung out heavily—it was also the year that Club 57 and the Pyramid Club institutionalized gay-straight socializing on the Lower East Side. And around then he met the photographer Peter Hujar, twenty years his senior. The two were occasional lovers, but their relationship was paternal-filial or maybe fraternal. Hujar was an artist of the first water, with rigorous standards he passed on to Wojnarowicz; he was also a bohemian of the old school, intransigently commited to voluntary poverty as a consequence of resisting an impressively broad range of pursuits that could be construed as selling out. He exerted a powerful and lasting moral influence.

Wojnarowicz, who had for some time been stenciling vaguely political images around on the streets—most famously his iconic burning house—took his first steps in drawing and painting at the piers, crepuscular ruins with vast expanses of crumbling walls crying out for embellishment, beginning gradually at the well-trafficked Pier 34 and eventually taking over the hazardous, decaying Pier 28 with his murals. His timing was impeccable; in 1982 the East Village art boom was on, an efflorescence of galleries ranging from slapdash to slick (there were eventually 176 of them, although not all at the same time) that seemed to proliferate overnight and faded almost as suddenly. It seemed like everybody who'd been in a band the previous year was now having an opening. The scene was an assortment of wet stones on the beach. Rene Ricard summed it up pithily at the time: "The feeling of new art is fugitive, like

the FUN [gallery]: here for a moment, gone forever. It's only truly valuable before it's surrounded by the mystique of money, while it's still owned by culture, before it becomes booty."

Artists could make a name for themselves in very short order, for instance Wojnarowicz, who "between the end of '82 and the end of '83 . . . had three one-man shows at three different galleries . . . while also participating in fourteen group exhibitions," not including his ongoing pier project. He was painting on driftwood, garbage can lids, supermarket posters. His imagery alternated between homoerotic scenes and purposeful emblems, like the pictures on lotería cards: globes, animal skulls, burning children. He was a hot ticket, his works flying off the walls—which didn't necessarily mean he was being paid commensurately, since the galleries had no backers and tended to run like Ponzi schemes when they weren't being fleeced by their clients, who might not take them seriously enough to pay their debts. Wojnarowicz realized the irony that his success was owed at least in part to the flatness of the surrounding landscape. He told Dennis Cooper that "his success was destroying him because he couldn't reject it in good conscience."

While all this was going on, AIDS was gradually taking hold of the city, and Carr punctuates her story with an ominous counterpoint of incidents and dates. The *New York Times* story headlined "Rare Cancer Seen in 41 Homosexuals" ran on July 3, 1981. Larry Kramer published his call to arms, "1,112 and Counting," in the *New York Native* in March 1983, and a few months later the incomparable Klaus Nomi died. In April 1985, Cookie Mueller could still tell readers of her health and advice column in the *East Village Eye* not to worry about AIDS: "if you don't have it now, you won't get it." She was to die of it herself four and a half years later.

But the toll was mounting inexorably; no treatment was available, just a menu of "holistic" placebos, mostly involving diet. Peter Hujar was diagnosed in January 1987; by then there were over 30,000 cases in New York City. He died in late

November, and Wojnarowicz was diagnosed the following spring. By the fall he had started making work that directly addressed the crisis. He had photographed Hujar on his death-bed, and he silkscreened the image onto canvas and laid over it a quote from an official in Texas: "If I had a dollar to spend for healthcare I'd rather spend it on a baby or an innocent person with some defect or illness not of their own responsibility, not some person with AIDS . . ." From then until the end of his life his work came so fast and was so highly charged it could look as if the disease had actually rekindled him rather than gradually draining his energy.

Under AIDS, the late '80s and early '90s were a kind of war; I don't remember who it was who compared it to the first battle of the Somme, which decimated the young male population of Britain in just 24 hours. And the vast losses were aggravated by the inaction of the government and the murderous contempt of the soi-disant Christians who blamed the victims. Many of Wojnarowicz's rants may now sound crude, adolescent, ineffective in their scattershot rage—fantasies of torching Jesse Helms, or his calling Cardinal John O'Connor a "fat canni-bal from the house of walking swastikas"—but in their time they were not only understandable but necessary, expressing out loud all the stuff people were thinking but mostly kept to themselves, and that is one of the things that art is meant to do. Furthermore, his rage and its public manifestations were prob-ably tonic—to the extent that anything could be tonic under the relentless advance of the disease—forestalling mere despair and collapse. He kept a schedule of work and travel that would have been grueling even for someone in the pink of health.

In his book *Close to the Knives*, published in his last year, Wojnarowicz considered memorial rituals, and suggested that the most appropriate expression of grief for victims of AIDS would be for the survivors to "take the dead body and drive with it in a car a hundred miles an hour to washington d.c. and blast through the gates of the white house and come to a screeching halt before the entrance and dump their lifeless

form on the front steps." He died on July 22, 1992. Four years later his partner, Tom Rauffenbart, in the course of an ACT-UP action, threw his ashes over the fence onto the White House lawn. Wojnarowicz was a gifted artist who was denied the satisfaction of achieving artistic maturity, but in the face of great odds he seized the chance to become an actor in history. Cynthia Carr's book is unimprovable as a biography — thorough, measured, beautifully written, loving but not uncritical — as a concentrated history of his times, and as a memorial, presenting him in his entirety, twenty years dead but his ardor uncooled.

2012

IV

Suspect

PHOTO BY EVA PIERRAKOS

Is the mugshot the only true portrait? Is every other approach to portraiture a fiction based loosely on the physical appearance of a given human being? What is a mugshot? Is a mugshot strictly a photograph taken by the police to identify a suspect? Or can the definition be extended? When we say

that a photograph resembles a mugshot, what do we mean? Do we mean that the subject displays no discernable emotion? Do we mean that the space is shallow, that the subject is backed against a wall? Do we mean that the subject is upright and facing forward? What if the subject were in profile, as in a literal mugshot—would that pose also remind us of a mugshot?

Can a mugshot or a portrait that reminds us of a mugshot record an emotional engagement of whatever sort between the photographer and the subject? Does the lack of overt emotional affect seem somehow more truthful than a display of emotion? Is visible emotion on the face of a subject the moral equivalent of dark glasses or pancake makeup? Or is a lack of overt emotional affect seemingly more truthful because it is the underlying state, whereas any given emotion is weather, transitory and fickle? But would that mean by extension that a landscape cannot be truthful unless it is devoid of weather?

Doesn't a mugshot also imply a portrait executed against the will of the subject? Can a portrait in which the subject ostensibly collaborates continue to remind us of a mugshot in other than superficial ways? Is a mugshot more truthful than a portrait that is merely reminiscent of a mugshot precisely because it precludes active collaboration on the part of the subject? If so, is that the case because the subject is seen strictly through the eyes of another? If we could see ourselves as others see us, would we recognize what we saw?

2007

Instantaneous

It seems that many, many people collect snapshots. As far as I'm aware, the first book on the subject came out around 1976, but the idea has mushroomed in the last decade, a result of both increasing interest in amateur expression and the refinement of scanning technology. There are now hundreds of such books, and an untold number of websites and blogs. Collecting snapshots is not quite like collecting anything else. They are singular, generally, and generally anonymous. Their numbers are incalculable. It is impossible to establish a canon, or even any but the most transient criteria. They are all equally rare. Their pursuit is entirely subjective. John's and Mary's collections of snapshots have been exhibited in museums and their catalogs published in Switzerland on expensive paper, but they don't do anything for me. Conversely, my pictures may not speak to John or Mary. Collecting snapshots is like collecting interesting stains.

This picture may not in fact detain you for more than a

minute. All you see are two old people, awkwardly lit and framed and poorly focused, the composition tilted from presumed ineptitude rather than adherence to Constructivist principles. But! Here I will buttonhole you. Notice how the composition is tilted in order to set her upright—she is the center of power and deserves nothing less. Notice how the picture depicts a moment that can stand metonymically for the whole course of a long relationship. After all these years he is still trying to sweet-talk her—he may be making excuses, or reciting poetry—as she continues to reserve judgment. Notice how beautiful they both are, and how you can see their younger selves still burning within. Notice his galluses and sleeve-garters. Notice the shallow space, the underlighting, the wallpaper, the matching chairs, the radio. Notice how the tilting and the underlighting and the shadows and the disarray in the foreground make the picture look satirically scandalous, even give it a bit of a true-crime aura. Notice how the picture embodies what you may not previously have thought of as romance.

I have confidence in my eye. So do John and Mary, presumably. If we were disagreeing about Bordeaux vintages or minor Augustan poets or alternate takes of "Koko," we could each cite authorities to back us up, could refer to a history of opinions, could generally act as though there was such a thing as an objectively correct view. You can't do that with snapshots, and you never will be able to do so. The snapshot forces everyone who sees it to make an authority-free decision, and—if an explanation is sought—forces everyone to become a critic, in the best sense of that word. Everyone who looks at a snapshot can become an exemplary critic, one who doesn't generate pull quotes or ritually invoke boldface names or rely on a mess of filters. Historically, the snapshot was a great equalizer, allowing people of all classes to make pictures, and once again it is a great equalizer, forcing everyone to think for themselves.

2008

Ghosts

All photographs are ghostly to one degree or another, but silent-film stills truly belong to the realm of the uncanny. Photographs are ghostly because they are slices of the past; even pictures taken yesterday record things that no longer exist, if only the after-dinner still life on the table. Silent movies, because of their limitations, were and are more specifically photographic than sound pictures—they could not rely on anything but the image to convey meaning. The most interesting silent movies made use of an arsenal of techniques for this purpose—double exposures, irises, split screens—that have largely disappeared from commercial cinema. In addition, silent movies relied on various pictorial and theatrical conventions that predated the motion-picture vocabulary and have since faded away.

Silent-film stills, then, are slices of heightened experience from the past, which at least potentially makes them preternaturally vivid, but they are mediated by ways of seeing and means of expression that are unfamiliar to us, making them to some degree alien. And since a still isolates one moment of a story, with the steps leading up to and away from it unknown to the viewer who hasn't seen the movie, stills are particularly mysterious and tantalizing—more so than the average photograph, which is designed to fit its entire story within its borders.

Silent-film stills at their best are vivid, alien, enigmatic, and alluring all at once. They are not simply pictures of dead people in unguessable circumstances, but views of the subconscious residue of dead minds—a whole other planet.

Today I finally saw Marcel L'Herbier's *El Dorado* (1921), which I'd been wanting to see for twenty or thirty years, largely on the basis of this shot. It's a melodrama, as the credits announce immediately. The story is maybe laughable—it's a variant of *Stella Dallas*: the doomed low-life mother who sacrifices herself for the future of her child. It trades on the exotic power of Spain as it then was—the exteriors were shot in Granada and Seville—although most of the movie takes place in the titular nightclub, which in many ways is the same room as every casbah hotspot you've ever seen in the movies, from *Casablanca* on back. Everything of real visual interest happens in that nightclub: looming shadows, voracious mouths, insistent headgear, expressionistic decor, and smeary distortion employed to convey drunkenness and squalor.

The shot above occurs at the very end, and when I got there I felt as though I should have guessed its context from the start: she's dead, of course, and has now symbolically attained heaven, which is to say the real El Dorado. The lettering is the same as the nightclub's sign, only done up in what we're invited to see as gold. Appropriately, I feel like the man in Stephen Crane's poem who sees a ball of gold in the sky, goes up to investigate and finds out it's actually mud, then comes back to earth and looks up, once again seeing a ball of gold. I have now seen the movie, which while it is a great deal more than mud is nevertheless a bit of a letdown. But the still retains its uncanny power. I could attempt to break it down: the shimmering letters, their appealing crudity, their relative size, her position relative to them, her position on the table, her makeup, her magician's-assistant bisection, her gravity—whatever. The picture forces my rational mind to surrender. It remains a mystery, even if I can account for all of its particulars.

2008

The Empty Room

The more empty the photograph, the more it will imply horror. The void that dominates the empty photograph is the site of past human activity. It presents itself as a hole in the middle of the picture. The beds, tables, chairs, lamps are not the subject; they are the boundary. Some empty images tease the eye, suggesting clues that may dissolve upon closer examination. Most often the scene is as near to a blank canvas as is possible without fading entirely into nothingness. But then we as habituated viewers tend to brush a dramatic gloss upon pictures that give us no actual cause for suspicion that what we see is not just as perfectly banal as it seems. The lighting and composition awaken unconscious memories of crime-scene photos; the drama comes from what is missing. It's a bit like Sherlock Holmes's dog who failed to bark. What is missing is an apparent reason for the picture to have been taken.

The pictures for the most part do not contain human beings.

They do not depict scenes that are beautiful or interesting in themselves. They do not give enough of the right kind of information to have been of use to real-estate agents. Their focus is too specific to have served in tax surveys. It is unlikely that the inhabitants of these dwellings would have taken the pictures for their own amusement. The photos do not look sufficiently professional to have been taken by the press, even assuming the press might have had reason to take an interest in random hallways or staircases. That only leaves one possibility, which is that they were taken by the police, for the purpose of securing evidence at the scene of a crime.

Over the years I have looked closely at police evidence photographs from New York, Paris, Sydney, Los Angeles, Mexico City, and some others besides. Every city seemed to have its own distinct—what? "Style" is not the word, is it? For one thing, it was unconscious, whatever that thing was. Could we call it a "fingerprint," a "profile," an "MO"? The available language appears loaded, but for good reason. The connection is not idle. Detectives are in the business of detecting patterns of display or behavior to which the parties themselves are oblivious. Criminal investigation is in effect an intense critique of style, which subjects people, places, and things to relentless

examination, every homicide detective as rigorous as the most exacting scholar or curator or impresario or fashion buyer or grant-panel judge, lavishing attention most often upon people, places, and things that would not otherwise be the object of such scrutiny. As a consequence, criminal investigation is uniquely suited to supply a broad range of answers when we want to know how people lived, since most crime scenes are rigorously ordinary, since crime can occur anywhere, since people do not have the opportunity to clean up for company. The archived remnants of criminal investigations of the past are superior if neglected anthropological documents. But because these are also pictures, photographs, we can confer aesthetic values upon them that were never intended by anyone connected with their making; they are no less real for all of that. Like homicide detectives, we ordinary viewers learn to recognize patterns, often by intuition and without necessarily being able to name the connecting thread.

Take a look at the picture above. The scene is distressed, a bit desolate, strictly insignificant. It could be a crime scene. And yet something is amiss, no? Overleaf is another picture from the same period, also empty, banal, unstudied. That it

shows a barber shop might make the viewer remember the murder of Albert Anastasia, although that did not occur until 1957. If you look closely, though, it soon gives the game away. At top center is a large klieg light, at right is a light-diffusing black metal sheet on a pole—known in the trade as a "flag"— and at center right, in front of the mirror, is a slate with cryptic markings. The photo is a "daily," a record made of a film set when production has struck for the day, so that it can resume the next day with continuity intact. It's from a movie called *What! No Beer?* directed in 1933 by Edward Sedgwick and starring Buster Keaton and Jimmy Durante. The shot on the previous page gives fewer clues, only the incongruous movers' blanket almost unnoticeable at the bottom right corner and a sense of the lighting being just too refined. That one comes from the 1931 feature *Men Call It Love*, directed by Edgar Selwyn and featuring Adolphe Menjou and Leila Hyams. These pictures are documentary studies, strictly speaking, although what they document is confection.

The Hollywood dailies show what appear to be potential crime scenes, platonically and artisanally conceived, striking in their randomness, their ordinariness, their carefully

groomed untendedness. But their mystery is twice removed. They are not pictures shaped around a void, but flat records of shorthand renditions of life. By contrast, the crime-scene photographs (the first two pictures here, as well as the one at the end), taken in Brooklyn in the 1930s, are effectively spirit photographs. Like those abjectly fraudulent pictures of revenants and ectoplasm, they impart strong emotions despite themselves. Spirit photographs absorb ambient grief and combine it with guilt, the suppression of doubt, and the acceptance of absurdity, resulting in grotesquely volatile tableaux. The crime-scene photographs more subtly serve up a brew of any number of states: anxiety, uncertainty, boredom, stupor, rage, desire, hopelessness.

In 1929 the French writer Pierre Mac Orlan published an essay called "Elements of the Social Uncanny"—his term for a sort of metaphysical aura, or a seam between worlds, that can sometimes be found amid the ordinary grime of urban life. He illustrated the piece with an anonymous and uncaptioned photograph of a bed, its sheets soaked in blood, in a room with striped wallpaper. He writes:

> Here is a hotel room . . . The actors in the drama are no longer present. Only the blood remains, and all the thoughts it inspires, from the initial moral and physical disgust to a detailed reconstruction of the frightening set of actions that have led up to this simple image, almost indescribable but heavy with fear, with hot and greasy odors, with anxiety.
>
> It is not an interpretation of a fact by an artist; neither is it an image that holds a mirror to reality. It is simply a truth revealed by the provisional death of the force that once gave life to that scene of carnage. Death and an equally momentary immobility reveal and highlight the alarming qualities that give this unclean and vulgar image an emotional power that works on the imagination much more clearly and profoundly

than would an actual view of the room, without the mediation of the lens.

By "momentary immobility" he means the frozen moment of the photograph. He goes on to write that "it is thanks to its incomparable power to create death for a second that photography will become a great art, one that cannot simply be ranked among the visual arts but which, with singular power, finds its place among everything that constitutes the life of the mind." His idea is that photography is a kind of soul murder, one that leaves its victim unaltered in what passes for life but entombed forever in two dimensions like a butterfly in a case. It follows that the empty photograph, which exists to show what cannot be shown, actually contains that unshowable matter. When a photograph freezes a scene, it also accumulates all the actions and states of mind that have led up to it. Every photograph is imbued with an invisible array of circumstances and contingencies, and these secretly operate on the viewer. We can sense in our bellies when we are looking at disturbance.

Arcade

People visited the arcade to stage a play for themselves and a select audience of their family and friends. The photographer supplied flats and props and the shallow space between them, and the subjects reserved the option of creating a performance in that setting. Most people did no such thing, of course, but just sat there like stumps, overwhelmed and maybe intimidated by the lights, the camera, and the photographer, who in those circumstances was likely to be a seasoned carny. The

photographer might be spieling at them, three hundred words a minute, while the pikers would be struggling to follow along, finally giving in to whatever that last thing he said was. Which usually meant stuffing an extended family into a prop canoe or charabanc, snap, snap, and outta there. The ideal way to treat drunks was to stick their heads in those holes—in boards that supplied the rest of their pictured body: boxer, beauty queen, infant—effectively immobilizing them.

Performance was understood as a central component of portrait photography from the beginning. It has taken many forms over time, but the premise of arcade photography descends in a straight line from the mid-nineteenth century. That was when the big photo studios became streamlined chain-store operations and standardized various conventions of setting: the pillar, the plant stand, the rustic fence. While those objects were primarily intended to rest the subjects' self-conscious hands and arms, they also carried a mild implied narrative, something about an appreciation for nature or wisdom. Before long, operators at shore points and lakeside resorts and on the Bowery had begun to supply facsimiles of the beach views and hot-air balloon scenes that were otherwise unphotographable, at least with their equipment. By the early twentieth century you could stroll into an arcade and take your pick of dozens

of settings: biplane, jail cell, outlaw saloon, Hawaiian beach, Niagara Falls, rear platform of train, top of the Eiffel Tower. The props and flats bore a strong resemblance to their larger cousins in the burlesque theaters; maybe they were made by the same people.

Some arcade photographers dispensed with setting altogether, if they were working in a place and time when people had very little money but still needed to be photographed. People got themselves photographed if they were vain, if they were lonely, if they were bored, if they were drunk, if they missed somebody, if they wished that somebody would send them a picture in return, if they felt full of pep and needed to express themselves, if they had eaten and drunk and shot at the shooting gallery and maybe seen a show and had thereby exhausted all the other entertainment resources in their burg. Getting

yourself photographed was a pastime and an existential necessity. It reminded you that you existed outside your own head. It showed you your face as others would see it. It gave you an opportunity to compose yourself, although few had the skill to do so successfully, and often the photographer's haste and hard sell would mitigate against it. Most people come off in arcade pictures as if they had suddenly been shoved onstage to face an audience of thousands.

Perhaps they had an intimation of how their picture would one day slip away from a family archive dispersed after a death and enter the junk marketplace, and from there the visual circulatory system of the digital world, where it might be seen by more people than they knew in the course of their lives. They had once innocently entered into a contract to perform, by

virtue of temporarily occupying a small theatrical space, and now the contract, after many dormant decades, perhaps posthumously, was being put into effect. The arcade photo has not gone away entirely; these days it occurs primarily in booths and the effects are digital, which is to say that it occurs in a flat, notional space, essentially a green screen. What is missing is the fiction of live theater, of scenic conventions so old they have become detached from their moorings, of rough painting and basic carpentry. The classic arcade photo was an art of the poor, a dramatic staging of an ideal. It gave proof, however threadbare, that the subject had visited the imaginary world.

Fotonovela

"*Maybe it would be better if we stopped seeing one another. Maybe there is no remedy to our solitude because . . . we don't love each other enough.*"

Fotonovela, fumetti, roman-photo—the terms betray the fact that the form never got much traction in the Anglo-Saxon realm. There is no word for it in English, exactly. You could say "photo-comics," but risk being misunderstood when you are referring to narratives, often but not always romantic, that are conveyed by means of photographs arrayed in panels on a page, with running text often in talk balloons. Their impact has been almost entirely restricted to countries that speak Spanish, Italian, or French; their readership is overwhelmingly female, at least in Europe. Their history formally begins in 1947 in Italy, in the magazine *Grand Hotel*, soon followed by its French sibling, *Nous Deux*; both magazines still exist.

Fotonovelas flourished in the '50s and early '60s (into the '80s in Latin America), then began a slow decline that still refuses to yield to extinction.

"Everything was all mixed up. She closed her eyes and thought she heard Daniel. "Your hair is so fine and aromatic!"

The culprit, of course, was television, in combination with social anxiety. Fotonovelas were associated with the poor and unlettered (my mother aspirationally ignored their weekly appearance in *Femme d'Aujourd'hui*, to which she subscribed for almost fifty years), the naïve and sheltered and perhaps delusional. Roland Barthes, having written that "love is obscene precisely in that it puts the sentimental in place of the sexual," went on to call *Nous Deux* "more obscene than de Sade." Some years earlier, in a less militant phase, he noted of the fotonovelas that "their stupidity touches me" and ranked them with other "pictographic" forms, such as stained-glass windows and Carpaccio's *Legend of St. Ursula*. There are even more specific antecedents, although no record of actual influence: Nadar's famous conversation with the centenarian

chemist Michel Chevreul, published as sequential captioned photographs in *Le Journal Illustré* in 1886, or *La Folle d'It-teville*, the collaborative photo-novel by Germaine Krull and Georges Simenon, from 1931.

At this thought a blind fury takes her over. She decides to smash everything that doesn't enclose tender memories.

It comes as no surprise to learn that the immediate ancestor of the form was an Italian magazine series that adapted American films, using ordered stills and minimal text to convey their plots. The fotonovela is essentially a low-budget movie on paper, relying heavily on certain cinematographic conventions: the two-shot, the three-quarter shot, the close-up. Or it could be simply defined as a paper-based soap opera, since televised soap operas don't waste much time on establishing shots, either. The forms also share romance-centered story lines and a traditionally female audience. There have been exceptions, such as the long-running Italian title *Killing* (*Satanik* in France), which ditched romance for sadistic violence, although it observed the same intimate scale. Unlike most implacable masked super-criminals, Killing preferred to murder with his

hands. Other genres, including many low-budget film staples
(the Western, the monster movie, the heist picture), are out of
the question owing to their physical demands. On the other
hand, the enclosed nature of the form means that you can set
a story in the United States, say, by simply attending to a few
sartorial details, such as police uniforms.

The wound to the heart slowly settles through the body.
"(I see him again for a few minutes and realize how much
I still love him.)"

The European sartorial details, for their part, can intermit-
tently put you in mind of the movies of the New Wave, which
were similarly low-budget and intimate. The visual difference
between them has mostly to do with lighting; the fotonovela
defaults to the soap-opera full-coverage model, which has the
intent and effect of eliminating any possible ambiguity. Its set-
tings are ruthlessly *bon chic bon genre* (but then you could say
that about almost anything by Éric Rohmer); its casting choices
tend toward archetypes of beauty, waywardness, or authority

while avoiding distinctive appearances (but then Sophia Loren and Claudia Cardinale both made their professional debuts in fotonovelas). Every frame is simply composed and centered; nothing is happening at the edges. The form differs most radically from cinema in its treatment of time, which in the fotonovela is entirely determined by the individual consumer. You can linger between frames if you wish—and you can also run the story backwards or interleave it with another story—but the makers cannot introduce a long take or a jump cut or a music cue.

The biggest guy swings at the brave boy, who narrowly avoids it by suddenly stepping back. "Wait til I get up, you bastard!"

The form is simple and utilitarian, geared in every detail to meet common understanding. It is a screen for the reader to project upon while ostensibly immersed in the travails of fictional characters. It traffics in emotional hardware—longing, doubt, regret, passion, envy, betrayal—chiefly through verbal expression and mostly without dramatization. Plot points occur principally in the dialogue. Action, when it happens, is staged neoclassically; fights are choreographed and

frozen, as on a Hellenic amphora or in a painting by Poussin. There is seldom any physical damage, and the actors are never mussed. Even when terrible things occur, the effects are muted. Fotonovelas can often seem like extended modeling sessions; the actors seldom strike poses that do not display their clothing to advantage. It is as if the figures in a department-store catalog enacted a semblance of life, imagining what it must be like to feel, held back by the immobility of their outfits. In their way fotonovelas are a guide to comportment, promoting restraint and self-possession, directed at a working-class public that owns little but its emotions.

Then a piercing, inhuman scream echoes through the valley. Vanessa swallowed up by the void!

2019

Masked and Anonymous

The press photographer's task is to obtain a likeness of the person who is at the center of the news. This proves difficult since the subject, who is either accused of crimes or tied however flimsily to someone who is, wants to avoid being photographed at all costs. Hounded at every step, unable to escape, even in shackles, the subject resorts to makeshift concealments — hat, sleeve, lapel, handkerchief, newspaper — in order to prevent facial capture. The photographer can only pursue, shadow, perhaps verbally goad the subject, waiting for a slip or a stumble that will cause the mask to drop. When that fails to happen, the photographer's sole option is to photograph the mask. The public, inflamed by press coverage of the case, wants

a face it can charge with its blame (and, often enough, spread the blame to faces that bear it a superficial resemblance), but is instead offered a metonym: hat, handkerchief, newspaper instead of a face. The photographer, in quest of a portrait, has delivered in its place an event: the defeat of portraiture by the subject.

Power manifests itself for the lens through stance, apparel, and furnishings, in the visual language of its particular culture. Power in the West has often been embodied by broad expanses of durable material: wool, silk, oak. The attached faces, through an intersection of intent and heredity, are always interchangeably anonymous. Power wants a face that will make the shareholders feel as comfortable as in their own country club, but it doesn't want the public to have a face on which to pin their grandmother's eviction. The face of the company, consequently, is a suit of clothes. When vice-presidents are fired they are replaced by other vice-presidents, and nobody notices because they wear the same suits. By further concealing

those instantly forgettable features, power explicitly draws attention to its implacable anonymity, furthermore asserting its impunity. A corporate board and secretaries wearing surgical masks may be setting off to rob a bank—which is what they might do all day long anyway, through legal means. The masks are gratuitous; the culprit is the social structure.

The infant is taken to the neighborhood photographer for its first formal portrait. Behold its creamy white perfection! Although darkroom haste and the passage of many decades have robbed it of its features you can still appreciate those tiny ears and the soft dome of the skull, tilted just so. Behind the child, though, is an ominous draped form, with vaguely human proportions and contours. This is known as the "hidden mother"—an actual term of art with reference to photographs from the late nineteenth and early twentieth centuries. The

mother has come along to calm and steady the child, but has chosen to remain unseen by the camera. But why? Is it because she doesn't want to compete with her baby, whose star turn this represents? Does the photographer charge by the face? Or is this a kind of ritual self-abnegation, of the sort that mothers have historically been conditioned to observe? Does the mother take her meals separately? Has she appeared in photographs with the infant's father? Will the in-laws love the child less if presented with a reminder that there is more than one parent?

About the subject of this picture we know one thing for sure: she has a lovely full bottom. Oh, also she has dark hair, as you can make out from the line extending under the front of her badly adjusted wig. And she is somewhere in Europe, in a bedroom featuring a mirror-topped Art Moderne dresser reminiscent of brothel photos by Brassaï. Whatever game is being played here, it requires that the subject see herself as not-herself, triply distanced by mirror, wig, and mask. Is she, like the shrouded mother, occluding herself for the benefit of the featured player, which in this case is her ass? She could be married to someone other than the photographer, or posing as the

Swedish au pair they both fancy, or staging a demonstration for a class of psychoanalytic interns under the supervision of Dr. Jacques Lacan. In any scenario, her faintly guessable face plays a secondary but hardly negligible role. The wig isn't a cheap one, and its slippage might be deliberate. It serves in combination with the mask to give her a passingly eighteenth-century aspect: a debauchee airlifted from a painting by Fragonard and deposited a bit the worse for wear in the pages of *Juliette*. The photograph is a circular riddle that causes the viewer's eye to travel, back and forth, from south pole to north and back again, always somehow expecting a resolution that is locked away forever.

And then you have the ostentatious mask, the panto mask, the mask that is not a concealment but an enhancement. Once a year the subject slips the bonds of his aging face, his constricting

daily uniform, his suffocating routine, and submits happily to hoots and jeers. He knows he is ridiculous, but now he is freed for an evening from the burden of having to pretend otherwise. Later he will tear the paper waistcoat, step on the paper hat, ruin the papier-maché bill with a flood of beer, and have to be helped home and up the stairs by younger men assigned to the task. The photograph he will keep in an album as a reminder of his triumph, his successful conversion into an object. If only he could have stayed that way, perhaps ornamenting someone's mantel, laughed at regularly and needing to be dusted. It would feel as good as being drunk and almost as good as being dead.

2019

Other People's Pictures

Over the years I've accumulated thousands of other people's photographs. I began buying them in the early 1980s, at flea markets and in junk shops. At first, I rarely paid more than a nickel or a dime. I was drawn to those that contained some aesthetic quality or bit of sociohistorical information, or ideally both at once. Often the selection was made rapidly, purely by intuition; only later would I be able to name the qualities that had caught my eye. The pictures were orphans, in several senses. Anonymous photographs had little commercial value. They were considered detritus, as inert as the grocery lists or medical records of the past. And they had all been released into the twilight marketplace by the death of their keepers and the apathy or absence of their heirs. That release often obliterated their context. If you bought two or more pictures out of the same box it might not be evident that they had a common origin. You might not even recognize that the person in this photo

was also the person in that photo, many years later. Found photographs are memories that have gone feral.

Imagine finding, in a rusted tin box stuffed with random and disconnected images (snapshots, postcards, funeral ex votos, chocolate-bar premiums), the picture on the preceding page: a photobooth image of a European intellectual, to all appearances. But how hasty a supposition is this? We think he's an intellectual because of the glasses, European because of the facial features, the mouth in particular. But he might be a bank clerk, perhaps an immigrant from northern Europe (he is blond), now living in Bayonne, New Jersey, where he takes pains to keep his heavy wool suit from the moths. Now imagine finding, in the same box, the photo immediately above: an American GI striding purposefully down the street of what is certainly a European city, to judge by the paving stones and the wicker café chairs. Would it occur to you that the pictures might show the same person, and furthermore could have been taken only three or

four years apart? They are both photographs of my father, and neither is what it appears to be. The first picture, taken circa 1942, was in fact a fake, concocted to fit false identity papers. The glasses are plain glass, the hair is dyed, and he borrowed the maiden name of his Luxembourgeois grandmother to become "Philippe Werner," in a successful effort to prevent his being deported to a forced-labor camp. Three or so years later, after the Allies crossed the Rhine, he joined the Belgian army. That force having been destroyed by the Germans in 1940, it had no equipment, no matériel, no uniforms, so it had to borrow everything from the Americans. Half a century later a copy of the second photo, perhaps obtained from the photographer, was featured in a local shop-window homage to Our American Liberators.

On the basis of the first two images, would you recognize this street urchin, his pants so cheap that you can delineate every knucklebone through the pockets? He seems to be wearing the

same jacket as in the first picture, but you might not notice. Judging from his expression, his clothes, and the trash-strewn condition of the small park where he stands, the photograph was probably taken not long after the Liberation, which is to say at some point between the other two photos. There is a theme that runs through those snapshots from 1944 and 1945: everyone is beautiful, starved, ragged, and ecstatic. But without supplemental information, would you guess the time and the circumstances? The pictures seldom carry any helpful inscriptions on their reverse side. I barely know the stories myself. My father and mother are long dead, as are all aunts and uncles; I have no siblings or first cousins. My father told me selected stories from his past, but they tended to be the ones that could be neatly packaged as anecdotes, and he did not dwell on the war years. I always thought he had secrets, and imagined he would at length reveal them, perhaps on his deathbed; such was not to be.

He again seems a different person in this picture, striding along the streets of the same city, this time with my mother

during their courtship a few years later, both looking cosmopolitan in their matching blazers and pocket squares. (They both still live with their parents and work at entry-level jobs.) Like the GI photo, it was taken by a street photographer, and that, had you come across it in that rusted tin box, might be all you would register. Until about sixty years ago, street photographers could be found in every city, hanging around the center, sizing up prospects, snapping their picture and handing them a card with the address of the studio where a print could be purchased the next day. Like photobooth photos, the prints made by street photographers have an equalizing formal aspect; arrayed in rows they could be stills from a single motion picture, no matter where they were taken.

If I look at my family photos hard enough I start to see them as types, distinguishable from the great mass of their anonymous kin only by a few threads of oral tradition, of which I am the custodian. They are nothing much as pictures, really, barely worth a pause while digging through the crate for the outliers and the beautiful accidents. If they were released from my hands they would merge into the photographic sediment—the endless numbers of dull family snapshots, inert group scenes, pro forma portraits that flow sluggishly through the low-level secondary markets of the world. Each of those is a marker, the living trace of a human who may otherwise survive only as a census entry, or not even that. We cannot discern their accompanying stories, and we can't do anything for them. They are specters. They live in the photographic sediment as in a bardo, suspended within the world, still visible but very gradually being absorbed into the dirt that constitutes our past.

2019

Souvenir

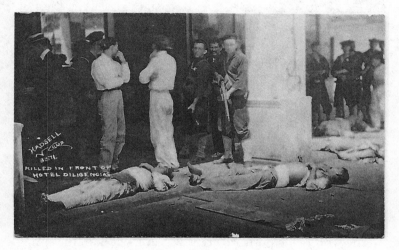

In the spring of 1914, nine American sailors were arrested by the Mexican government for unauthorized entry into a loading area of the oilfields in Tampico, Tamaulipas. They were released with an apology, but without the 21-gun salute also demanded by the United States naval commander. President Woodrow Wilson ordered the fleet to prepare for an occupation of the port of Veracruz, pending authorization from Congress, but then news of an arms shipment headed for the port overrode that formality. The weapons, procured by an American arms dealer, were destined for the newly self-appointed president, Victoriano Huerta, who had been assisted in his coup d'état by the American ambassador; despite this, the United States sided with his rival. Battleships and cruisers landed a force that would ultimately number some 2,300. In the city they met with fierce resistance from determined but poorly equipped local citizens. The occupation lasted seven months. The picture above, taken

by Walter P. Hadsell, an American photographer resident in Veracruz, was published as a (silver-gelatine) postcard and enjoyed wide circulation, even being bootlegged by other photographers.

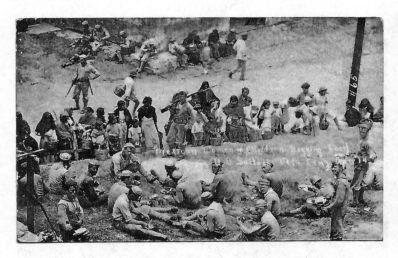

The worldwide postcard craze was at its peak in the spring of 1914 (it would largely succumb to the conflict in Europe starting that August). The Mexican Revolution (1910-20) in its many phases was documented in postcards, by photographers on both sides of the border. The pictures did double duty, as news photos (the folder on the Mexican Revolution in the *New York Times* morgue is filled with cards mailed to the offices from the front) and as snapshots in which potential purchasers might see their own image. American sailors in Veracruz might, for example, send home a picture like the one above showing themselves enjoying a hearty lunch, guarded against a ravenous crowd of Mexican women and children. The photographer chose to center the women and children, although they appear largely featureless, while taking care to depict as many American faces as possible. This card, as crisp as the day it was badly printed, was perhaps preserved in an album for the better part of a century, a remembrance of youth.

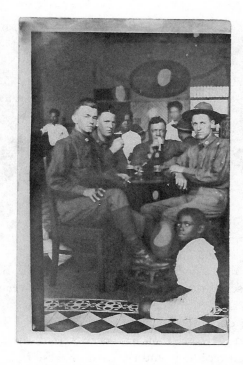

In pictures destined for the American trade, native inhab-
itants of countries entered by the American military gener-
ally appear as servants, beggars, or corpses. The unattributed
postcard above may date from the Border War, which raged
at intervals from 1910 to 1919. The Americans are having a
beer in a cantina, and the dark-skinned locals serve essentially
as decorative accessories, along with the patterned floor tiles.
The child of African descent at front right, who looks no
more than 8 or 9 years old, is shining shoes; the American
rests his foot on an iron step mounted on the shoeshine box.
The proceedings are casual, but the picture is as formal as a
court painting. The raised foot is in fact the center of the pho-
tograph, signifying dominance in explicit if rather superflu-
ous terms. Despite the stains probably resulting from sloppy
printing, the card was clearly carried around by its initial
purchaser for some time, as a souvenir of a happy moment.

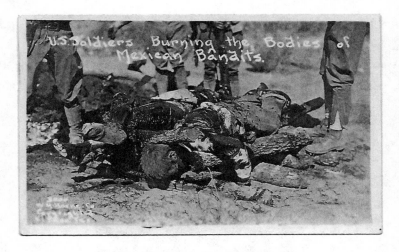

The so-called Bandit War was a subset of the Border War (itself a subset of the Mexican Revolution). Between 1915 and 1916, raids and skirmishes multiplied as parties of Mexican rebels made quixotic attempts to reclaim parts of Texas, New Mexico, and Arizona that had been seized by the United States in the preceding century. Each of these forays was met with bloody reprisals by the Americans. This photo postcard, by Walter H. Horne of El Paso, is not atypical of the documentation of the conflict; other cards show the bodies of dead Mexicans being dumped into carts, hauled away, buried. The pictures are trophies, intended for dissemination. This card, along with another similar shot, was mailed to me by a reader after I'd written an op-ed about the Abu Ghraib photos for the *New York Times* in 2004. I had described those snapshots of abuse—by U.S. military personnel of Iraqi prisoners—as trophy pictures, and that reminded my reader of the cards brought home by her grandfather. She seemed eager to get rid of them.

The memorialization of death was not limited to foreign conflicts. In 1904 you could mail away for this souvenir, which celebrates the use of the electric chair by the state of Ohio from 1897 until the summer of that year. In the center of the faded cabinet card is the chair itself, in an oval vignette bordered by

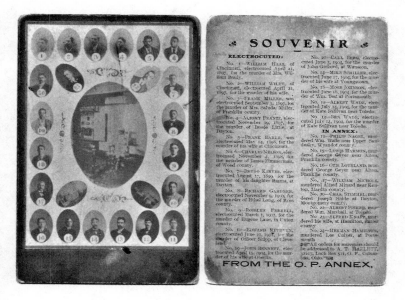

decorative frills. Surrounding it are 24 numbered portraits, also in oval vignettes. Although the subjects of the portraits are as formally dressed as bankers, they are in fact victims of the chair. Sixteen of them have died in it and the remaining eight await their turn in the Annex. The reverse gives their names, the barest outline of their alleged crimes, and their dates of execution, if applicable. Who bought this picture? Were the purchasers drawn by a sense of justified revenge, or by civic pride in the modernity of the equipment? Did they mount it in an album or display it on the mantel? Was it a conversation piece? Was it intended to serve as a warning to their errant children? Did they perhaps imagine throwing the switch themselves, fully empowered by the law to administer death?

All of the above are commercial objects, produced in significant numbers (aside from the cantina picture, probably made on spec). They were not exceptional. There are hundreds of postcards of death from the Mexican conflict, and there are postcards of electric chairs in other states in later years. And then there are the unspeakable photos of lynchings, primarily of African

Americans, that circulated as cabinet cards and postcards in the late nineteenth and early twentieth centuries. I won't show you any of those. The bottom photo will have to substitute: it depicts six men stringing up and aiming guns at what appears to be a dummy; I can provide no context. The United States is perhaps not the most violent country in the world, and certainly not the worst colonial oppressor, but few other nations have ever produced photographs like these. There are commercial photographs of executions in China during the Boxer Rebellion; they were produced by Europeans, as exotica. There are photographs of various atrocities in various conflicts; they were made to inspire outrage and usually circulated by hand in small numbers. The American model of vicarious death-dealing is fairly singular. Trophy pictures are a form of savage entertainment, thinly justified by legal pretext. The atavistic residue of this pursuit surrounds us every day. The cruelty is the point.

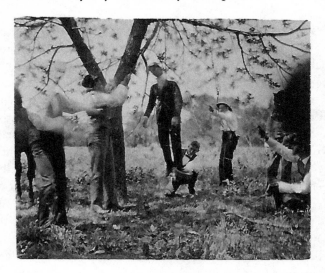

The Spirit Hand

In March 1848, the two Fox sisters, of Hydesville, New York, demonstrated that disembodied knocks and raps, presumably emanating from the beyond, occurred in rooms in which they happened to be present. Their mother soon displayed the same talent, and the three became a sensation, passing from local interest to international fame with what was, for the time, extreme speed. Although a neighbor reported that one of the Foxes had told her they were merely cracking their double-jointed knuckles, this had little effect on their reputation. Around the same time a young Scot, Daniel Douglas Home, who claimed that his rappings predated the Foxes' by two years, and who possessed a much wider repertoire of effects, including abilities to levitate and float, alter his height, handle fire, and physically manifest spirits, in addition to a degree of personal charisma not apparently enjoyed by the Foxes, became the first true star of the nascent belief system known as spiritualism.

That spirits of the dead could cross into the material realm and show themselves and even communicate with the living was an idea that took the Western world by storm in the mid-nineteenth century. Unsurprisingly, its popular appeal was cemented in the wake of the Civil and Franco-Prussian Wars, when large numbers of the bereaved sought to make contact with the untimely departed. But spiritualism also achieved, for a time, considerable intellectual respectability, enlisting prominent adherents in all countries. Victor Hugo and his family spent years regularly consulting what would later be called the Ouija board, at first trying to reach their dead daughter Léopoldine and eventually conducting dialogues with, among others, Dante, Shakespeare, the Ocean, and Death itself. The

astronomer Camille Flammarion, a major scientist of unquestioned integrity, became the de facto leader of the movement in France. William James and Henri Bergson were both sympathetically inclined, if not actually enlisted in the ranks. For more than half a century the matter was taken seriously, if not necessarily endorsed, by almost everybody who had any sort of belief in posthumous existence.

That the phenomenon began suddenly did not trouble anyone, presumably since similar things had been reported by seers and mystics through the ages. That the physical manifestations were subject to continual upgrades does not seem to have aroused much skepticism at first, either. The spirits who modestly rapped on tables soon began to rotate those tables, tilt them from side to side, lift them into the air. Then spirits began to speak through a human intermediary, called a "medium," and rattle chains, ring bells, blow trumpets, perhaps manifest their faces or even their robe-shrouded discarnate bodies. The mediums additionally might while in a trance produce dribbles or streams of a substance called "ectoplasm," a spectral goo somewhere between mucus and mozzarella on the viscosity index, allegedly manufactured by immaterial forces from the mediums' own material fatty deposits. Sometimes the ethereal fluid even assembled itself into little rudimentary body parts.

That the manifestation of spirits would eventually be recorded by photographic means was inevitable, especially since spiritualism and photography had experienced coincidentally synchronous careers through the nineteenth century. The results, when they came, were mixed at best. Although photography gave spiritualism enormous additional publicity, it fatally undermined the movement's credibility. The pictures are, for the most part, grossly and transparently fake. Even allowing for ignorance of photographic processes on the part of the wider public of a century ago, it seems incredible that anyone could have invested belief in "spirits" that either are crudely lithographed and glaringly two-dimensional or are identical in lighting, pose, and expression to photographs taken of the

subjects in life, which suggests either that the dead are frozen forever in their most familiar earthly attitudes, or else that the beyond is severely limited in its range of imagery.

The pictures obviously say a great deal about the nature of belief, about how the wish for heaven can make even intelligent and well-educated persons willfully suspend reasoning and disregard the evidence of their senses—a sadly relevant matter to this day. But some of the pictures also have a wild, irreducible beauty. They are meant to be photographs of the invisible, the inexpressible, the incomprehensible, and sometimes they succeed, at least in being deeply strange—for example, the picture by the researcher Albert von Schrenck-Notzing of the medium "Eva C." (Marthe Béraud) generating a string of fire between her hands has a disturbing power that is not diminished by the knowledge that its salient effect was undoubtedly concocted in the darkroom.

The failures are just as good when the requirements of verisimilitude force them to disregard all the standards of photography as they were then understood; they are off-center, oddly or bluntly or badly lit, filled at their margins with the detritus of *life*—they look very much like keyhole views of the forbidden. Their roughness is their strength, as you can tell when you look at contemporaneous pictures of ghosts made to entertain skeptics and with no intent to deceive, which are invariably more polished, more stagy, more symmetrical, and much more predictable and jocularly dull.

The best spirit photos are those that look as though they couldn't help being made, that are driven by an urgency that overpowers conscious control of the equipment, that not only represent phantoms but seem somehow to have been taken by them. Most of the pictures that fall into this category are the ones showing mediums at work. Often shot in conditions of near-total darkness, in domestic settings that usually look vaguely unclean, during performances that swing erratically between boredom and hysteria, these must rank among the most unstable and anxiety-producing photographs on record.

Either they document chaos, as people levitate and furniture goes flying, or else they show things that look utterly obscene without actually being pornographic, as when mediums are contorted by their possessing spirits or vomit up gushes of ectoplasm.

The spirit photographs per se mostly hew to the conventions of nineteenth- and early-twentieth-century portraiture, although the presence of the revenants messes them up in interesting ways, the flurries of vignetted faces in the later period looking more frantically vital than the shrouded pale spooks of the earlier phase. There is a third category of photographs, those which purport to document "fluids" or auras or emanations or thought itself. These are most often abstract, are quite beautiful in a painterly way, and look like avant-garde works that could be produced even now. In fact they *were* avant-garde productions, employing cameraless photography — made by direct exposure of the photosensitive plate or paper to light and shadow — and various kinds of darkroom manipulation decades before the Futurists and Surrealists began experimenting with them.

Pierre Apraxine and Sophie Schmit, in their introduction to *The Perfect Medium: Photography and the Occult* (2006), point out the limitations of a purely aesthetic approach to the photographs, which, they argue, is just as benighted as judging them strictly on their claims. While it seems hard to imagine looking at such pictures without at least being curious about the conditions under which they were made — with the possible exception of the "fluid" photos, which can seem as though they were not made by humans at all — Apraxine and Schmit's case is buttressed by an earlier German catalog, *Im Reich der Phantome: Fotographie des Unsichtbaren*, edited by Andreas Fischer and Veit Loers (1997).

In that show the spirit photos were matched with a selection of art-world productions from all across the twentieth century that seemed to bear them some relation, however vague. The mandate was exceedingly loose, including double

exposures by El Lissitzky and rayograms by Man Ray among a panoply of works that share nothing but aspects of technique with the spirit photos. Only the pieces that suggest the artist had actually been inspired by occult photography, such as the funny-creepy staged photos by the Belgian Surrealist Paul Nougé (dress shirts and a ball escape from a trunk, a woman is frightened by an animated coil of string, etc.), contribute anything at all to the intended dialogue. The art pictures seem to have been meant by the authors as a justification for the spirit photos, but employing that sort of aesthetic seal of approval can only result in condescension and diminution.

Photographs — all photographs, regardless of their intended use — are subject to aesthetic consumption and judgment. That was not always the case for pictures not intended as art. The idea was pioneered by the Surrealists in the 1920s, was very slowly approved by curators and institutions beginning in the 1950s, and has been generally accepted at least within the last twenty-five years or so. This represents an ironic reversal of the way things stood for more than a century, when photography waited outside the museum door, hat in hand, to be admitted under very particular conditions. Now every snapshot, mug shot, post-mortem record, insurance document, and forensic exhibit is potentially an art object, and some of them possess more aesthetic vigor than many photographs taken with specifically aesthetic intent.

Such is the expanded range of our visual hunger and license that vernacular photographs often look strongest when they fly in the face of aesthetic conventions, even through ignorance or indifference — which in practice usually means that they anticipate, perhaps naively, the approaches of art photographers of future decades: flat, deadpan pictures of buildings and signs that precede Walker Evans, say, or compositions without an obvious center that seem to predict Robert Frank's work. Painters taught art photographers the value of unlearning the prevailing conventions usually taken for granted, and then the photographers taught the rest of us. It has almost become a

habit by now. There is also a certain agreeable shock value in removing pictures from their contexts altogether, although that only succeeds when the pictures are a priori iconic—when the provenance of the image and its train of associated meanings are instantly identifiable by the average viewer (such as Richard Prince's appropriated Marlboro cowboys), which means that they carry enough of their original context with them to put up a good fight in their new surroundings, generating tension by the very fact of being matted and framed.

On the other hand, photos that are less common and require some amount of explanation and historical placement are neutered by being presented in a vacuum. The spirit photographs can be viewed as art objects—and the law of inversion holds, since the most powerful works in the genre are the least observant of the conventions of their time: the least composed, most chaotic, least polished, most apparently spontaneous, most frontally lighted—but they cannot be divorced from their history. By the same token, while they must be granted their historical context, that is not enough to make them intrinsically interesting. A show of discredited relics would be of interest only to antiquarians.

The first spirit photographer whose works have survived was a Bostonian named William Mumler, who was developing a self-portrait in the spring of 1861 when he saw the faint image of a young girl beside his own in the wet-plate negative. He immediately assumed it was the result of his using a previously exposed plate that had not been cleaned sufficiently. He printed it anyway, and at length it came to the attention of the spiritualist press, which took it as proof positive that spirits could be photographed. Mumler, who later claimed to have been "mortified" by this, nevertheless quit his job as a jeweler's engraver and set himself up, however reluctantly, as a professional medium/photographer. Within a year or two he was being investigated, by both skeptics and believers.

In 1863 a spiritualist recognized the shade appearing in his own portrait as someone still living, and denounced Mumler

in the press. Similar incidents followed, and Mumler's reputation languished until, in 1868, he moved to New York City and resumed his practice there, with great success. A year later he was arrested and charged with fraud and larceny. The resulting trial pitted photographers and skeptics, such as P. T. Barnum, against Mumler's sitters, most of them spiritualists prominent in earthly affairs. The trial effectively put spiritualism in the dock alongside Mumler, and perhaps for this reason he was acquitted, although his reputation never quite recovered. He was forced to return to Boston, where he continued quietly taking spirit photos for another decade, including a celebrated one of Mary Todd Lincoln—who allegedly visited Mumler's studio incognito—showing her late husband's spectral form, his hands on her shoulders.

In France, the practice of spirit photography was delayed for a decade by the prudence of Allan Kardec, the original leader of the movement there, who warned his followers that ghostly images were all too easy to obtain by using badly cleaned plates. Kardec died in 1869; four years later, abetted by the *Revue spirite*, Kardec's erstwhile organ, Édouard Buguet began producing spirit photos. There followed the usual investigative process, in which ostensibly agnostic scientists gave Buguet their imprimatur. The *Revue spirite*, for that matter, was not above enhancing previously published texts by Kardec to make them sound more enthusiastic about spirit photography. Nevertheless, Buguet's moment lasted only about a year and a half. A Paris policeman investigating the spiritualist movement, ironically because of its possible ties to socialism, also happened to know something about photography. Buguet went on trial for fraud. Once in court, he promptly told all. Not surprisingly, his procedure involved sleight of hand, double exposure, and the sort of information-harvesting perfected by vaudeville mind-readers. He got a year in jail and a five-hundred-franc fine, and spirit photography in France became, as it were, a dead letter.

Great Britain never experienced that sort of preemptive

court case, although controversies arose regularly. The strength
of belief among British spiritualists was such that spirit pho-
tographers could be conclusively exposed as frauds and yet
continue on for years afterward as if nothing had happened.
William Hope made more than 2500 spirit photographs be-
tween 1905 and his death in 1933, despite strong suggestions
that he had switched plates and, later, irrefutable proof that
he had employed a "ghost stamp"—"a small slide set into a
tube, which, when light was passed through it, could leave a
picture on a negative." Ada Emma Deane produced nearly two
thousand pictures before becoming a professional dog breeder
in 1933. She was notorious for the pictures she made at several
war-memorial ceremonies in the early 1920s, in which a nebu-
lous swirl of faces, apparently of dead soldiers, hovered above
the crowd. Newspapers gleefully pointed out that the spirit
faces included those of living athletes, but the exposure had no
effect on Deane or her clientele.

Hope's and Deane's most prominent champion—in fact the
world's leading proponent of spirit photography in the twenti-
eth century—was Arthur Conan Doyle, who after the success
of Sherlock Holmes championed dozens of causes of all merits
and descriptions. Perhaps because his second wife was a me-
dium, perhaps because of his attempts to make contact with the
spirit of a son who had died of war wounds, he was especially
ardent on the subject of spiritualism, again and again staking
his reputation on claims considered dubious at best by almost
everyone. The most famous such incident began in 1920,
when he declared genuine a number of photographs of fairies
taken by two teenage girls in Yorkshire. Between the weight of
Conan Doyle's name and the fervor of British spiritualists, the
matter remained alive for years, and has continued to be cited
in histories of the paranormal. It was not until 1981 that one of
the perpetrators confessed that the fairies were drawings, held
in place with hat pins.

To our eyes the tip-off is not just that the fairies are obvi-
ously flat, but that they are frozen in stylized postures that

betray their origins in Edwardian popular illustration (their source, *Princess Mary's Gift Book*, 1915, also contains a story by Conan Doyle). To people who wanted to believe, on the other hand, that peculiarity might have made them seem more rather than less credible, since it matched their expectation of what fairies would look like, which in turn had been conditioned by that style of illustration. Similarly, the sheet-draped ghosts in other photographs may seem silly to us, but their intended audience found it natural that revenants would still be wearing the shrouds in which they were buried, or that they would have been issued flowing classical raiments at the door of paradise. That the abstract photos of "fluids" appear the most otherworldly to us is in part a result of our own conditioning by a century of image saturation countered by the purity of abstraction. Another consequence is that today the leading motif in spirit photography carried out by believers is the "orb," a glowing circle of light with no other visible properties that hovers in photos, frequently nocturnal but otherwise random, taken by digital cameras. The Internet is rife with sites devoted to these apparitions. The cryptophotography of the present looks impoverished compared to the riches of the past, but it may well be that the passage of time will lend it charm.

The most recent significant development in spirit photography is also among the most mysterious. In the mid-1960s, Ted Serios, an elevator operator in a Chicago hotel, demonstrated the ability to produce images on Polaroid film held in a camera placed at a distance and triggered by someone else. He seldom succeeded in obtaining the specific images requested of him, but the images he did produce seem unaccountable, and his errors, if that is what they were, are often fascinating—asked for a picture of the Chicago Hilton, where he had worked, he came up with an image of the Denver Hilton instead. His heyday lasted three years, during which he was tested many times, the incidents witnessed by numerous scientists and stage magicians; the famous debunker James Randi was unable to reproduce the feat. But the Polaroids look very much like photographs

of photographs, made on the fly. They are usually blurred and badly framed, but their angles and lighting give away their provenance in commercial photography. This may be more apparent to the present-day eye than to the eye of forty years ago, for which the crisp shadows and dynamic compositions of the travel-brochure imagery of the time merely mirrored contemporary reality. Perhaps investigators were misled into scrutinizing Serios—by all accounts a truculent drunk—when the actual trickery was engineered by one or more of his ostensible supervisors, but there is no indication that that line of inquiry was ever pursued.

Spirit photographs may intend to document the realm of the immaterial, the post-human, the ether, but they are moving precisely because of the grubby human and material stories they inadvertently disclose, of boundless grief and stubborn self-deception and feeble guile and pathetic compromise. They speak of propriety and barbarism, doubt and obsession, love and chicanery, exaltation and despair. They embody every sort of contradiction and every affective extreme. They can be terrifying, not because of their sideshow ghosts or tinpot effects, but because of the emotional undertow that lies just beneath their surfaces. It is not hard to imagine being unbalanced by loss and then thrown into a darkened room where the last tenuous grasp of reality finally gives way, or to imagine larkishly producing a hoax and then finding that a great number of people have become psychologically dependent on its indefinite perpetuation. There is a great unwritten book, or more than one, lurking behind these pictures, but it could only be a work of the imagination.

2006

The Show Window

In 1976 Rupert Murdoch bought the *New York Post*. That was probably the last really important thing to happen to newspapers in New York City before their decline—which by then had been going on, in some estimations, at least since the *New York World* folded in 1931—became steep and terminal about twenty years ago.

The *Post*, of course, was founded by Alexander Hamilton at the dawn of time. It underwent various evolutions but never had much by way of pizazz, even when its front page was redesigned by Norman Bel Geddes, and even when it shrank that basic design to tabloid format. It was the most liberal paper in town, but it was so diffident and soft-spoken it was easily overlooked. Its headlines were not commands—they were suggestions.

Much louder was the bumptious *Daily News*, which had had the tabloid field to itself since the *Daily Mirror* died in the newspaper strike of 1963. It delighted in bellowing, belching, and throwing its elbows around.

But with no competition it was bellowing in an echo chamber. It grew slack. Its editors forgot how to write headlines. Every day as you passed the

newsstand you'd read the front page in a glance and move on. It was like a teletype. You hardly ever bought it anymore.

In 1976 I was 22 and had just gotten out of college. I had a few jobs around the city, first in midtown and then south of 14th Street. I walked by newsstands a lot. I read everything, or at least their front pages.

The first thing I noticed about Murdoch's *Post* was that he changed the masthead to a drop-shadow Gothic three times louder than Bel Geddes's elegant if subdued art deco title.

The second thing was that front pages changed with every edition, sometimes on the hour. That is to say, a given day of succeeding editions of the *Post* might yield six or seven different headlines, depending on how many exploitable events had occurred. Some people presumably had to buy them all.

I wasn't about to, but I nevertheless found myself walking by newsstands many times a day, awarding myself errands and coffee breaks so I could see the new headline.

Suddenly newspapers were electrified. It was as if we were witnessing a revival of the excitement they had generated in the golden era of the tabloids, the 1920s and '30s.

Because once the *Post* got going, the *News* had to awaken from its slumber. It could not compete by churning out headlines lifted straight from the wire service dispatch.

It had to recover its inner animal, its bestial instincts,

its willingness to seize the readership by its vital parts, its hectoring and bullying capacities, its primal rudeness.

And with two papers going at it, not just every day but sometimes every hour, the newsstand display became nearly audible.

The very air was charged. Somebody even raised the cash to put out a third daily tabloid — although it was so ephemeral there does not seem to be any record of it online.

And all this was happening in the New York of the 1970s, which was famously burning. Death, chaos, riot, and squalor ruled the streets. In its apparent decline, the city almost seemed to have returned to its state three-quarters of a century earlier, when giant buildings sprouted from farmland overnight, and rustic innocents newly in town found themselves in rags by the end of the first week, in jail by the end of the second, and wearing dinner jackets and smoking panatelas by the end of the third.

Anyway, for almost as long as there had been newspapers, they seemed to have been of two sharply different kinds, at least outwardly: the gray broadsheet, vast as a tablecloth, scornful of pictures and exclamations, suffocating in its respectability,

and the scandal rag, all sex and mayhem and bluster, mostly made up on the spot by drunken copyreaders and liberally butchered by morphine-addicted typesetters.

At least this was true until the advent of the press lords, such as Pulitzer and Hearst, who beginning in the late nineteenth century tried to have it both ways and generally succeeded.

The merger of hard news and sensationalism created a new kind of entertainment. In the days before radio the

papers seemed to transmit the news instantly. A new headline was a detonation on the street.

Newspapers loomed as large over the city as in this set designed by Gerald Murphy for Cole Porter's musical *Within the Quota*, in 1923.

Right around that time, however, yet another refinement was occurring: the tabloid. The *Daily News* made its debut in 1919. It was half-size, ideal for reading on the subway, and it featured bigger headlines and larger pictures. It took the paper a few years to discover its true calling, however.

But by the mid-1920s it was off to the races. The *News* was a radical distillation of everything that had come before: the hysteria of the Hearst papers was retailed in blaring headlines and confirmed by the most stupefying images possible,

while inside were more pictures and fewer words, catering to a clientele that was too busy to read much, or else couldn't read very well, owing to slum schooling or recent immigration.

And this readership, assuming they weren't reds, could be sold nearly anything as long as it handed them a thrill. On a slow news day you could just make shit up. Didn't matter if the punchline on page 2 turned out to be obvious and flat. They'd have to buy the paper to find out.

That principle led to the next step. In 1924 Bernarr Macfadden, who launched the American obsession with physical fitness with the magazine of that name at the dawn of the twentieth century, and went on to invent the confessional journal, foisted the *New York Evening Graphic* upon the city.

Macfadden jumped into newspaper publishing knowing nothing about the trade. He therefore made a paper in his own image, oblivious to custom. He dispensed with world news, the stock market, and most government business in order to focus on sex and crime.

And he famously oversaw the creation of the composograph, which is to say a photograph contrived in instances

when an uncontrived photo would be impossible, such as the spectacle of Caruso greeting Valentino at the pearly gates.

Or for that matter the producer Earl Carroll's notorious Depression-era party at which starlets allegedly bathed in champagne.

The *Evening Graphic* went bust after eight years, staggering under accumulated debts from libel suits, but not before it had released into the world a collection of journalistic freebooters steeped in showbiz, such as the hard-boiled yet unctuous Walter Winchell, the future TV host Ed Sullivan—who was the *Graphic*'s head sportswriter—and Sam Fuller.

Fuller was the *Graphic*'s seventeen-year-old crime reporter, noted for breaking news of the death from a drug overdose of the amazing Jeanne Eagels, surely destined for stardom. Later he went on to put everything he learned in the tabloid world into his movies. His pictures transpose the tabloid ethos into the cinematic medium, with headlines, smart talk, gun play, eye-opening shots—also with a quantity of raw emotion of a sort that rarely finds its way into tabloids.

He was fixated on newspapers all his life. In 1952 he made *Park Row*, about the New York newspaper world of the late nineteenth century. In 1936 he wrote *The Dark Page*, his fourth novel, which was based on his experiences at the *Graphic*. It

was filmed as *Scandal Sheet,* also in 1952, by Phil Karlson, starring Broderick Crawford.

Meanwhile, the heritage of the *Graphic* proceeded variously. Among its heirs were a flurry of rags that started up more or less simultaneously in various

cities in the early '30s and were run from behind a screen by Walter Annenberg, who had not yet achieved respectability. There were *Brevities, Briefs, Scandals, Tattlers.* They were shut down and their shills jailed within months if not weeks by action of the New York Society for the Suppression of Vice.

But after the war standards were gradually relaxed, so much that by the 1960s they had been dispensed with altogether. It was not only skin mags that caused parents and teachers to forbid Catholic schoolchildren such as me from entering the candy store across the street from the train station.

These rags came out helter-skelter, for six months or a year, from someplace in the Bronx or a loft in the Novelty and Amusement District, with a masthead full of John and Jane Does.

The weirdest stories were unverifiably datelined from obscure ports on the other side of the world, and sometimes you had a funny feeling you'd seen that picture before in some completely different context. The papers were staffed by beginners, drunks, lamsters, dope addicts, poets. You'd sometimes find copies on top of a locker in the changing room at the factory.

Now and then you could catch a genuine human roar from local papers that resisted being either huckster vehicles or homogenized Chamber of Commerce sheets, such as the amazingly enduring *St. Louis Evening Whirl*, today a more subdued online presence.

But leave it to the French to take the phenomenon sideways. In 1928 Georges Kessel and his brother, the reporter and novelist Joseph Kessel, talked the august Gallimard publishing house into backing *Détective*, a true-crime tabloid that would cut across the classes with raw stories, high-lit writers, and modernist visuals.

The plan worked out; circulation jumped from 250,000 to 800,000 within months. And yet *Détective* was far from simple. Its vicarious perch on the border between order and disorder, its amused tolerance for mayhem at a safe distance, its appreciation for the promiscuous mingling of louche glamour and grim terminal depravity—it exemplified all the ambiguities of the Parisian bourgeois attitude toward crime.

It implied a view of class in which you the reader proved your aristocratic bona fides by virtue of your ability to encompass high and low with equal sang-froid. Predictably, the bourgeois eventually got bored and went elsewhere, taking the fine writing and snappy art direction with them.

Still, while even the best of its imitators faded away after a few years, *Détective* has persisted, and is now in its 85th year, the last sixty of them a fairly continuous decline. These days it looks superficially like any

other busy supermarket tabloid, except that its pictures are all of pitiful victims, often children, and of the butchers who did things to them you'd rather not know.

Its queasy mixture of sadism, abjection, and titillation make the reader turn for relief to the Mexican shock-horror press, which is at least straightforwardly uncomplicated about its retailing of violence. Or so at least it seems to a reader who can just about decipher Spanish, innocent of any nuances.

You might say that the twentieth century was constructed by tabloids, written in 48-point headline type, every day given its crash or bomb or murder or riot, shouted one day and forgotten, maybe, a week later, or maybe not.

With allowances made for the higher-caliber events, which naturally call for larger type sizes, the ultimate measure of a news story residing in its compression value, its allowing itself to be expressed in the fewest characters,

an inexorable process by which history achieves its summit in three words, then three syllables,

then two, finally attaining the loftiest status possible: red type.

Tabloids controlled the streets and the subways, dominating the

immediate public consumption of news even after radio came in, after the light-bulb headline crawl began along the side of the Times Building, after people started gathering around store windows to watch television sets they couldn't yet afford.

The tabloid front had become something more than an eye-catching lure with a fact built in:

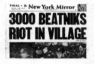

it had become a sign, in every possible sense of that term.

You could read the headlines from quite a distance across a subway platform.

You could make an educated guess based on half a headline jutting out from under somebody's elbow.

Even lying in a wastebasket or smeared along the curb the headlines continued shouting.

It was not merely the size but also the impact of that Railroad Gothic type. It made letters look not just capitalized, but capitalizations of capitals. They were hypertrophied, luridly outsized.

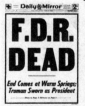

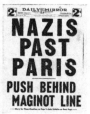

And for many years they were hand-cut or hand-forged, their slight imperfections accentuating their urgency.

Each front page was in effect a poster, a sign in a world of signs. Each reader was a sandwich man, bearing the headlines to be read by everyone who passed, while he or she stood invisible behind them.

The city was a clock with three hands. Shop signs measured years, movie posters and boxing posters measured weeks, and tabloid fronts measured days.

Boxing posters were the tabloids' first cousins; they had common grandsires. They too understood how to make eyes plunge down a page, how to weight the top in order to promote gravity below. Movie posters could be seductive or witty, but like tabloids, boxing posters had to shout, visually.

Eventually artists noticed this. It took them long enough, considering how many decades had elapsed since they first started cutting up newspapers. Michael McClure for example noticed that the form was ideal for conveying beast language, since how else would you expect beasts to publish?

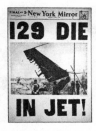

And characteristically Andy Warhol got straight to the point. You couldn't improve on the tabloid front page, so why not simply render it?

And Jacques Villeglé noticed how that Gothic typeface retained its tensile strength when it was torn from walls by kids or people waiting for a bus.

And he and Raymond Hains began cutting rectangular pieces straight off the city walls, sometimes helping the design out a little bit by introducing their own rips. The letters retained their impact even as they ascended into the ether of floating signifiers.

And Gil J. Wolman took the opposite tack, detaching strings of headline matter from newspapers with scotch tape and reassembling it in different forms on other surfaces. He called this practice "Scotch Art."

And William Burroughs cut up newspapers with scissors and reassembled their pieces on his tabletop, looking for messages lurking below their ordinary sense, looking in effect for the subconscious mind of the tabloid intelligence. The number 23 was unfailingly significant.

And finally Dash Snow figured out that you didn't particularly need to do anything to the *New York Post*, even in the twenty-first century, other than dribble a little paint to suggest the artist's will.

It had taken artists until the 1960s to notice and borrow the totemic power of tabloids largely for reasons of class. Until then tabloids had been infra dig, something you didn't bring into nice houses, such as those of collectors. Now, however, the culture was rolling over and shedding useless and outmoded prejudices. Even a highbrow journal could be a tabloid.

Even avant-garde literature could strut in a tabloid coat.

Pop-culture publications with a bit of attitude could split the difference, presenting as magazines on the rack

and opening into tabloids when you held them.

And naturally it stood to reason that militant political journals would employ the form. They had been doing so for decades, after all, but without fully understanding the power of front-page design until the 1960s. The *Black Panther* paper was immediately compelling in a way that no mere tract could possibly be.

And it had scores of imitators, such as the news arm of a short-lived party that aimed to do for the white underclass what the Panthers were doing for their African-American brethren, reclaiming both John Brown and the Confederate battle flag in the process.

As well as by a New York City high-school under-ground newspaper in the highly charged season that ran from 1968 to 1971 or so.

A season in which the Situationist International also compressed its ideas into newsstand hoardings for rapid consumption by readers flee-ing teargas canisters thrown by riot troops.

By the time I was 22 and Rupert Murdoch bought the *New York Post*, all of these variegated factors had consciously or not been burned into my brain and those of my peers. The tabloid front page was an elemental component of our common visual vocabulary.

Unsurprisingly, it became a major constitu-ent factor in the common aesthetic that was emerging then, a set of musical, sartorial, be-havioral, and perhaps political motifs that for better or worse were herded together under the label of "punk."

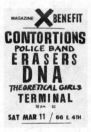

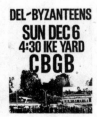

Just as it was crucial that music be taken down to its constituent molecules before any sort of reconstruction could occur, so headline type functioned as the bedrock layer of written language. It signified HERE and NOW. It gave you a clear choice. It did not insult your intelligence. It didn't cajole.

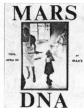

It framed the picture plainly. Word and image were forceful—they might grab you by the collar and force you to look—but you weren't told to like whatever it was. Was liking even relevant to whatever it was?

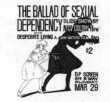

And the boxing poster was re-claimed for the combat of the soul. We knew instinctively that you are your own principal opponent, and that one of you is going down for the count.

The graphic should function at a biological level. Even your platelets can respond to headline type. In reality, we were using headline type to camouflage complexities of thought and feeling we didn't know how to process. And we didn't want to lose face, so we kept it stony.

But the moment ended, as moments will, in this case with a massive assist from the real-estate industry. The reaction to that end took tabloid form, at first as a curiously self-conscious exercise in historical evo-cation. In this case the comix, the jocular masthead, and the resort to the expressions of two decades earlier immediately made the item suspect, like the

new guy in the militant grouplet who has big bushy sideburns, talks too loud, and comes up with all the nutty ideas.

The more convincing approach set it out like a frying pan full of coals. It looked like a tab-loid, like a poster, and like a tombstone.

And now tabloids are approaching the end
of their effective existence, even if they may
well not disappear altogether for quite some
time, since they have not only been central to
the culture but have been indispensible to its
fringes. But their sphere of influence, so vast
not so many years ago, is nearly atomized. They no longer reso-
nate in the present in any meaningful or sustained way.

Digital type makes them look sharp in exactly the
same way that a knockoff Italian designer suit makes
a cheap hood look upscale. Color photography
gives them a sheen of bright desperation, like a film
of sweat. They don't realize how panicked their
laughter sounds because they're drunk, pretty much
all the time now that the boom has started to fall. But they will
go down fighting.

2014

The Famous

Weegee (Arthur Fellig, né Usher Fellig, 1899-1968) was, as pretty much everyone knows, a brilliant tabloid press photographer and a genius at self-promotion. The two skills were intertwined in his makeup, and it's a good thing they were, because otherwise we might only be rediscovering his pictures now. That he is sometimes given sole credit for what amount to entire fields of photography, such as crime-scene shots, is an indication of what is perhaps his most extraordinary achievement: he broke the class line in the medium. In 1945, when Weegee's *Naked City* was published, only a comparative handful of photographers were known by name to a wider public. They were artists, who had had museum shows: Alfred Stieglitz, Paul Strand, Edward Weston, and not many others. The remaining 99% of photographers were artisans, and you were no more likely to know their names than that of whoever designed your socks.

The young Fellig found his way to photography more or less by chance. He came to the United States with his family from Galicia, in the Pale of Settlement, at age 11, was not overburdened by formal education, and went to work at an early age, eventually assisting a tintype portraitist who plied the streets with a pony as a prop. This led to a decade and a half of work in photo labs, which may be where he acquired his moniker—from "squeegee boy," although he certainly encouraged people to think it derived from the Ouija board, as a consequence of his vaunted ability to arrive at crime and accident scenes before the cops did. In any case, he was a hustler from the start. Once he got an opportunity to take news pictures, he worked the corners disdained by other photographers: sticking

close to police headquarters, staying out all night, frequently checking reports on the teletype. He was a character, loquacious and unkempt, with an ever-present stogie in his yap.

Because he was so colorful, and because he came through with shots no one else managed, he was profiled twice in 1937, in *Life* and *Popular Photography*. That was not a measure of his art. Rather it marked him as the sort of only-in-New-York personality chronicled by the likes of Joseph Mitchell and A. J. Liebling. (Weegee always claimed that Mitchell had profiled him for the *New Yorker*, although if so the piece was never published and no manuscript has ever been found.) In fact, the received idea, persisting for decades, was that for all their sensational qualities, Weegee's pictures were conspicuous for their lack of skill. Bruce Downes, publisher and editor of *Popular Photography*, could even write in his introduction to *Weegee on Weegee* (1962), that "he accumulated an impressive collection of pictures, the photographic quality of which was uniformly poor."

Of course, Weegee did take thousands of pictures in the course of his newspaper work, and many were rushed or indifferent. But the inability of his contemporaries to gauge the true worth of his output was due to a sort of typecasting, as well as to the enduring Victorian idea that nothing could be considered beautiful without also being uplifting. Weegee's photographs, by this reasoning, could not be art because they had emerged from the gutter—but that is also why the public enjoyed them enough to make *Naked City* a bestseller and Weegee a celebrity. His pictures held up a mirror to their time, although most people would not have been eager to see their own face reflected.

Today we can look at Weegee's photographs with very different eyes. Photography itself is perceived very differently from the way it was when he was working. We can now place Weegee in a variety of contexts—his immediate competitors, his contemporaries around the world, the full timeline of the art— and such considerations have only enhanced his stature. He

no longer looks like a freak, except in his mastery of publicity, which no other tabloid photographer of his time approached or perhaps even attempted. (There is also the sad fact of his later years, when Weegee tried to become an "artist" using the same vaudevillian strategies, but with far different results, since he was unwilling or unable to transfer the emotional qualities of his news photography to his experiments with distorting lenses.) Weegee can now be seen as the portraitist of a vanished world, that of the urban working class before television and processed foods and anomie. And he did not just take their pictures. He was one of them, and shared their viewpoint.

Before Weegee, the urban masses were photographed by outsiders, largely well-meaning: John Thomson, Alice Austin, Jacob Riis, Lewis Hine. They treated their subjects for the most part with respect, but that was itself a measure of their separation; the subjects could easily become types, nobly representative of their kind. The one photographer who approached Weegee's level of intimacy with his subjects was Brassaï, but he was a bohemian, which meant he could have it both ways. There isn't a grain of piety in Weegee's work, which doesn't mean that there isn't tremendous empathy. Weegee stood shoulder to shoulder with his subjects, and he saw things as they might if they'd had cameras—and possessed a penetrating eye and razor timing, of course. His pictures are often sentimental, their humor is low, their moralizing is cheap. But the photos answering to such a description have to be seen as part of the broad fabric that is the whole of his work, which is itself a city. Right across the street from them are icy pictures of the dead, in which Weegee's empathy is registered obliquely. He liked to photograph corpses with a lot of air above them, so that you could register how hard they fell.

For all his easy familiarity with his subjects, Weegee was a public photographer: he never penetrated a certain privacy barrier, never entered people's homes. His overarching subject is the theater of the streets, but it is a tautological given that anyone who happens to appear within the frame of a Weegee

photo is, as a consequence, an actor. Young lovers embracing on a park bench implicitly agreed that their clinch was a public act; flophouses set private activities in a public place no matter the preferences of their inmates. Weegee took pictures of intentional theater often enough—circuses, costume balls, wartime rallies. His principal quarry, though, was the theater that occurred spontaneously and unforeseeably on the street. This, more often than not, surrounded the aftermath of crimes and accidents. Since Weegee was nothing if not thrifty, and knew how to make maximum use of his opportunities, he realized early on that such a scene would yield two sets of pictures: of the victim and of the crowd.

The victims are always ignominious, mashed face down, hanging half off the sidewalk, strewn among baked goods or bocci balls, half-covered with newspapers, with two cops conducting a conversation over them. His crowds, meanwhile, are often so avid that without a caption it's impossible to tell whether they are seeing a dead body or a live movie star. "Their First Murder" (1941), maybe his greatest picture, is an explosion of heads at different angles displaying the whole range of emotions from anguish to glee, like an allegory by Hals or Hogarth that happened to occur one day for a fraction of a second in front of his lens. Weegee could not have known he was making a picture that would long outlive the memory of the event it depicted, but nevertheless he was responsible for making his own luck. Certainly there can't have been many other photographers of the time taking pictures of small-time crowds—but maybe only Weegee's principal employer, the left-wing daily *PM*, would have published such a thing.

Weegee timed the publication of his book superbly. Its success allowed him to go Hollywood, however briefly, just as the clock was running out on his public and his subject, one and the same, who were just about to begin the trek out to the tract-house suburbs that would occupy the next twenty years. And there were already intimations of change in the air. At Sammy's Bowery Follies, Weegee documented the city of

forty or fifty years earlier reenacting itself for the benefit of swells and college kids to whom it was all an entertaining grotesquerie. Although there's a smile on every face, the festivities appear so terminal that it comes as a shock to learn that the place managed to hang on until the early 1970s, after Weegee's death, by which time the Bowery had become exclusively the province of stumblebums.

Weegee was an unlikely collection of skills and attributes, who could perhaps only have existed, or at least flourished, in his own time. He was a man of the people, when that counted; a character when that helped attract business; a sentimental cynic when that was the currency; but an artist when hardly anyone was prepared to notice. He managed to pass for simple because he talked like the boys down at the cigar store, but his eye had already been to every kind of school.

2012

The Stalking Ghost

Vivian Maier was an ambitious and prolific photographer who conducted her work in the open, but kept its results almost entirely to herself. No one has any idea why that is. We know about her work only by chance, and through cultural and economic circumstances specific to the early 21st century. Had her end come even a decade earlier, it is quite likely that her photographs would have been destroyed and her name relegated to a mere census entry and a dim memory in very few minds. Instead she has been propelled to posthumous fame, and fortune by proxy. She has attained that rarefied position by virtue of her talent, to be sure, but also because of the romance of serendipity as well as the singular opportunities afforded by the Internet to certain kinds of beaverish promoters. Thus her story, as patiently and lucidly detailed by Pamela Bannos,[*] moves along two timelines at once, before and after death, both of them labyrinthine and marked by passages of seemingly permanent obscurity.

We know that Maier was born in New York City in 1926 to French and German immigrants, that she moved to France with her mother at the age of six and moved back in 1938, that she had little formal education, perhaps worked in a sweatshop after her return and was employed in a doll factory by the time she was seventeen, by which time she may also have permanently lost contact with her immediate family. We know that she returned to France for a year when she was 24, on that trip making her first photographs that we know of—at least three

[*] *Vivian Maier: A Photographer's Life and Afterlife,* University of Chicago Press, 2017.

thousand of them. We know that she lived in New York from 1951 to 1955, earning her living by attending to small children as babysitter or nanny, and that during that time she acquired a Rolleiflex and eventually a flash attachment for it, and experimented with color photography. We know that, alone or with a family, she visited Quebec City in 1955, and then took trains across Canada and down to Los Angeles, where she evidently intended to stay, although within a few months she had moved to San Francisco, where she found employment as a nanny. But that interval, too, was brief; in early 1956 she moved to Chicago, where she was to remain for the rest of her life. We know that she made a brief trip back to New York that September, the following year planned an extensive journey to South America that she never undertook, traveled through subarctic Canada in 1958, and then took a trip around the world in 1959, revisiting the Champsaur Valley of her French origins for the last time. We are reasonably sure that she did not leave Chicago of her own volition after 1965.

We know that she had 22 separate addresses in and around Chicago, the first for 16 years, the second for seven, and the last for ten, the others mostly sheltering her for a year or less. We know that she made a great many photographs—at least 100,000 of them and probably more—persistently with a Rolleiflex until the mid-'70s or maybe later and perhaps with a Leica for a decade or more afterward. We seem reasonably sure that she never had an intimate relationship—when mistaken for the grandmother of one of her charges, for example, she angrily riposted that she was "a virtuous woman." We know that she primarily worked as a nanny or attendant, that she was tall and big-boned, wore "mannish" coats and shoes, affected an accent that did not exactly accord with her biography, lied about her family background and early years, and hoarded newspapers, as well as her photographs and books (which she shelved spine-in), to such an extent that the structural stability of her employers' houses was sometimes endangered. We know that in the early '90s she rented five storage lockers to house

her possessions, and left them there until she stopped paying the rent in 2007. We know that their contents were purchased by an auctioneer for $260 and sold by him to an assortment of speculators for around $20,000.

Although we know that she possessed an extensive library of books on photography and monographs on photographers, we don't know exactly when she decided to become a photographer, whether she ever had professional instruction in the medium, or what use she intended, if any, for her very large body of work. Although most of her employers were aware that she took pictures, since her Rolleiflex hung around her neck on nearly every trip out of the house, we don't know why none ever saw more than a handful of shots, mostly pictures of their children or themselves. We don't know why she eventually stopped printing or even developing her rolls, and cannot account for the disparity between the glory of the full frames she exposed and the relatively few prints she made from them, many of which, in the words of the photo historian Marvin Heiferman, are "often indifferently printed and cropped to extract the more obvious details from bigger and more complex pictures." Not to mention that there is no overlap between the images for which she has become known posthumously and the ones she herself chose to print. We don't know why she was so secretive, why she often used aliases when dealing with shopkeepers, or why she failed to cash thousands of dollars' worth of income-tax refund checks.

We know that an interval of some eighteen months passed between the dispersal of her possessions and her death. She was still alive when she started to become well known as a result of discussions on street-photography forums on the Internet, although it seems that no one was aware of this. On November 25, 2008, Maier fell and hit her head on the sidewalk and was subsequently hospitalized; she died the following April 21 without regaining lucidity. John Maloof, a real-estate agent who was the first to evangelize for her and market her aggressively, and who ended up with the bulk of her output, claimed that

he had finally Googled her name and found her obituary the day after her death. In any case, because of the way her estate was handled, less in the initial auctions than in the profuse eBay sales by Maloof and others in the months following those auctions, we have no idea what may have happened to entire slices of her oeuvre. Prints and negatives were sometimes purchased by people who had no name to attach to their authorship, and despite her posthumous fame (five books of her photos have been published to date) they may still not know. If she took pictures before her 1950 trip to France, for example, they may be sitting unidentified in some collector's boxes somewhere in the world.

Maier was a quick-witted street photographer with a vast range of curiosity and an ability to adapt swiftly to changing circumstances in the field. She was audacious, braving high perches and dense crowds and defying official barriers and behavioral conventions in pursuit of shots. Her baked-in reclusiveness may have assisted her in assuming the willed invisibility that is the street photographer's secret weapon. She was clearly aware of developments in the art as they happened, so that her early pictures suggest the possible influence of such photographers as Helen Levitt, Lisette Model, Sid Grossman, and Leon Levinstein, and later on of Robert Frank, Diane Arbus, William Klein, and Garry Winogrand. Unlike those photographers, however, she never benefitted from the presence of a community of peers, trading tips and insights and spurring one another on to greater goals and unexpected turns. Thus, even as she honed her magisterial gifts she remained an eternal student, on the sidelines of her medium. Her faltering will to print and even develop her images also likely resulted from lack of community, audience, dialogue, greater purpose. As she aged, her once-extensive repertoire of approaches narrowed to a series of stock manoeuvers. A large percentage of her later pictures were of newspapers—stacked, spread, crumpled, tossed.

She also made hundreds of short films, which she never edited, and some audiotape recordings, including one in which

she grills random pedestrians about their views on Watergate. For many years she pursued her career as if she were actually covering events for the press, shooting speeches, parades, street arrests, movie premieres, demonstrations, and the aftermath of riots and natural disasters. You sense in her work a burning desire to engage with the world. And yet that desire was stymied by her defenses, some of which, at least in her later years, took on paranoid overtones. She once told an employer that if she had not kept her images secret, "people would have stolen or misused them"; she told a bookstore owner that she thought people were spying on her with binoculars. She may have been a high-functioning paranoid personality, which would account for her secretiveness. Or she may have slid into it later in life, and at first kept her work generally unseen because she was uncertain of its merits, or had been rejected once and never got over it, or feared the social barriers between her as an uneducated woman employed in domestic service and the brahmins who judged the art of photography, or was so involved in the process of taking pictures that she couldn't take time out to think of trying to circulate them.

Many photographs turn up on eBay by makers who are either anonymous or so unknown they might as well be. Maier differs sharply from the norm by virtue of her vast output, and because of the patterns that can be observed thanks to that vastness. She did not merely take good and consistently interesting pictures—she had identifiable themes and preoccupations, like any photographer worth a monograph. She often photographed men sleeping in the open, older women, women wearing hats, the legs and ankles of obese women, men and women seen from behind, people with physical deformities, people taking pictures, shoes of all sorts in every kind of circumstance—and of course she consistently made self-portraits, pictures of her reflection or her shadow, finding ever more inventive approaches. She was parsimonious with her film, usually only taking one frame per subject, and such contact sheets as have been made public show a high rate of hits per

roll. Quite a lot of her pictures possess the terse, epigrammatic, irreducible quality of the best street photographs. But we have only a limited overview of her career, not so much because her output was so vast but because of the many prickly questions of ownership that obscure our sight.

At the head of Bannos's first chapter is a diagram showing the dispersal of Maier's estate. At the initial auction in 2007 the major buyers were Maloof, Ron Slattery, and Randy Prow, in addition to multiple unnamed others. Slattery and Prow later sold some of their acquisitions to Maloof, and some to Jeffrey Goldstein (and he, in turn, sold some to a Canadian buyer, who then sold to a Swiss). Maloof, before he realized what he possessed, sold negatives as well as ink-jet prints to many unknown eBay customers. He ended up with the lion's share of the undeveloped film, which he processed himself, and made prints of his selections, made one of the two films about her, was responsible for three of the five books of her work, and runs the single remaining web site devoted to her. He has a good eye, to judge by his selections, but then again no one but he has seen what else his archive holds—anywhere from 40,000 to over 100,000 images. He has not been open about his dealings and holdings, refusing to cooperate with journalists, other filmmakers, scholars, and researchers, including Bannos.

The Maier industry had already been percolating for months before someone on a web forum raised the question of legality—of who owned her work, and who was authorized to reproduce it. Maloof initially held to a finders-keepers defense, but eventually flew to France and cut a thin deal with a nebulous cousin, thereafter proclaiming that he owned copyright. Besides not accounting for the significant portions of Maier's oeuvre still owned by Slattery (who is the source for most of the illustrations in Bannos's book, which usefully enlarge the perspective)—he made a separate arrangement with Goldstein—Maloof also failed to fully investigate Maier's bloodline. In 2014, an attorney named David Deal—a former freelance photographer who had obtained his law degree partly

as a consequence of seeing his work appropriated and misused on the Internet—filed papers on behalf of another potential Maier heir, whose father had been the brother of one of her grandfathers. The probate court did not accept this claim outright, either, but instead ceded control of the estate to the Cook County public administrator pending a full investigation.

In the cloud of unknowns surrounding the case, perhaps the thorniest factor is that of Maier's only sibling, Karl, who died in 1977 after a lifetime spent in and out of psychiatric institutions—no one knows whether he ever fathered a child. In the absence of firm proof one way or the other, the court could conceivably maintain control of Maier's estate until it reverts to the public domain in 2079. In the meantime the court ordered Maloof and Goldstein to make copies of all documentation pertaining to the matter: every photograph and every ancillary development in the Maier industry. "In other words, the estate was requesting that John Maloof and Jeffrey Goldstein provide copies of images from their collections so the public administrator could sue them for copyright infringement." The reaction, at least among certain photo-world bloggers, followed the topsy-turvy logic of current American populism: that David Deal and by extension the state were "stealing" Maier's work from the people, rather than the other way around.

Maloof and to a lesser extent Goldstein threw themselves into the project of creating Maier's public profile—Maloof's life changed radically as a result—but they were not exactly disinterested parties. The fact that Maier was still alive when the project began gives the case a certain ghoulish overtone, for all that the timing was accidental and at least at first unknown to all. That she was a woman, and one who in many ways lived on the margins of society, adds further wrinkles to the case. That Maier had not made any arrangements for the disposal of her estate, that she did not edit her work to any serious extent, that she did not seem to value her images quite in the same way that most subsequent viewers have—all these raise ethical issues of various sizes. But who would benefit if only

the images she printed herself were allowed to circulate? Are artists always the best judges of their own work? Should the artist's intent persist after death, especially when that intent is uncertain? Do Maier's proclivities with regard to printing and developing accurately reflect her judgment of her work, given that she seems to have valued the act of picture-taking above the later stages of the process? Besides leaving the world an impressive body of often startling images, Vivian Maier has endowed the house of photography with a particularly vivid, restless, stalking ghost.

2017

V

Cut with the Kitchen Knife

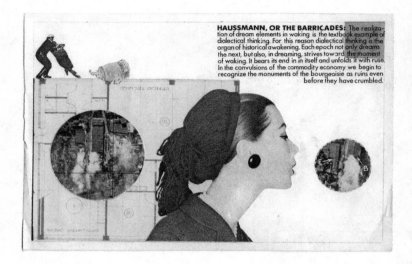

HAUSSMANN, OR THE BARRICADES: The realization of dream elements in waking is the textbook example of dialectical thinking. For this reason dialectical thinking is the organ of historical awakening. Each epoch not only dreams the next, but also, in dreaming, strives toward the moment of waking. It bears its end in in itself and unfolds it with ruse. In the convulsions of the commodity economy we begin to recognize the monuments of the bourgeoisie as ruins even before they have crumbled.

Collage was the dominant motif in twentieth-century art. Among other things it was a symbolic enactment of revolution: taking apart the detritus of the old order and refashioning the pieces into constituent elements of the new. When revolution still seemed like a promise—which was true to some degree as late as the making of this collage, circa 1979—we all had fantasies about how we'd repurpose and retrofit the appurtenances of the standing world. Maybe the French Maoists would use the inner courtyard of the Louvre to slop hogs; maybe the sex-lib people would hold giant orgies in the shells of cathedrals; maybe you and I would make our nest in the linens department of B. Altman and swim in the gutted pit of the Stock Exchange.

Collage repurposed old magazines and assorted visual junk, converting them into architects' renderings of the future, which

is to say the dream state. The fact that people are still making collages today attests to the fact that the flame has not entirely gone out. Maybe. When making collages still involved scissors and glue, you had to kill one thing to make another. When the process is digital, nothing has to be sacrificed and everything is in some way provisional. Then again, the most vigorous field of collage in the last 25 years has been music, and there for the first time in the history of the practice you've had bloody disputes over ownership. No elderly engravers ever sued Max Ernst, and Ernie Bushmiller never lodged a claim against Joe Brainard. And when mixmasters in Rio favelas assume control over symphonies, you get something very close to the primary ambition of collage.

The other major function of the collage was disorientation— "to win the energies of intoxication for the revolution," as Walter Benjamin, author of the text cited in the collage above, put it. But is that even possible anymore? The chance meeting of an umbrella and a sewing machine on a dissecting table, unheard of 140 years ago, is banal today, when everything in the world is denatured surrealism. Realizing this is like finding out that the revolution happened ten years ago, in March, at eleven o'clock, while you were brushing your teeth. Although everything changed, so smoothly that you automatically changed right along with it, it didn't alter anything fundamental about power, or ownership. On that score, a few documents changed hands and that was that. Is it possible that the future prophesized by the collage was merely the landscape of media saturation? Or is there another shoe suspended—of which we're oblivious because our dialectical thinking has languished—that will eventually drop?

2008

Torn Down

In 1985, an unknown person briefly went around tearing down sections of compacted poster-gneiss from the walls of lower Manhattan, mounted them on light stock, and sold them as postcards. I'm very sorry I only bought one; I probably thought they'd be around longer than a month. The unknown person was perhaps aware that he or she was reviving *décollage*, also known as *lacération*, the art devised by Raymond Hains and Jacques Villeglé in Paris starting in the late 1940s. The idea was that a vast, constantly renewed collective artwork was available for the taking on the walls of the city. It was a sort of readymade in Duchamp's sense, since its primary essence was commercial imagery, but it also transcended the readymade by virtue of having been serially lacerated by the crowd, who shredded the posters because they were bored, because they

were angry, because they needed a scrap of paper, because they were waiting for a bus. If there ever was a truly populist avant-garde art, that was it.

It was the purest art of the city: open to all, viscerally satisfying, and recording an actual dialogue between citizens and the stuff they were force-fed. It was bright and explosive and hurtling toward nothingness as you watched. In New York City at the moment of the postcard, the display was less bright because there was less commercial fly-postering of the type seen today — therefore less color — and much more in the way of monochrome photocopied gig flyers wheatpasted by the band members. There were still many unpoliced blank walls then and many plywood-covered storefronts, which sometimes carried so many layers of postering that sections would peel off, from combined weight, like icebergs calving. The posters were advertising of the most zero-degree sort — bands that existed for one night, bands that existed only in one person's imagination, texts written in a code understood only by the writer. The laceration therefore was less a matter of citizens talking back to authority than a phase within a cacophonous ongoing babble. The postcard, with its fortuitous subliminal impression of the World Trade Center, is a fragment of something overheard.

2007

The Seventh

One night an old Pontiac driven by an overburdened father of six went out of control on Avenue A and crashed into a corner building, bringing the whole thing down. The noise was overwhelming, an explosion. People came running from bars and bedrooms. The tenement—empty for years—just dissolved into a hill of bricks, from under which one solitary taillight poked out, its turn signal still for some reason pulsing red. Eventually the cops showed up and tied off the scene with sawhorses, but by then a party had begun to take shape. Somebody had a radio or maybe it was a cassette player, emitting charanga. Joints and bottles of Ronrico and forties of Olde English went around. Percussion started up, keys and knives on bottles tapping the clave rhythm. A man in late middle age who looked like a goat kept enjoining the crowd in a loud bray to "show some resPECT," but nobody paid him any mind. Cop cars at night, with their lights spinning around, splashing the sides of the buildings and visible from blocks away, nearly always put everybody in a party mood. By now there were at least a hundred people milling around, laughing and pointing, shrieking and clowning, quite a number of them dancing. Even the cops were getting into it.

An ambulance and a firetruck arrived along with another squad car. The firemen got busy digging through the rubble while the ambulance crew stood around and shot the shit with the locals. It turned out it wasn't even the second or third building collapse of the day, but the seventh. One in Hell's Kitchen, two in Chinatown, three in Harlem. This not counting the fires. Even as they spoke, said somebody, two separate tenements along Avenue C were burning, one of them

for the third time—what could be left of it? And how about those Mets, somebody else said. Everybody laughed, then the conversation petered out. What could anybody say? For all anybody knew, their building might be next. You didn't really want to go around to the back and see the fault lines in the brick face, or go down to the cellar and see the sag. You really really didn't want to speculate about what your landlord might have in store or what his tax situation was like.

Time passed. It seemed like the whole neighborhood had showed up. People in pajamas rubbed elbows with people in disco outfits. A guy appeared with a shaved-ice setup in a shopping cart and immediately began doing a brisk business. By now the cops had gotten to the car and were deploying mammoth pliers on the roof, trying to wrench it open. It was something to see, like mice trying to open a can of sardines, but it was taking too long. The crowd started losing patience. "Hey papi, you want a hand?" yelled a woman who looked like a ten-year-old until you saw her face up close, and some guy in the back shouted a rejoinder in Spanish that cracked up the whole crowd. Pretty soon everybody was calling out lines at the cops the way they shouted at the screen when a movie started to drag. The cops fastidiously ignored the backchat, just as they ignored the characters standing right next to them smoking cheeba.

Everybody who was anybody was in the crowd. The man with the crutch was all over the street. It was never clear whether he actually needed it or just used it as a stage prop. He was often, as now, seen walking normally while gesticulating with the crutch, shouting all the while. Over there, bending the ear of a young cop who was attempting to pry himself away without leaving his post, was the little man who showed up at all public functions, waving a greasy, much folded piece of paper that may once have been an official document. His cause, an ancient and esoteric grievance, was instantly forgotten by anyone who listened to two minutes of it, although it seemed to keep him alive. The dirty shirtless man with the

nine misshapen and mange-ridden dogs was there—from the look of them you assumed a carnival of incest—and so was the marooned Swiss woman with the stainless-steel hip who regularly woke up everybody on the block calling all night for her cat, Mickey. Lolling here and there were various of those locality drunks—usually somebody's brother—who got themselves adopted by the tenancy of a half-block, so that little girls bought them jelly cakes at the bodega and their mothers thrust sweaters upon them in October and baseball hats in June.

An hour limped by while the cops kept working. Soon after the crowd hit its maximum the excitement level started dropping fast. People went back to bed or dominoes or television, probably, but it almost looked as if they had just evaporated, like spilled beer on a car hood in the sun. One minute there were fifty people standing right in front of you, and then you blinked and they were gone. You could hear the music fading away down the avenue. Soon enough there were just three skels left alone on the asphalt with their quart of Don Diego rum, and everybody else was spared the sight of the crushed body as the cops hauled it out on the gurney. The ambulance's doors finally slammed, and it took off at full throttle with lights spinning and sirens blasting, followed by squad cars doing likewise. You might wonder how dead a body had to be for them to slink off in silence, but most likely they were just having a little fun.

2010

The Long Summer Evening

Bruce Barone's photographs are annals of a former world, one which was documented so fleetingly and obscurely that I sometimes have felt it existed only in my imagination. More than once I've needed visual evidence of that world and could not lay my hands on any. It seemed to have disappeared, that time that now seems notional even when you are confronted with hard evidence of its existence. It was one of those points of overlap, a purgatorial era—stuck between past and future, between living and dead—a time-slip. American cities in the 1970s and early 1980s were restless ghosts, unable to believe they were no longer alive. They trailed their bricks and stamped tin and terra cotta like winding sheets. They were so dead that for a while it almost seemed as if the poor had been put in charge.

Barone, unlike many photographers of the time, was not trying to make pictures of what he wished existed, or of what happened in protected spaces behind closed doors, but recorded what actually transpired when he walked down the street, in midtown Manhattan or in Hoboken. Midtown meant the greater Times Square, of course, and at that time it consisted of dollops of hustle and danger ladled out here and there along a plateau of inertia. It was on the nod much of the time, but could wake up angry. The setting was the ruins of the entertainment capital and nerve center of the Western world, circa 1905–1930. That era's taste for filigree lent to every glassine-envelope transaction the flavor of those eighteenth-century prints in which ragged vagabonds are shown tending fires in the shadow of Roman colonnades. No one worried about the end of the world; that had already taken place.

Hoboken, a mile-square patch on the waterfront in Hudson County, New Jersey, was once a brawling German sailors' town, and back then it retained a bit of that atmosphere, mostly in its bars. It also hosted the memory of Frank Sinatra—embalmed there even when he was still alive—as well as whole clans of Appalachian migrants, a class of people you didn't often see elsewhere in the metropolitan area. Hoboken could remind you of *On the Waterfront*, parts of which were filmed there, or it could remind you of Walker Evans photographs, of industrial Pennsylvania or blighted Alabama depending on the particular block. Until developers happened upon it, Hoboken was a tranquil place, as homey as a dirt yard and as concentrated as a sitcom setting, its main drag lined with mysterious storefronts full of oddities, open whenever the proprietors woke up during daylight hours, and its town hall surrounded by benches where slumbered the ancients, the city's collective memory.

Barone's photographs catch the distinctive silence of the era, its somnolence, its vague menace—unspecified, sometimes,

even after it had kicked you in the head and taken the six bucks in your pocket—and its weather. It was always early evening in summer then, with long shadows collecting in the cracks and the gutters, unless it was winter and snowbound and the light after dark was a pinkish orange from the snow reflecting the pollution dome overhead. His pictures note the various forms of enterprise: storefronts that are either on the verge of grand opening or have just closed for good, record shops resembling government archives in Eastern Europe, greasy little luncheonettes that seemed to obtain their provender at day-old sales, bars strung out along the whole spectrum from decrepitude to pretension, the inexhaustible preponderance of wig stores.

Behind this static, inertial, gently decaying streetscape were the warrens of its inhabitants—railroad flats in tenements, cells in residential hotels—which were always too small and too crowded and too hot or cold for enduring comfort, so that people were pushed out onto the streets to conduct their daily routine. Most of them shuffled inconspicuously from coffee cup to coffee cup, but the younger and more energetic employed the streets as a stage. They played themselves, or slightly amped-up versions of themselves, enacting some behavior on the continuum between dancing and martial arts, or

if they were a bit older they were selling something, maybe
neckties or Jesus, or maybe the skills they'd picked up in some
earlier existence.

It might appear from these pictures—as it sometimes did
back then from the evidence of marquees and storefronts—that
the only viable going concern was porn. And then there were
art and punk rock, two speculative pursuits that didn't pay but
might eventually, and gave meaning and purpose to youths
who might or might not have been ambitious had they lived
at another time. Punk rock was both an attempt to contrive
an aesthetic that would match the ruins and a device like a
tribal mask that would make its bearers appear larger and more
threatening. This latter it utterly failed to do, and punks walked
around unmolested only because nobody cared enough to give
them a hard time. That their aesthetic promoted urgency rather
than languor, severity rather than sentiment, star power rather
than anonymity, carried a certain irony that was unsufficiently
appreciated at the time.

Barone, understanding this, counts off all those aspects of
the time that the punks fed on but ignored. His portrait of the
lost metropolis of twenty-five or thirty years ago is appro-
priately elegiac, like a slow passage for unaccompanied cello.
It's filled with pretty girls and bright-eyed kids, but they in-
habit their city like birds of passage. Even the occasional crowd
seems fugitive and half-formed. The world is drowsy, as if no
news would be happening anytime soon, and it's so quiet you
imagine you could hear the fall of individual dust motes spiral-
ling down through the afternoon air. Inside the bar, meanwhile,
we sit with our drinks, looking out the window, waiting for the
moment when the streetlights go on.

2009

Commerce

Every sign of human progress entails a rent increase.
—Georges Darien

What this country needs is a good two-dollar room and a good two-dollar broom.
—Captain Beefheart

One morning as I was walking up First Avenue, a dog ran past me with a dollar bill in its mouth. A few seconds later a fat man came puffing by in hot pursuit.

Preparing to go do laundry, I accidentally knocked a box of detergent off the windowsill. I dashed downstairs to retrieve it, but by the time I got to the sidewalk it had already vanished.

For years I bought my produce at a place on First Avenue called The Poor People's Friend.

My friends J and P worked at an agency located in the basement of the Empire Hotel, across from Lincoln Center, that assisted foreign students traveling in America. They often had to come to the aid of travelers who had spent all their money and lacked carfare to the airport. Frequently students would barter small items for bus tickets; one day somebody traded them a car. It was a tiny car, maybe Japanese (I don't recall the make), and clearly on its last legs. It was ugly in an unobtrusive way, its body freckled with rust spots. The argument against possessing a car in New York City has mostly to do with parking problems, but this car was immune. We merrily parked it on corners, at crosswalks, in front of churches and fire hydrants, secure in

the knowledge that it wouldn't be towed, let alone stolen. Tow truck operators would take one look and realize that nobody would be paying ransom. We kept the car for almost a month, until, probably, some dutiful cop could stand it no longer.

Second Avenue, south of 14th Street, was at that time deserted after sundown. One of the few sources of illumination, apart from streetlights, was the row of spotlights shining down on the sidewalk from the East River Savings Bank branch between 6th and 7th Streets. One night J and I were walking along when we saw, carefully lined up in the glow of the spots, the complete works of Wilhelm Reich, in chronological order of publication. We each took two books, feeling a bit guilty about it, since they seemed intended for some purpose. We joked that they were meant to greet visiting flying saucers.

One day, walking my dog on 13th Street between First and A, I noticed that of the sidewalk habitués, every man, woman, and child was wearing an identical Kenny Rogers T-shirt. Few of them would have figured among the singer's target audience. The shirts had perhaps, as they say, fallen off a truck.

Among the many curious enterprises on Elizabeth Street was a grocery store that only opened at night, approximately between midnight and dawn, and only stocked a handful of items, chiefly canned garbanzo beans. The store was run by an old woman dressed in black. We never managed to catch her eye, and never heard her speak.

There was a shoe store on First Avenue that you couldn't enter. It was down a short flight of steps in what is known as a French basement, and you couldn't enter because it was crammed to the ceiling with shoeboxes in a sea of dust. Only the owner could negotiate the narrow alleys between the towers. He would bring out the shoes and you tried them on and transacted business on the stoop. It was in effect a vintage shoe

store, but it had not originally been one; the stock had been acquired new and then, for some reason, been left to sit there for a few decades. I still have the store's business card, which is not only illustrated with an engraved depiction of a man's lace-up boot, circa 1914, but also lists the telephone number (GRamercy 7-5885) and address (New York 3, NY) in ways that suggest it was printed no later than 1962.

I sometimes bought shoes from a man named Jerry, from whom I sometimes bought drugs, too, mostly pills. Those were his twin enterprises. When I arrived at his apartment, he would invariably be wearing a sleeveless undershirt and pegged trousers, and just as invariably he would be ironing something on a board identical to my mother's.

If you sat in the right bar long enough, sooner or later someone would offer to sell you something—a tape recorder, say, or a supply of disposable diapers. The vendor would move from table to table with exaggerated stealth, opening the brown paper bag under his arm just enough to permit a glimpse of the item's packaging. Once I scored a portable hairdryer at the Gold Rail on 111th Street and Broadway and presented it to my mother on Christmas. A few years later, my friend D gave me, for my birthday, an 8-millimeter movie camera and tripod, as well as a film cutter that was, however, meant for Super-8 stock. I knew instantly that he had purchased those items in the men's room at Tin Pan Alley, a bar we favored on 49th Street.

Everybody envied M his job. Once a month he traveled to Kennedy airport, where, at a set time, he would receive a call on a particular pay phone. A voice would read him a list of numbers, which he would note down. Moving on to an adjacent telephone, he would call another number and read the list to whoever answered. A few days later a courier would bring him an envelope full of cash.

For many years there were numerous commercial establishments that sold marijuana. Some were candy stores, some social clubs, some bodegas. What they had in common was a slot in a rear wall into which you would push your money, generally $10, and from which you would collect your little manila envelope. The most famous were probably the Black Door and the Blue Door, which glared at one another from opposite sides of 10th Street. One was an empty room; the other featured a pool table. One marked its bags with a Maltese-cross stamp, the other didn't.

By the late 1970s, the fabled Fourth Avenue district of used bookstores had dwindled to fewer than half a dozen, most of them no longer even located on Fourth Avenue. One of the most venerable, Dauber & Pine, had moved to University Place, where it was selling off its remaining stock and no longer acquiring anything new. One day the store suffered a fire, which was quickly contained but left residual smoke damage. The damage was heaviest in the foreign-language department. The store owners tackled the problem by filling shopping bags with afflicted French books, each bag priced at $2. The books, however, not only were varyingly charred and smelling of smoke, but they had been in poor condition to begin with. Furthermore, they were almost uniformly nineteenth-century yellow-backed boudoir trash, the works of Paul de Kock and Xavier de Montépin—Madame Bovary's reading material. Nobody ever bought the bags, as far as I could tell, though

they constituted merchandise so ineffably conceptual they could have commanded thousands in a gallery setting a few blocks to the south.

One day I was sitting in the pastry shop, in a booth. I could hear every word spoken by the large party at the table in the center. They were reminiscing about racetrack scams of the past. A small man with a raspy voice deplored modern tele-communications. At one time, he recalled, he and his brothers had rented a house overlooking the finish line at Pimlico, or maybe it was Hialeah. One of them hung out the window with binoculars. The instant the winner came across, he flashed a hand signal to another brother on the phone. Their man in New York would then signal to a confederate standing in line at the pari-mutuel office, who would bet large, since the official results would take another two minutes to be posted.

Until the 1990s I never paid more than $180 a month in rent. Still, given the condition of my crumbling building—of all the buildings I inhabited over the years—I felt that anything over $100 was high. I knew that R kept an apartment (he seldom visited it, spending his time in other beds) on 3rd Street, in the Men's Shelter block, which because of that street's annoyances and perceived dangers was only $50 a month. My colleague H, for that matter, had inherited her lease from a dead aunt; her 7th Street apartment was a mere $38. And I once met an old-timer who paid $30, but he was bitter about the annual increases imposed by the landlord lobby—when he had originally moved into his 2nd Street tenement in 1960, the rent had been $10. We agreed that ten bucks approximated the value we derived from the neighborhood and its housing stock.

Once, while visiting my parents in New Jersey, I ran into a high-school classmate I hadn't seen in years. When he found out where I lived, he told me he visited the neighborhood sometimes in his capacity as a freight agent for a large-scale

marijuana importer. The outfit rented an apartment a few blocks from mine that was employed as a depot for goods being moved from one distant city to another. Years later N, a friend who was a musician and a carpenter, told me he had spent the previous three months refitting a nearby apartment for a pot dealer. The circumstances were different, though. Prices had increased significantly and so, correspondingly, had apprehension. This dealer, a wholesaler for local traffic, had engaged my friend to put in numerous false walls and invisible compartments and sliding panels, as well as a booth by the door for the guard, with a hole through which he could poke the muzzle of his piece.

For years there was a general store, of the most traditional sort, on 9th and Second. I did my photocopying there, bought aspirin, string, drywall screws, mayonnaise, and greeting cards on various occasions. You could not imagine that they could possibly carry the exact spice or piece of hardware or style of envelope you needed, since the place was not enormous, but invariably an employee would disappear into some warren and reemerge with your item in hand. In my memory I am always going there during blizzards. Another sort of general store stood on the corner of 14th and Third. It may have had another name, but its sign read "Optimo." It was cool and dark inside, with racks of pipes and porn novels and shelves of cigar boxes and candy. Of its two display windows on 14th Street, one featured scales, glassine envelopes, and bricks of Mannitol—the Italian baby laxative favored by dealers in powder for stretching their merchandise. The other, presumably catering to students from the nearby Police Academy, held shields, badges, and handcuffs. I often wished that Bertolt Brecht had been alive to admire those windows.

Once after leaving the World, a club on 2nd Street, I was riding in a taxi with J and R. Rounding a corner, we saw a mutual acquaintance, using a coat hanger, breaking into a parked car.

We knew he did things like that, but none of us had ever seen him in action. It was like watching a nature documentary — or better: it was exactly like looking out the window and seeing an egret building its nest.

Usable objects not worth selling could be disposed of easily. You just put them out on the street and they would disappear, within minutes, as if they had been thrown into a river. Depending on the building, a similar result might be obtained by putting the stuff in the lobby or a stairwell. When I finally threw out my old green couch, though, nobody would touch it. I felt personally insulted. It was admittedly a little ragged, but its springs were all present and intact, and it was long enough to serve as a comfortable spare bed. The cushions, of course, were nabbed immediately, but the rest of it lingered on the sidewalk until someone stuffed it awkwardly through the back door of an abandoned car and set it on fire.

Bodegas sold mysterious little bags of dime-sized cookies decorated with pastel florets of frosting. The bags cost a quarter, and every time I went to a birthday party I would buy one and tape it to my present. As far as I know, nobody ate even one, and no wonder: while they looked soft, they had all the resilience of marble.

For years the local bookie occupied an actual hole in the wall: a storefront only as wide as its door and maybe ten feet deep. He didn't hang out a shingle reading "Bookie," but then he didn't need to. For some reason he abandoned this space in the early '80s and relocated to a back table in the pizza parlor.

When I felt that prices in Manhattan were getting too high, I would cross the river to Hoboken, where you could still find $1 shirts and $5 suits long after those items had risen tenfold in price at home. One day I passed the window of a residence on the main drag in which two or three old paperbacks were

displayed along with a scrawled sign reading "For Sale Inside." I knocked and was admitted. In addition to a couple of revolving racks of fantastically gaudy crime novels from the 1940s and '50s, the room also contained three generations of a family, apparently Southern, from a babe in arms to a grandmother sprawled hacking and gagging on a couch, with a sheet twisted around her middle. Something was cooking on a hot plate. No one spoke. At least five pairs of eyes regarded me hollowly. I browsed in record time, paid, and fled, feeling like a census taker.

Down the street from me was a store called Coffee and Dolls, run by two blond brothers in their forties whom we referred to as "Jimmy Carter" and "Billy Carter." The store's name was accurate, apparently—the window displayed dolls and sacks of coffee beans. No one was ever seen buying either item, however. The fact that the storefront provided a thin cover for the permanent ongoing poker game held in the basement could not have escaped the attention of many people, perhaps not even the police.

When I walked my dog around the block we would sometimes meet a German shepherd and his walker on 13th Street. The dogs liked each other and would play, not a small matter since my chow did not like many other dogs. The owner of the shepherd was a thin guy with a mustache, about my age. I don't remember much conversation, although he was pleasant enough. One day I found myself on Fifth Avenue, near St. Patrick's Cathedral. Up ahead I spotted a mendicant in a wheelchair, with a blanket covering his lower extremities, his neck and torso contorted by cerebral palsy or something similar. When I got close enough to see his face I was thunderstruck—it was the owner of the German shepherd! I thought I must be mistaken, that there was really no more than a general resemblance, but when I walked past him—carefully keeping a line of pedestrians between us so he wouldn't see me—I was sure. It was definitely the same guy. Had he been in a terrible

accident and lost his livelihood? As it happened, I had just been reading about the "cripple factories" of the early twentieth century, where able-bodied men and women were taught to fake blindness and other handicaps to increase their take as beggars. The very fact that I had been reading about such things convinced me that I couldn't possibly be witnessing a present-day equivalent. I felt guilty for not reaching out to him or giving him money, although I couldn't persuade myself to go back. A few days later, however, when I walked my dog around the corner to 13th Street, there was the shepherd—and there was his master, as hale and cheerful as ever.

Z had come from Germany to make his way as a musician, and after a few years his career was progressing rapidly. He played in three or four bands, all of them admired, some measurably in advance of what the other outfits on the scene were doing. He had also, over the years, become a heroin addict. As addicts will, he was driven to ever greater exigencies to raise money to support his habit. His musical employment gave him little financial advantage; as far as I know, none of his bands was ever recorded. He therefore became a burglar. One night he set out to rob the apartment of a former girlfriend. She lived on the top floor of a tenement, her bedroom window—which Z knew to be unlocked—located on the rear, about four feet from the fire escape. Grasping the railing of the fire escape, Z swung his legs over to the window ledge. He inserted the tip of his right sneaker beneath the top of the frame of the lower sash and pushed upward. The window, as he hoped, slid gently open. When he had raised it as far as he could, he dangled his feet inside and gave a mighty push, hoping that momentum and gravity would propel him in. He had fatally miscalculated, however, and dropped five stories to the concrete surface of the back court. A day or two later, the *Daily News* covered the story in an inch-length column filler. "Romeo Falls To Death," it was headed. It told the poignant story of a young émigré musician who was such a romantic that he contrived to slip

into the bedroom of his beloved as she slept. Sadly, he had met with misadventure.

Sooner or later everybody I knew tried to buy something from the deli on Spring Street, and everyone had the same experience. Usually it was a hot day, and the store hove into view just when the need for a can of soda presented itself. So you'd enter, go to the cooler, pick out a cold one, and take it to the counter.

"Five dollars."

"Excuse me?"

"You heard me."

Some people left meekly; some tried arguing, to no avail. If the owner didn't know your family, he didn't want your business, and that was that.

The Late Show was one of several $3 clothing stores that flourished in the neighborhood in the mid-1970s. Everything in the store cost $3, whether it was a T-shirt or a three-piece suit in cut velvet. The place was run by Frenchy and Angel, surviving holdouts from the methamphetamine culture that had ravaged the area half a decade earlier and driven out the hippies. Frenchy had once been wardrobe manager for the New York Dolls; he walked with a cane and moved as if he was fifty years older than his actual age. Angel was so thin she could have hidden behind a telephone pole. She wore ordinary dark glasses

that looked outlandishly oversized on her. One day I took my ditsy friend F, visiting from out of town, for a shopping trip there. Since she had arrived unprepared for the weather, I had lent her my brown leather bomber jacket. She carelessly threw it in a corner and went to work, stepping up to the counter hours later with an enormous haul. After she paid we looked for my jacket and couldn't find it. It turned out that, while our attention was elsewhere, someone had picked it up, tried it on, and bought it.

Among the peddlers on Astor Place, the same set of the works of Khrushchev (Foreign Languages Press, Moscow) circulated from hand to hand for at least a year. Nobody ever bought it, but every day it would appear in someone else's stock.

Inflation. On August 6, 1979, I hit the street clutching a $10 bill. With that sum ($9.98, to be precise) I bought three slices of pizza, a can of Welch's strawberry soda, a pack of Viceroys, six joints, two quarts of orange juice, two containers of yogurt, and a pint of milk. For some reason I was moved to enter those details in my notebook. I often revisited the entry. On May 29, 1981, I noted that the shopping list would cost around $12 at current prices. On March 24, 1983, the sum had risen to $13.50, and a year later to $15. On August 2, 1986, I calculated the cost as $39.35—loose joints were rare on the street, and by then a dime bag of marijuana yielded about two joints. On December 1, 1990, the cost had reached $72—$12 minus the pot. On March 28, 1993, I figured it had attained $92.75, or $22.75 for everything but the marijuana.

One day when L went to buy heroin on 3rd Street, as he often did, he was hijacked. That was not unusual either, but this time the thieves maneuvered him into an abandoned building and took not just his money but also every shred of his clothing. He was forced to make his way home naked. Fortunately he only lived about ten blocks away.

The last time I saw W, he was selling records on the sidewalk on St. Mark's Place. He told me he was disposing of his property to raise funds for a trip to Asia. I don't remember buying anything from him—his tastes tended toward the impressive-looking but unlistenable—but unless I was broke I must have thrown some dollars his way. His travel plans sounded so grand—months apiece in Kashmir, Thailand, Bali, etc.—that I wondered whether he would ever realize them. A few weeks later I got word that he had committed suicide, in his apartment.

"My dream," V told me more than once, "is to come upon a parked truck transporting Kodak film. Think about it: Film is small, light, untraceable, easy to dispose of, and proportionately expensive. A find like that could set you up for years to come." I lost track of V, so I don't know whether he ever fulfilled his dream.

When S inherited his father's estate, although it was not a major sum, he promptly retired. That is, he quit his job, moved into a room in the George Washington Hotel on 23rd Street, and took his meals at the donut shop on the corner. He read, wrote, strolled, napped. It was the life of Riley. He might have continued in this fashion indefinitely had he not made the acquaintance of cocaine.

2006

The Liquid Dollar

MUDD

77 WHITE STREET

NEW YORK, N.Y.

This is a drink ticket. It was currency at one time—actually it was better than the greenback equivalent, because it contained added value in the form of prestige. A drink was a drink, but a drink ticket was a badge of rank. If you wanted to impress a potential pickup, buying them a drink with a ticket carried more weight than flashing a roll. I'm amazed this ticket was never spent, and can only imagine it whiled away the years in some forgotten pocket until after the chance to redeem it had passed. Drink tickets were fought over, stolen, begged for, dubious promises made in exchange for. The drink ticket had a fixed value—it could be redeemed for one drink, top-shelf or well, beer or wine—but while it could generally be obtained for a line of blow, it wasn't necessarily self-evident whom you could perform this exchange with or under what circumstances. In any case, the blow-for-tix swap was probably less common than trades founded on sex, friendship, services rendered, or—above all—a brush of the wing of celebrity.

This drink ticket, issued probably in 1978 or '79, was a harbinger of the following decades. Velvet cordons were just coming in downtown; in the future lay VIP rooms, ultra-VIP

rooms within VIP rooms, bottle clubs, memberships, and whatever crushing nonsense is currently on offer. At the time, my friends and I worked minimum-wage jobs, and most of us were paid in cash—not that we were in the black-economy sector, mind you; it was just cheaper for bosses than cutting checks, and it was understood that many of us wouldn't even have bank accounts. So the drink ticket provided an important lesson in economics as well as a glimpse into the future. We learned that not all dollars are of equal value. We learned that the better off you are, the more eager people will be to give you things. We learned that wealth has never been obtained through labor, or at least not through one's own labor. We learned that wealth envies celebrity more even than celebrity envies wealth—and this at a time when it was possible to be a bona fide celebrity and still be dead broke. This knowledge was lost on us, of course. A creature of today at large in the drink-ticket economy would set about brokering the stupid things.

2008

Like an Artist

Glenn O'Brien (1947-2017) was the leading boulevardier of my particular subgenerational pocket, the one that flourished in lower Manhattan from the last days of the hippie era until sometime around the end of the twentieth century. He was an exemplary if atypical citizen of its culture, and something of a figurehead as it evolved from local, fringe, and "underground" to international high fashion. He lived and worked on the leading edge of style at all times, and was invariably at the right club at the right hour on the right night, although his résumé suggests someone from an earlier era. As if he had flourished during the Regency or the fin-de-siècle, he was a dandy and a wit, an aphorist and a tastemaker. Although his point of entry was Andy Warhol's Factory, he worked primarily with words, as magazine editor, book editor, columnist, and copywriter. He exuded cool, sangfroid, and—unusually for the time and place—quiet competence.

But those jobs, for all the money, prestige, and mobility they gave him, were not his primary claims to fame. In that era careerism was regarded with suspicion, and in that much more physical time he made his mark by his sheer presence on the scene: his role as both a throwback (some part of him always inhabited the world of *The Sweet Smell of Success*) and as the very image of hipness. His cultural footprint was broad and significant, if not always noticeable to the average cultural consumer. He was putatively most visible as the underwear model on the Andy Warhol-designed inner sleeve of the Rolling Stones' *Sticky Fingers* (1971)—although the jury is still out on whether his picture was the one actually used. *TV Party,* the antic talk/variety show he hosted from 1978 to

1982, was his most prominent showcase viewed from a certain angle, although in its time its audience was restricted to people, largely in lower Manhattan, who could tune in the public-access UHF channel on which it ran (a set of DVDs has since been issued). He wrote and produced a feature film starring Jean-Michel Basquiat, a youthsploitation picaresque originally titled *New York Beat*, although financial woes kept it from being released until 2000, nearly two decades later, when it was retitled *Downtown 81* and took on an entirely different significance—historical and elegiac in the wake of Basquiat's early death. And he edited *Interview* (1971-74); worked at magazines ranging from *Rolling Stone* to *High Times* to *Allure*, *Spin*, *Maxim*, *Mirabella*, *Purple*, and *Arena Homme Plus*; co-wrote and edited Madonna's *Sex*; edited some other touch-stones of the period (Kathy Acker's *Blood and Guts in High School*, Terence Sellers's *The Correct Sadist*); wrote a column on advertising for *ArtForum* ("Like Art," 1984-88) and one on men's fashions for *GQ* ("The Style Guy," 1999-2015); and briefly toured a conceptual standup comedy act in which he covered, as a musician would a song, a routine by the legendary B. S. Pully (1910-72), who played Big Jule in *Guys and Dolls* and was known for working blue.

He was also involved in the advertising business himself, starting as a copywriter for the late Barneys New York chain in 1986 and becoming its creative director two years later. After that he worked for Calvin Klein; "I did the 'Marky Mark' underwear campaign with Kate Moss, and the jeans campaign that President Clinton demanded be investigated by the Justice Department," he wrote on his website. (In that 1995 campaign, young models, male and female, are interrogated by an off-screen voice. Nothing untoward occurs, but the innuendo is laid on thick, from the cheap carpeting and fake-wood panel-ing of the set to the light leaks and bits of leader in the film to the questioner's voice and affect—50-ish, gruff, insinuating. Everything suggests a screen test for porn, at best, and prob-ably something worse.) He represented perfume, hotel chains,

bottled water, and U2, and "named and positioned the interiors company . . . Royal Hut."

If this was problematic for some, no one mentioned it. After all, in the 1980s art and commerce became fully acknowledged bedfellows. Artists were photographed wearing banker suits and smoking Montecristos, strove to be featured in ads for Absolut vodka, caroused with real-estate magnates and deep-pocketed promoters with unplaceable accents. Once-ragged lofts were given makeovers; the potato fields of the Hamptons were plowed under for new constructions of ever-increasing size; V.I.P. rooms made it possible to go clubbing without risk of contamination by the unwashed; and anybody who was anybody ate in the kitchen at Mr. Chow's, because it only held one table—reservations not accepted. It was all as Andy Warhol had foretold, with additional glitter from the wand of supply-side economics.

O'Brien was quite sanguine about all this. "Advertising was like art, and more and more art was like advertising," he wrote, near the end of his life. "Ideally, the only difference would be the logo. Advertising could take up the former causes of art—philosophy, beauty, mystery, empire." He felt that Barbara Kruger's work, in which she employed advertising techniques to highlight social and cultural contradictions, was merely inferior advertising. "There are no ethics in fashion. There are no ethics in magazines. There are no ethics in advertising." Naturally, he was a liberal; he despised Trump, the NRA, Israeli apartheid, the sanctioning of Cuba—he also despised burqas, on which he took the French government's view. He was, more precisely, a Kennedy White House liberal, who believed in honor, truth, justice, a few laughs, and a good pour. The Chinese silk banners of Marx and Engels that hung on the *TV Party* set were merely a pun on the word "party," although he had at least sampled Marx. He just thought it was time for Marx to chill. He was an achiever, a print-world architect with a wide range of social and practical skills, who charmingly pretended to be a gentleman of leisure but would

never go hungry in his lifetime. He was educated by the Jesuits, which means that he wore Irony in scarlet on his breastplate.

No wonder he cut such an odd—and oddly beguiling—figure in the New York low bohemia of his youth. It must have been a great day at the Factory when he first walked in, sometime in 1970: here was a potential future member of the ruling class, somehow handsome and intelligent at the same time, who had internalized the principles of cool so deeply that he always pitched his voice as if he were selling you reefer in the men's room at Minton's in 1946. And he was keen on hanging out with people who were not like him, which was pretty much everybody at the Factory. (He was, for one thing, heterosexual.) Despite circumstantial differences, he instinctively grasped and absorbed Warhol's view of the world. He understood the transience of fame, the power of the image, the somatic effect of repetition, the allure of emphatic understatement, and the contrapuntal sympathy between the ordinary and the transgressive. Some other people did, too, but like Warhol and unlike most of them O'Brien possessed an innate executive ability that would allow him to make hay from those insights.

Intelligence for Dummies, a collection of his writings (2019), is magazine-like in its layout, with different fonts and sizes of type, sliding margins, occasional bursts of double columns, and many artful photographs unobtrusively illustrating the pieces. It mixes together essays, columns, lists, and tweets under six broad categories ("Art," "Politics," "Music," etc.). These make for a complex, multifaceted presentation that exemplifies his many contradictions. O'Brien was a gifted writer, although his most formally realized works largely appeared in art monographs and exhibition catalogs, which were, as always, read by few.

His major impact as a scribe came from his columns, which were many, some of long duration. In that function he shone. He was a brilliant maker of remarks, and his remarks on the page are of a piece with his remarks in the field. The trouble with remarks is that they seldom survive their context, meaning

their time. When he wrote his column "Glenn O'Brien's Beat"
for *Interview* in the 1980s, for example, each installment was
like a phone call from its author, relating news, gossip, gags,
passing observations, and sharp judgments delivered offhand.
It possessed urgency and resonance. But phone calls dissolve
into the ether along with the strings of information that bind
them to the world. And no one writes a column *sub specie ae-
ternitatis*. You can footnote all the proper nouns in a column,
but not the wind blowing through the streets at the time of
writing.

Think of columns as much longer tweets; the years will turn
their gossip, trends, forecasts, and recaps to mud. It's impos-
sible to quote one without accidentally including a Dan Quayle
joke. Fortunately, O'Brien had several other modes. He was at
his best with the subjects that engaged him most directly, such
as fashion advertising:

> Why don't [many] publications allow criticism of
> fashion? Because fashion brings home the prover-
> bial bacon, Osbert. That's why we are so blasé that
> it's nothing getting the New Yorker with a two-page
> Versace ad that features two five figure hookers on a
> bed on drugs, one passed out in a garter belt showing
> her complete ass and the other making goofball eye
> contact with the reader, as it were, and this is a normal
> thing, because fashion brings home the bacon.

(He did keep his eye on the bottom line: "Andy must have real-
ized then that even if film was his future, painting was still the
way to bring home the bacon.") And he could imaginatively
project himself into a consciousness that felt like kin, as when
he looked at photographs of Kurt Cobain after his death:

> He is slumped as if exhausted or about to fall down—
> but junkies don't fall down—maybe it's just "I have
> very bad posture." Kurt is knocking back a quart of

Evian, unlike Keith and his Jack Daniels. He is lucid,
but still the light seems to be flickering. The pose is ob-
vious. His posture is crushed. He's in a slump. He's on
the edge of the world we inhabit, peeking into another.

But then he could be cornball or vaguely fogeyish, as in his
complaint about the decline of embarrassment or his proposal
for a Guilty Party in the elections or his suggestion that the
Pentagon sell ad space on the B-2 bomber. As befits a dandy, he
excelled at handing out advice:

It's always better to be overdressed than underdressed
for an occasion. It will appear that you are going
somewhere better later . . . If you order white wine in a
restaurant and it's not cold enough, dump the contents
of a salt shaker into the ice bucket and mix well.

So some of these pieces now fall flat, sound like routines or,
worse, like historical ephemera. Some of the contents here re-
mind me of the volumes of mid-century modern saloon chatter
by Bennett Cerf, which as a kid I found enjoyably mystifying
when I'd turn them up at yard sales. Not coincidentally, O'Brien
acknowledges his debts to Steve Allen and Jack Paar, urbane
talk-show hosts of that same era, and of course his choice of
profession is unavoidably connected to the period as well:
"The creative executives enjoyed much of *La Vie de Bohème*,
hobnobbing with photographers and models, frequenting jazz
clubs, possibly smoking an occasional jazz cigarette." What
chiefly distinguished O'Brien from his downtown milieu was
that at no point was he ever a bohemian. Instead he was, eter-
nally, a hepcat. "Hip is a noun, a verb, and an adjective. Hiply
is the adverb. Hip is a joint. When hips get together they do
the bump. They do the hip shake. When a hip gets cut off and
smoked, it's a ham." He was hip beginning at the very last point
when hipness was still connected to secret knowledge imparted
by members of a disenfranchised minority, in his case largely

by gay men. He remembered the era in lower Manhattan when common aesthetics and partying proclivities seemed to override other sorts of identity. "Everywhere Andy went we all went. Usually we would wind up dancing at a club. The clubs we went to were basically gay discos but they were integrated in a way that no longer exists as far as I know. We were a weird posse of gay and straight guys and straight girls with wandering tendencies."

The book is something of a curate's egg, but then he wrote so damn much, much of it tossed-off and time-sensitive, and the specific lines I can recall are mostly wisecracks, although his wisecracks are pretty good. (He places what seems to be a signature line in Basquiat's dialogue in *Downtown 81*—ventriloquized by Saul Williams, since the original soundtrack was lost—referring to the art-world magus Henry Geldzahler as "Henry Godzilla.") The real keepers in this volume are precisely detailed and often moving evocations of his friends: Warhol, Basquiat, Nan Goldin, Richard Prince, James Nares. He conveys them in ways that are strangely difficult to quote, since they are contingent on chatter, circumstance, anecdote, and location, and evoke by accretion.

> I remember Jean-Michel saying Boom all the time. It was an exclamation point with right on built in. Boom. Boom. Boom for real.
> I remember the way he talked, soft but really fast and forceful. Urgent you might say. With Jean-Michel everything was urgent.
> I remember him painting a painting that was so great and then just painting over it and that was so great.

The book is handsome, although the design can be distracting (I found myself inadvertently avoiding the pieces set in sans serif type), and there are far too many typos for a professional production, some of them substantive (Lee Perry somehow appears as "Leo Perry"). For people who did not

know O'Brien, it can only point in the general direction of his physical presence, which is much more of a consideration than it would normally be for a writer: his deadpan stare, his sotto voce, his timing, his imperturbability, and of course his sartorial magnificence. Readers are advised to look up the listicle published by *GQ* after his death, which spotlights the jewels of his closet: his double-breasted cream-colored shawl-collared dinner jacket by Steed, of Savile Row; his battered John Lobb ghillies; his hand-painted neckties and Charvet shirts; and of course the crown jewel: the Perfecto jacket on which Basquiat painted his trademark crown between the shoulderblades, a garment that should guarantee admission to heaven.

2019

Poet and Movie Star

"Rene Ricard is a poet and movie star," reads one of his contributors' notes; unlike many such notes it was absolutely true. He arrived in New York from Acushnet, Massachusetts, at 18, having changed his name to Rene from Albert Napoleon Ricard, which sounds like a row of liqueur bottles. He presented himself at the Factory, where Andy Warhol assigned him to wash dishes in *Kitchen* (1965). He didn't fare much better in his other parts: He is silent in *Chelsea Girls* (1966) and generally unseen in *The Andy Warhol Story* (unscreened; 1966) and **** (*Four Stars*) (shown once; 1967). But he went on to parody his superstar abjection, rather movingly, in Eric Mitchell's *Underground USA* (1980).

In his *Diaries*, Warhol called him "the George Sanders of the Lower East Side, the Rex Reed of the art world." He did not mean it as a compliment. But while there's no question that Rene was an acid-tongued gossip, he was an Olympian acid-tongued gossip, far beyond the realms of mere columnists. In a better world he would have been our Baudelaire—and he may yet be that, given the culture's propensity for posthumous compensation.

He was a movie star, a poet, an art critic, and a painter. As a critic he only wrote a bare handful of pieces, but they were major events. He was the poet-advocate of Julian Schnabel and Jean-Michel Basquiat at the start of their careers. In his 1982 essay, "The Pledge of Allegiance," on the Fun Gallery and its graffiti painters, he set forth his credo: "I pledge allegiance to the living and I will defend art from history. I will rescue art from the future, from its attrition into taste, and from the speculative notion that it will become more valuable with time."

Those are brave words, and considering how the art world soon evolved, foredoomed; his career as a reviewer did not last much longer. "I had to make my history quick because there would be no future, merely a gossamer world blown about on the zeitgeist, till zeitgeist, the wind of the times, is blasted away by kamikaze, the wind of God."

He knew art the way few people do. An online reminiscence by Erik Wenzel accurately conveys the flavor of his table talk: "Always look at paintings on copper . . . Paintings on copper maintain the richness of pigment that canvas sucks up. You can always tell with green. Green is a fugitive and unstable pigment, if you have a good green, then you can rest assured that what you see is pretty close to what it looked like the day it was painted." He spoke this way even in passing. And note that his formal schooling ended after eighth grade.

He was my upstairs neighbor for just under a decade. He'd accost me in the halls when he was high, wearing his Civil War cap, often to rave something about Lorenzo da Ponte, Mozart's librettist, who'd originally been buried in the Catholic cemetery that once lay across the street. Rene suggested that the graves were still in their underground locations and that their occupants regularly commuted over to spy on us. I didn't know if he recognized me from one occasion to the next; sometimes he'd repeat the previous rant.

Then, one night in the winter of 1988, I went by myself to Film Forum to see Erich von Stroheim's last picture as a director, *Walking Down Broadway* (1933), which was recut by the studio and ignominiously retitled *Hello, Sister!* A recurrent subplot in the film involved a construction worker who after quitting time would get tanked in the saloon next door. When he could just about stagger upright he would break in to his worksite and steal a few sticks of dynamite, then go home and throw them under his bed before passing out. After a few such transits, the inevitable occurred. The house blew up. Walking home from Vandam Street I considered that my building contained not a few people capable of just that. I felt a fuzzy glow

of speculative fear, then laughed it off. The minute I stepped into my hallway, though, I saw my neighbors running around in a frenzy, pails of water in their hands. It seemed that Rene had burned down his apartment. His electricity had been cut off for non-payment; he lit with candles; he was habitually high and smoked endless cigarettes; his apartment was decorated with priceless works of art and a decade's worth of stacked newspapers. Miraculously, the fire did not spread beyond his four walls.

After that I didn't see him for a decade. But when I ran into him somewhere he knew exactly who I was, and he showed me unprompted kindness, much needed then. Somewhere between those two points I had read "The Party Manifesto" in some downtown periodical:

> I will never chase the rich again. Let me starve.
> I will never apply for a grant. Let me starve.
> I must look out for my biography. After all,
> I may be a pariah but I am still and always
> Will be a living legend. I'd rather starve.

I hadn't heard a voice quite like that before. Frank O'Hara certainly never bit the hand that fed him. I wanted to read more but it wasn't easy; Rene's works were all published in fugitive small editions, beginning with the one made to look like a Tiffany box. What I found when I finally started reading was true to my first impression, which is to say that his poetry has an overlay of bitchy cool and an underpinning of woe, but its real genius is epigrammatic. Rene is like La Rochefoucauld with a broken heart. It's either too easy to quote him or too hard, because singling out any line seems unjust to all the rest. I'm not sure at what point I discovered that he was painting his poems, but when I saw the results it seemed like the perfect solution, enshrining each of those lines in a way that makes printing on a page seem mere and common. And while I assumed that all those poem-paintings were done on found canvases,

what I didn't realize is that he made many of the paintings, too—he could, as he did at least once, inscribe a poem onto a thrift-shop painting, then duplicate the whole thing himself.

He became ever more elegant as he aged. In the words of the critic Lisa Liebmann, by the time he died "he looked . . . like a seventeenth-century, Franco-Iberian grandee: Specifically, the cold and brilliant Cardinal de Richelieu." He was brilliant, and he was rhetorically armored, but he wasn't the least bit cold. Just as his life could vacillate between glory and squalor, his poems are all heartbreak and defiance, ruined love and declarations of an independence he insisted on even when he sat at the best tables.

2014

Neighbors

I lived in 15 different places in the 28 years I spent in New York City: brownstones, prewar apartment buildings, and more than a few tenements; uptown, downtown, and in Brooklyn. I had hundreds of neighbors all told: silent and invisible wraiths, loudly querulous parties who inhabited the hallways as much as their own homes, heedless young things who went right on with their noise despite my complaints, studious types who complained about *my* noise — not unjustifiably at times. I lived upstairs from violin teachers, downstairs from drug dealers, and next door to gun-toting militants. I shared a bedroom wall with a couple who practiced alarmingly violent sex (apparently consensual), an airshaft with people who liked to throw their trash out the window, a roof with an ad-hoc one-apartment flophouse for middle-aged alcoholics. Many of my neighbors I never actually met; most I knew only on a nod-and-grunt basis. You know how it is in New York: unless it was a question of noise or the possibility of a fire we fastidiously ignored one another's activities, because that was best for everyone's health.

The place I inhabited the longest — a bit over ten years — was a double tenement on the Lower East Side, a five-story edifice built in 1903. When I moved in, in 1979, the place differed from most of the buildings nearby chiefly in that it was fully inhabited. The landlords, a couple of elderly European post-war immigrants, lived on the third floor, but did such a poor job of maintaining the place that they were about to have it taken away from them and a receiver assigned by the courts. By the time I left we had gone through twelve landlords in half as many years, and the selling price had climbed from $90,000 into the millions. And yet all of us who lived there had spent

the years wondering if and when the thing would collapse. You could see cracks running all the way down the back wall; the beams in the cellar were sagging; the place was held together with spit and caulk. When I moved into my apartment one of the first things I wanted to do was strip off the duct tape that zigzagged across the living room walls. I tugged at an end, ripped—and found nothing but plaster dust behind it. The walls were disintegrating, apparently.

Eventually it did dawn on me that the duct tape itself might be the culprit. It was most likely the work of the former tenants, two men and a woman who played in some band I'd never heard of. They also left behind a broken guitar-effects box, a toilet wallpapered with porn of all flavors, and inexplicable clusters of nails studding the dirty red walls everywhere, high and low. Who knows what kind of racket they made on a nightly basis? When I moved in, the downstairs neighbor was a mystery and the one next door was married to a rock star and seldom came around anymore. The apartment overhead was occupied by a little old man, very courtly and very sad, who lived with a wife and daughter I never saw. I did hear them, however. Both were apparently insane and, for a year or so until they were carted away, both of them moaned all the long nights through. The sound was unearthly, like the lowing of sea creatures on a sandbar at dawn. The first few times I heard it my hair stood on end. It was undoubtedly a good thing I did as many drugs as I did in those years, or I would never have gotten any sleep.

As it was, I was often awakened by a poet who lived two flights up and enjoyed singing "Your Cheating Heart" off-key out his window at dawn, taking advantage of the natural amplification provided by the airshaft. But those were human noises, and as irritated as I might have been when my eyes started blinking and my hangover kicked in, I could forgive them later in the day. No such warmth attended my experience of perhaps the worst torture by neighbor I've ever endured. The apartment below me, perpetually in flux, was sublet for

a season by a young couple who argued, furiously and often. One day, after a particularly raging spat, one of them left, slamming the door. Ten minutes later the other followed suit. Five minutes after that the phone began to ring. And ring, and ring, and ring. It rang for three hours. I supposed that party number one was attempting to reach party number two, but in any case the piercing tone of the bell of the old Western Electric set, reverberating in the empty room below, was driving spikes into my skull, and because I had a deadline and a heavy typewriter I couldn't leave my apartment. I didn't know whose name was attached to the account, and Bell Tel couldn't tell me or turn the thing off. I went so far as to attempt to break into the apartment myself, but was stymied by the window gates. When the torment finally stopped I lay for a long while, shuddering.

I cursed their window gates even as I recognized how essential they were. When I first moved in I had none. One morning I woke up to noise coming from the living room, and walked in stark naked to find a teenager in the process of dismantling my stereo. He fled out the back window to the fire escape. A few days later he returned while I was at work and finished the job. I couldn't afford to replace my stereo, and went without one for three years, since I invested what little money I had in a set of secondhand gates, purchased from a celebrated peddler called John the Communist. Although they might have discouraged further prospective burglars—moot in any case since I had little left to steal—they were useless in preventing the violation of my apartment by two tomcats who jumped in one hot day and proceeded to spray the back room I used as an office, so that it stank of ammonia-intensive feline spunk for years afterward.

My burglar, as it turned out, lived upstairs with his parents and brother. His father and his uncle, who lived next door, were old stock, born in the building. His mother, Susie, was an exotic beauty whose extraordinary resemblance to Billie Holiday was undiminished by decades of drinking—by that time she looked like Billie in her last years. The boys ran wild,

and before they went to prison for unrelated matters they had at least attempted to rob everybody in the house. The parents took no responsibility for their misdeeds—they merely sheltered them, and they had problems of their own you wouldn't want to know about, let alone bear. For the men, a couple of guys who dressed like my dad but talked like movie gangsters, these probably stemmed from gambling.

Their neighbor on the top floor was Mary, the building's doyenne, who had been born in the house not long after its construction, when it stood in the middle of a four-block Italian enclave; one of the Triangle Shirtwaist fire victims had lived in the house. By the 1940s the eastern storefront had become the Sea Breeze Club, a Bonanno family clubhouse, equipped with the first telephone in the building. Mary enjoyed talking about her father, a bricklayer of unimpeachable character who nevertheless loved to hang out with the wise guys, and when his friends were rounded up by the cops one day and taken off in the Black Maria, he was disconsolate at being left behind and moped around like a kid.

The building was creaky and possibly doomed, since like most tenements it had been built on the cheap and only intended to last a few decades. Around the time I moved in, a car had gone out of control on Avenue A and slammed into an empty tenement near 3rd Street—and the whole thing had come down. We thought something similar might eventually happen to us. In the meantime the plumbing was corroding and the electrical circuits were iffy, and once the era of the rotating landlords began, the heating became extraordinarily unreliable, going off for as much as a week at a time, always in the coldest weeks. Trying to hold the house together in the midst of all this was the super, whose name was Zygmunt although everyone called him George. He lived in the first apartment on the right as you came in, was usually available—except on Sunday mornings when his hangover took precedence—and was a dab hand with a pipe wrench, although even he could only provide palliative and temporary remedies. "My friend," George

would say, punctuating his speech with wrench on pipe, "this fucking building made of paper. Crucifix!" (That last word was pronounced "kroo-see-feex.")

He did commendable work under the circumstances, although he never was able to fix the bathtub of my neighbors across the hall, with the result that they came over to use mine, two or three times a week for the entire term of my residence. We became good friends—if we hadn't, war would have broken out. By and large I loved my neighbors, although I worried constantly, owing to the presence of so many loose cannons in a single fragile container. One afternoon I took myself out to see Erich von Stroheim's last picture, with its subplot about the construction worker who hoards dynamite. I walked home thinking about how that character would not be out of place in my building. Then when I opened the door I beheld my neighbors, all of them, out in the halls, rushing around with buckets of water. We had very narrowly escaped a conflagration.

It seemed that the art critic on the fourth floor had neglected to pay his bill for long enough that his Con Ed service was cut off. He had been lighting with candles, and his apartment contained several years of newspapers and a small fortune in contemporary oil paintings. Nature had taken its course. It had to have been a miracle that his was the only apartment affected. In those days nearly everybody smoked, of course, and most people consumed alcohol and some form of drugs, and very few were attentive housekeepers. Drugs in particular caused many to lose track of key details.

Take, for example, the couple on the fifth floor with the boa. They loved their boa, loved feeding it mice, loved the sight of its glistening scales wrapping around a table leg—but drugs made them distracted. They neglected their biweekly purchase of mice for long enough that the snake was driven to find his meals elsewhere. One day he just disappeared. Had he been stolen? Had he chosen to join the alligators in the sewers? The question was answered definitively a few months later. On the ground floor a tenant, going to brush his teeth first thing in the

morning, opened his medicine cabinet—and very nearly had a heart attack when the boa rippled over the shelf from a hole in the wall. To my mind, this illustrated an important principle of apartment living: what goes around, comes around, although it may very well hit your neighbor instead.

2011

The Unknown Soldier

The last thing I saw was a hallway ceiling four feet wide, with a plaster molding that looked like a long row of small fish, each trying to swallow the one ahead of it. The last thing I saw was a crack of yellow sky between buildings, partly obscured by a line of laundry. The last thing I saw was the parapet, and beyond it the trees. The last thing I saw was his badge, but I couldn't tell you the number. The last thing I saw was a full shot glass, slid along by somebody who clapped me on the back. The last thing I saw was the sedan that came barreling straight at me while I thought, It's okay, I'm safely behind the window of the doughnut shop. The last thing I saw was a boot, right foot, with nails protruding from the instep. The last thing I saw was a turd. The last thing I saw was a cobble. The last thing I saw was night.

I lost my balance crossing Broadway and was trampled by a team of brewery horses. I was winching myself up from the side of a six-story house on a board platform with a load of nails for the cornice when the weak part of the rope hit the pulley sideways and got sheared. I lost my way in snowdrifts half a block from my apartment. I drank a bottle of carbolic acid not really knowing whether I meant to or not. I got very cold and coughed and forgot things. I went out to a yard to try to give birth in secret, but something happened. I met a policeman who mistook me for somebody else. I was drunk on my birthday and fell off the dock trying to grab a gold piece that looked like it was floating. I was hanged in the courtyard of the Tombs before a cheering crowd and people clogged the rooftops of buildings, but I still say that rascal had it coming. I stole a loaf of bread and started eating it as I ran down the

street, but there was a wad of raw dough in the middle that got caught in my throat. I was supposed to get up early that morning, but couldn't move. I heard a sort of whistling noise above my head as I was passing by the post office, and that's all I know. I was hustling a customer who looked like a real swell, but when we got upstairs he pulled out a razor. I owed a lot of rent and got put out and that night curled up in somebody else's doorway, and he came home in a bad mood. I ate some oysters I dug up myself. I felt very hot and shaky and strange, and everybody in the shop was looking at me, and I kept trying to tell them that I'd be all right in a minute, but I just couldn't get it out.

I never woke up as the fumes snaked into my room. I stood yelling as he stabbed me again and again. I shot up the bag as soon as I got home, but thought it smelled funny when I cooked it. I was asleep in the park when these kids came by. I crawled out the window and felt sick looking down, so I just threw myself out and looked up as I fell. I thought I could get warm by burning some newspaper in a soup pot. I went to pieces very slowly and was happy when it finally stopped. I thought the train was going way too fast, but I kept on reading. I let this guy pick me up at the party, and sometime later we went off in his car. I felt real sick, but the nurse thought I was kidding. I jumped over to the other fire escape, but my foot slipped. I thought I had time to cross the street. I thought the floor would support my weight. I thought nobody could touch me. I never knew what hit me.

They put me in a bag. They nailed me up in a box. They walked me down Mulberry Street followed by altar boys and four priests under a canopy and everybody in the neighborhood singing the "Libera me, Domine." They collected me in pieces all through the park. They laid me in state under the rotunda for three days. They engraved my name on the pediment. They drew my collar up to my chin to hide the hole in my neck. They laughed about me over baked meats and rye whiskey. They didn't know who I was when they fished me

out and still don't know six months later. They held my body for ransom and collected, but by that time they had burned it. They never found me. They threw me in the cement mixer. They heaped all of us into a trench and stuck a monument on top. They cut me up at the medical school. They weighed down my ankles and tossed me in the drink. They named a dormitory after me. They gave speeches claiming I was some kind of tin saint. They hauled me away in the ashman's cart. They put me on a boat and took me to an island. They tried to keep my mother from throwing herself in after me. They bought me my first suit and dressed me up in it. They marched to City Hall holding candles and shouting my name. They forgot all about me and took down my picture.

So give my eyes to the eye bank, give my blood to the blood bank. Make my hair into switches, put my teeth into rattles, sell my heart to the junkman. Give my spleen to the mayor. Hook my lungs to an engine. Stretch my guts down the avenue. Stick my head on a pike, plug my spine to the third rail, throw my liver and lights to the winner. Grind my nails up with sage and camphor and sell it under the counter. Set my hands in the window as a reminder. Take my name from me and make it a verb. Think of me when you run out of money. Remember me when you fall on the sidewalk. Mention me when they ask you what happened. I am everywhere under your feet.

1996

Acknowledgments

Many thanks to the editors and everyone else who invited, solicited, encouraged, and otherwise helped bring these pieces into being: Ad-Rock, Bruce Barone, Brian Berger, the late Marshall Berman, Eve Bowen, Chris Carroll, Mike D, the late Barbara Epstein, Sheila Glaser, Dominic Jaeckle, Luke Janklow, Nicholas Lezard, Greil Marcus, Michael Miller, Brad Morrow, Louise Neri, Patricia No, Jake Perlin, Dan Piepenbring, Robert Polito, Trevor Schoonmaker, Gemma Sieff, the late Robert Silvers, Nadja Spiegelman, Levi Stahl, Richard Vine, and Mathilde Walker-Billaud; my apologies to anyone I've inadvertently omitted. Thanks to Jem Cohen, David Godlis, Julia Gorton, and Robert Sietsema for their labors and to Philippe Bordaz for his; to Mike McGonigal for his verve and enterprise; to Annie Nocenti for (among other things) the photo on page 205; to the late Arthur Lee for the title; to Steve Connell for being a tireless and true-blue publisher; and to Mimi Lipson, without whom much of this could not have been written.

Most of the contents of this book have previously been published, sometimes in different form and under different titles, in the following: "Mother Courage," "The Source," "The Conspiracy," "The Heroic Nerd," "The Spirit Hand," and "Like an Artist" in the *New York Review of Books*; "I Was Somebody Else," "Summer with a Thousand Julys," "The Empty Room," "Arcade," "Fotonovela," "Masked and Anonymous," "Other People's Pictures," and "Souvenir" in the *Paris Review Daily*; "The Golem," "The Avenger," and "The Stalking Ghost" in *Bookforum*; "The Orphan"